Malcolm Morley

ITINERARIES offers in-depth studies of contemporary artists and their work. Outstanding writers provide fresh assessments of key figures from the recent past, some of them unduly neglected until now, and of the most important members of the new generation.

ITINERARIES books will be indispensable to current debates in the visual arts.

Series editors: Lynne Cooke and Michael Newman

Malcolm Morley

Itineraries

Jean-Claude Lebensztejn

Translated by Lucy McNair

REAKTION BOOKS

Published by Reaktion Books Ltd
79 Farringdon Road, London ECIM 3JU, UK

www.reaktionbooks.co.uk

First published 2001

Designed by Philip Lewis

Printed and bound in Italy by Conti Tipocolor srl

British Library Cataloguing in Publication Data
Lebensztejn, Jean-Claude
 Malcolm Morley: itineraries. – (Itineraries)
 1. Morley, Malcolm, 1931– 2. Painting, English 3. Painting,
 Modern – 20th century – Great Britain 4. Surrealism – Great Britain
 I. Title
 759.2
 ISBN 1 86189 083 4

Contents

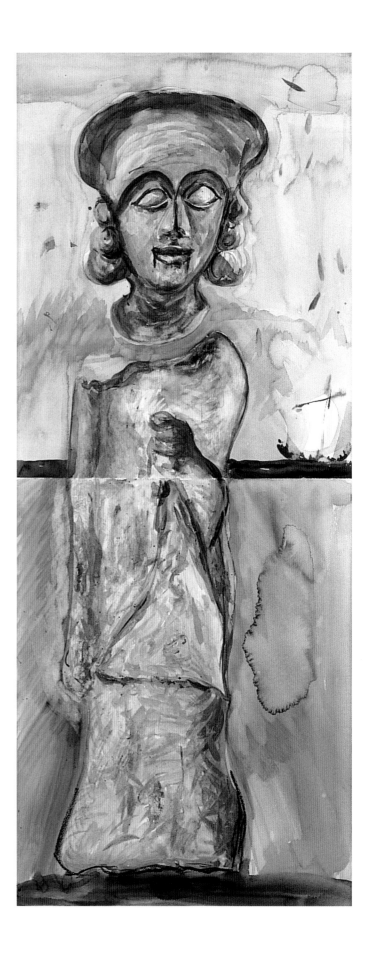

1 Memory

'I'm very bad with dates,' the artist warns me. No need to tell me; I had seen with my own eyes how, in 1993, he had signed a small, striped, abstract canvas for a friend and, without a moment's hesitation, dated it 1961, when it probably had been done in 1963. There was no dishonesty intended; Kandinsky did the same with his so-called first abstract water-colour, and Mondrian, arriving in Paris in late 1911 or early 1912, later remained convinced that it was 1910, according to which notion he dated his first Cubist drawings. Who can date the long-past events of one's life with precision? Practically no-one.

Certainly not Malcolm Morley. His sense of time is archaic, so extremely supple and loosely regimented that any effort to clarify a date or a sequence throws him into a state of near anguish. Yet sometimes I had to insist, knowing that the exact sequence of events can clarify certain things. He tends to exaggerate temporal gaps; he says that he left England at the age of twenty (when he was actually 26 or 27).[1] Or he describes one of the sources for his canvas *Farewell to Crete* as 'a small Minoan sculpture that's 6,000 years old and fresh as a biscuit',[2] and characterizes Cézanne as 'the quantum leap in eight hundred years of Renaissance space'.[3] (In Morley's Italian catalogue, Richard Milazzo corrected this by writing 'four hundred years of Renaissance space'.[4])

Certain names and facts shift around from one interview to another. Which ship appeared in his first four-panel cruise-ship painting – the *Leonardo da Vinci* or the *Cristoforo Colombo*? Did the painting that followed show the *Queen of Bermuda* or the *Empire Monarch*? Due to his past, his temperament and a sort of vagueness he likes to maintain, Morley's persona has taken on a legendary quality. A few of his stories are almost too perfect. Robert Pincus-Witten, in the published fragments of his journal, relates how, in 1983 during his first retrospective show at the Whitechapel Gallery in London (financed by Sotheby's), Morley was housed at the Ritz and lionized:

> Coming down to breakfast the first morning, he was informed by the 'maitre d'' that he could not wear jeans in the dining room. 'You're absolutely sure?' Malcolm asked the waiter, who grew more imperious at each demand for affirmation of the ruling. 'Yes, absolutely sure.' 'All right then', said Malcolm, and he opened his belt and dropped his pants.

Pincus-Witten added: 'Well, not really, but the story is so good with this ending.'[5]

1 *Untitled (Statue)*, 1982.

When I remind him of this text today (5 February 1999), Morley tells me that someone told him the story and that he stole it; it's the only one he's ever invented, he says; all the rest is true, literally or figuratively. Of course he knows that Pincus-Witten is an art critic, and the story is just too good not to pass into history.

But when he is in a bad mood, he can reject any discussion of a precise point,[6] even denying facts if he has the impression that they will turn into clichés. When a journalist once asked him if it were true, as had been written, that he learned his art at the reformatory, or even in prison, he answered, 'Utter bloody rubbish'.[7] Or he can be brutally frank: 'I don't like that train of thought at all. Not at all. I think the question is really bad.' If the journalist (in this case from the *Times*) insists, things can turn ugly:

> Did he want to talk about how his style developed?
> 'I don't want to talk about that.'
> What was he painting now?
> 'I don't want to talk about that either.'
> Was there anything he did want to talk about?
> 'Well, if I hear it, I'll let you know.'[8]

In 1998, Morley got it into his head to write *Showing the View to a Blind Man*, which he broke off after some twenty pages: 'It is almost as if I were a blind man, and I were trying to show myself the view. Perhaps something will come of it in the end.' Without really inventing, the painter embellishes and fabricates, recreating his past in words as he does in images. Others will dig through archives, interview survivors, re-establish the sequence of events: all of that is certainly important if one wants to understand history. As for me, I have no other witness to his past then the man himself, no other traces than newspaper clippings; I have to take him at his word, all the while trying to see clearly and retaining my scepticism. I reap the benefits of accuracy as well as those of error – just as he does. The paths of memory can be contradictory; it's up to me to accommodate them. I make a method out of this accommodation and credulity; with Morley, as with Genet, Arshile Gorky or Kenneth Anger, facts are invested with an autobiographer's fantasy and the mischief of memory. All of this constitutes a type of reality, a parallel world. There is more than one world.

2 Fathoms 04, 1963.

2 Youth

As far as one knows, Malcolm John Austin Morley was born on 7 June 1931 in Highgate in north London. His mother, Dorothy, was 21. She never revealed the name of his father to Malcolm, preferring to invent different stories: that his father was Italian, or that he was a famous sculptor. Malcolm himself would fabricate his own hypotheses ranging from rape to incest. Whatever the truth, mystery and violence held watch over his cradle.

The man his mother married when he was six years old was a former Welsh miner (not a seaman as has been claimed) by the name of Evans; Malcolm carried this name – and signed his first paintings with it – until the day he applied for a passport and discovered his mother's maiden name, Morley, which he took once he settled in America. His stepfather, he says, was a handsome man gifted with a magnificent tenor voice, a talent he could have developed professionally though he never wanted to. He sang in public in the style of Richard Tauber but with the voice of a Pavarotti; he refused to sing in falsetto, and when he hit a high C, Malcolm says it gave him goose pimples. In 1982, Morley painted a picture entitled *Alexander Greeting A.B. Seaman Ulysses M.A. Evans, Jr., at the Foot of the Colossus of Peanigh* (page 133). He claims this title came to him spontaneously.

He recounts several incidents from his childhood.

He was about five years old when his grandmother took him to the seaside at Folkestone:

> I was walking just a few steps ahead of my grandmother when I went up to a man with dark sunglasses sitting on a bench. I tugged him on the coat, and told him excitedly to look at the sailboats and the white waves and flags waving in the breeze. He said to me, 'Sonny, can't you read?' I couldn't, but I said, 'Yes, I can read'. He pointed to a button on the lapel of his black overcoat and said, 'Read this'. I couldn't understand what was written on the button. As he started spelling out the word BLIND, my grandmother came up and grabbed my hand and said, 'Can't you see the man is blind?'. I was so ashamed, I felt I wanted to sink into the floor. I wanted to disappear completely.
>
> I think of this incident many times. It has become a kind of metaphor in my mind. I think very often I am trying to show the view to a blind man and can never show it enough. And it applies to me as much as to anyone else.[1]

He was terrified of his stepfather. From the age of four, he says, he was always running away. His mother put him in a boarding school at an early

age (six? He's no longer sure today): 'This was the first separation from my mother, and I never recovered.'[2]

Around the age of eleven, this solitary child developed a passion for model airplanes and boats which he made out of balsawood. He has often recounted the following memory: he was about thirteen and had just completed his last and most beautiful boat, the battleship *HMS Nelson*. He placed it on a table near a window, intending to paint it later, when, in the middle of the night, a new kind of German bomb, one of 'the jet-propelled, pilotless bombs, known as Doodlebugs V-1',[3] landed in the street, destroying the entire front wall of the house including the boat. Malcolm and his family were unhurt but became refugees. The shock was so violent that Morley repressed this memory until it resurfaced 30 years later during a psychoanalytic session. One detail Morley added more recently is that his stepfather had just caught him masturbating and had told him, 'I'll kill you if you ever do that again.'[4]

He entered naval school at about thirteen, ran away after a punishment (twelve lashes of the cane on his behind) and signed up as a ship's boy on the tugboat *Salvonia*, then embarking for Newfoundland. With storms and seasickness, the crossing was rough.

Once back in London, he bummed around. He wasn't quite sixteen.

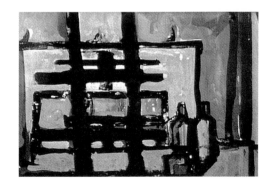

3 *Still Life at Nineteen, c.* 1950.

4 *City Light at Night*, 1957.

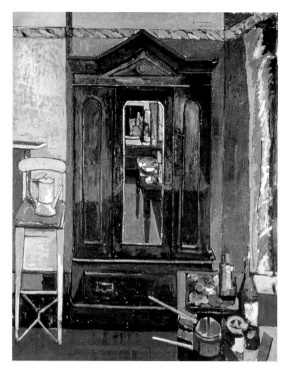

5 *Richmond Hill*, 1958.

6 *Studio Interior*, 1959.

He spent a year at Hewel Grange reformatory in Birmingham for stealing a woman's handbag: 'The dormitory I was in had a frieze of Schubert's Unfinished Symphony.'[5] He learned weaving and bricklaying; both became models for how he would paint: 'I think I have adopted a brick wall approach to make paintings.'[6]

Hardly out, he was picked up again, this time receiving six months in Portsmouth and, finally, three years at Wormwood Scrubs in London, always for small break-ins and other misdemeanours:

> It was drifting and petty theft. I always got caught . . . I was involved in the glamorous idea of a big gang of crooks. I wanted to pull off a big job. In a way, it was the same kind of ambition as wanting to pull off a big painting. But I never did pull off a big job. I always got caught for petty things . . . stealing a lorry load of cigarettes . . . They finally gave me three years. Then it was a real prison.[7]

One thinks of Jean Genet, another rootless child, another clumsy thief who always got caught, as if he was looking for a refuge and couldn't find an alternative. For both of them, prison in effect offered refuge, and the right emergency exit: 'Genet and I are proof that if you want to become an artist, you have to spend time behind bars.'[8] Denied a family life, both would remain related, as Sartre put it, to the family of *passéistes*.

8 *Happy Anniversary*, 1962.

7 *Aesop's Fables*, 1961.

At the Scrubs, Morley took drawing classes – for the sole reason, he says, of getting out of his cell. Then (as he had the right to take out two books a week and bribed the library supervisor for the fattest ones) he came upon an edition of *Lust for Life*, Irving Stone's fictionalized biography of Vincent van Gogh. It wasn't so much van Gogh's paintings that interested Morley (they've never interested him that much, he says, although in 1972 he painted a paraphrase of *Wheatfield with Crows*), but rather the history surrounding them: 'I ate it up – he writes a very good story. What I liked about the book was, it looked to me like something I could do. I could also be an artist.'

The rest of the story could have come out of Dickens. Morley signed up for a correspondence course in drawing, sending in sketches and receiving them back with corrections. At the end of two years, he was freed

9 *High July*, 1964.

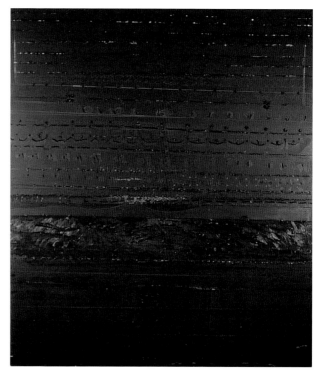

10 *Wormwood Scrubs*, 1964.

for good conduct. His goal was now to become an artist. He went to the artists' colony of St Ives in Cornwall. He worked as a waiter and painted watercolours, which received some attention. He returned to London to study at the Camberwell School of Arts and Crafts in 1952–3, then at the Royal College of Art under the guidance of Julian Salmon, the Jewish owner of the chain of Lyon's Cornerhouse restaurants, who paid for his studies without telling him. (There have been a lot of Jews in Morley's life, he tells me, including his first four wives.) Among his fellow students at the Royal College were Richard Smith, Robyn Denny, Peter Blake and Frank Auerbach. Although the teaching was traditional, it didn't lead to a lot of learning; the atmosphere was informed by pubs, scooters and late-night parties: 'The teachers would go to a pub, and learning consisted of how much you could drink.' Nevertheless, as Peter Krashes pointed out to

me, Morley's discipline and artistic methods – measuring a model with a brush held at arm's length – date back to Camberwell.

In early 1956, Morley saw an exhibition at the Tate Gallery called *Modern Art in the United States: A Selection from the Collections of the Museum of Modern Art, New York*, which included Abstract Expressionist works. It made a smaller impression on him, he says today, than has been claimed: 'My ambition was too big . . . I would have liked to be Pollock, but I wouldn't want to be after Pollock.' The painting that moved him during his student years was Cézanne's *Old Woman with a Rosary*, then a recent acquisition of the National Gallery.

> The works selected by the Tate included among others those of Baziotes, Gorky, Guston, Kline, Motherwell, de Kooning (including *Woman I*), Pollock (*The She-Wolf, Number 1*, 1948), Rothko, and Still. Since the 1967 article of Lawrence Alloway, it has been repeated that this show motivated Morley to leave for the United States. He himself has repeated here and there[9] that, meeting Newman in New York for the first time, he told him he was the reason, or one of the reasons, he had emigrated to the United States; he spontaneously admitted to me that this was not true – that he never told him that; in any case, it would have been a lie, since Newman wasn't in the 1956 exhibition, which was rather poorly received in London. Morley has told me that what impressed him at the Tate was the painting of Clyfford Still.

Morley has been married five times. The first four marriages didn't last very long; as soon as he met a girl, he wanted to marry her immediately, as if by doing so, he says, he could recreate the family he never had. He met his first wife, an American woman older than him, on a London bus and left for the United States, where they married. Having returned to finish his exams at the Royal College, he left definitively for the United States in 1958. The three crossings were made by boat.

His English paintings are urban or suburban landscapes and kitchen scenes, done in the style of the English Kitchen Sink school – Bratby, Jack Smith, Middleditch. He retains a great admiration for English painters such as Walter Sickert: 'I worked with Victor Pasmore, doing dreary backyards in the romantic tonal syndrome,' he said during a 1966 conference at Ohio State University.[10] Then, around 1960–61, there was a change which, he says, was 'radical, and contrived'; under the influence of his new

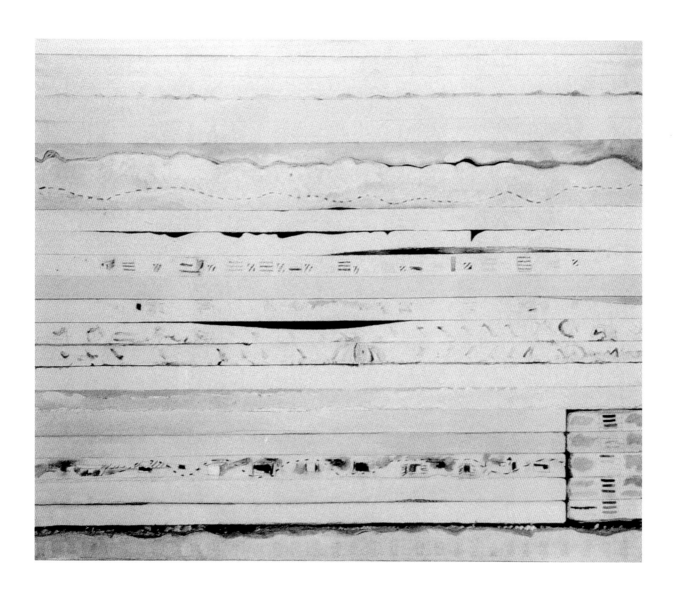

11 *Split Level, Weather Wave*, 1964.

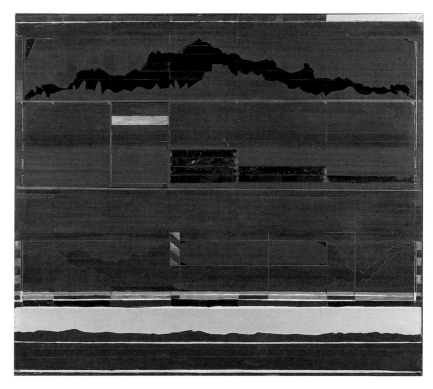

12 *Atlantis*, 1964.

environment (particularly of Cy Twombly), he began some abstract paintings, executed without grids in generally whitish or blackish tones, trying out different styles. He describes the first of these as 'almost a combination of Paul Klee and English stained glass'. (It's true that an English night landscape from 1957 [*City Light at Night* (page 14)] already shows something of the quality of certain of these abstractions.)

Although it has been repeated over and over again that Morley had his first solo show at the Kornblee Gallery in New York in 1957, this exhibition actually took place in October 1964. The artist showed a selection of abstract paintings in that month – 'several large oils that strangely and effectively project an intimate vision (rows of minute forms, as in an abacus of Paul Klee) in a monumental scale', according to a review by Dore Ashton, who added, '. . . he has yet to find his precise road, but his general direction is of considerable interest.'[11] In 1963 and '64, these paintings tended to organize themselves into horizontal stripes: *Mayor Rosebud's Garden, High July* (page 17), *Battle of Hastings, Split Level, Weather Wave*

(page 19)and the dark grey *Atlantis*. Some of these works make a passing reference to the sea and to boats. The large abstract canvas from 1963, *Fathoms 04* (page 12) (Is this a reference to Ariel's song in *The Tempest*, which was used by Pollock as a title for one of his canvases? No, maintains Morley; he admits to the Pollock reference, but insists that he didn't know the source was Shakespeare), seems to reproduce horizontal strips of canvas, some of which appear unstitched and hanging (they evoke assemblages of wooden boat slats). However, in Morley's mind the canvas was purely abstract, and what I read as representing an unstitched canvas (he allows the reading) was nothing for him but a way of breaking with the monotony of the stripes. The same goes for *Split Level, Weather Wave*. These canvases-on-canvas let the viewer discover the play between two levels of reality and reproduction; one can see an abstraction or an illusion in them in which, according to the rules of Baroque *trompe-l'œil*, the imitation and the thing imitated become almost indistinguishably enmeshed.

One of these canvases is blackish; the bands seem to close the space off and let an opening (but is it an opening?) of paint appear: a painting of greater texture applied with a pastry gun, a tool the artist sometimes used. Reproduced without title and dated *c.* 1963 in the Whitechapel catalogue,[12] it is dated 1964 in the provisional catalogue (O64-02), where it carries the title *Wormwood Scrubs* (page 17), after the London prison where Morley served time and where he had his first encounter with painting.

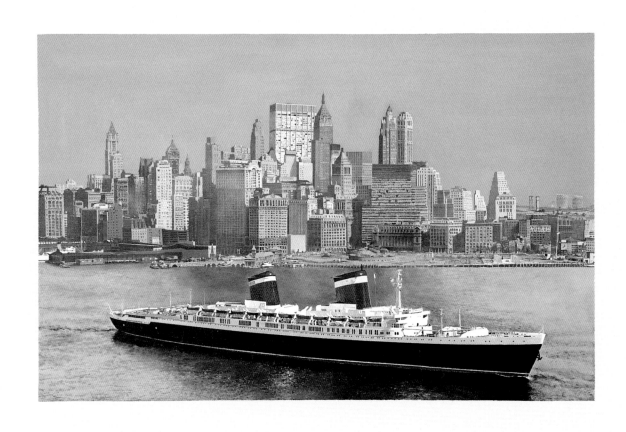

13 *United States with New York Skyline*, 1965.

3 Fidelity Paintings

What motivated Morley's move towards his specific form of extreme realism is not absolutely clear, although the painter has emphasized the influences of Ivan Karp and Richard Artschwager. His admitted reason is banal but vital: the need for living space. 'Malcolm Morley put it that he was "looking for a house in which no one was living" . . . It seems the only way you could get away from style and "art" was to paint things as they really looked . . . Realism has been just about the only direction where one could still stir up a bit of controversy and hostility,' says the painter Robert Bechtle in one of fourteen interviews with Photo-Realist artists published in a special 1972 issue of *Art in America*.[1] Morley didn't show up among the latter, the house of realism having become somewhat overpopulated. Besides, for him realism was something other than an uninhabited place; it was a place of resistance to the impossibility of painting where abstraction, in his opinion, seems to be caught today.

His motive in changing was, more precisely, to find an object for his art that art hadn't already touched. This object was not boats, as one might have assumed, but rather postcards, tourist brochures, calendars and printed photographs of all sorts: an object at the same time wholly iconophoric and inartistic: 'What I wanted was to find an iconography that was untarnished by art.'[2]

In November 1964, with his show of abstract canvases at the Kornblee Gallery barely closed, he embarked on his first boat paintings. For Morley, an exhibition was sometimes an opportunity to effect a more or less pronounced turnaround, but this one was less abrupt than the one that had motivated his first abstractions. He has said of these new canvases: 'They seemed to be a natural outgrowth of the abstract paintings, which had a very super-structured sort of look, like tiers of stripes. I would call them nautical names – *Plimsoll Line* – that's a measurement on the side of the hull.'[3] In one of his last abstract paintings, *Outward Bound* (1964) (page 24), done in Liquitex and oil, the outline of a boat is clearly visible under a grey, stormy sky; it resembles a strange geometric transition. Morley was obviously looking for his path.

Lawrence Alloway, in the first important text on Morley ('The Paintings of Malcolm Morley', 1967), describes the style that initiated this apparently radical shift which culminated in the boat paintings:

14 *Outward Bound*, 1964.

The paintings that mark the start of his present style date from the winter of 1964–65. They are monochrome images, traced and blown-up from photographs of battleships and sailors. Over a crisp, two-tone outline he washed a film of diluted Higgins ink to unify the image and to produce a quality similar to the grain of photographic reproduction. The dim tonality of these monochromes failed to satisfy him but he explored photographic sources further. Instead of the nostalgic implications of the dimmed image, he turned to the bright hard hues of colour photography.[4]

While the preceding paintings had been oils, these grey boats or battleships were done in acrylic and in ink: *Boat* in grey on an orange background; *HMS Hood, Warspite, Warspite* (*Ready*), and *HMS Hood* (*Foe*) and *HMS Hood*

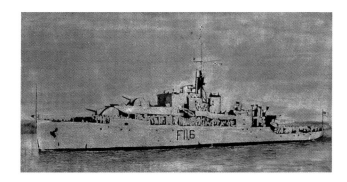

15 *Boat*, 1964.

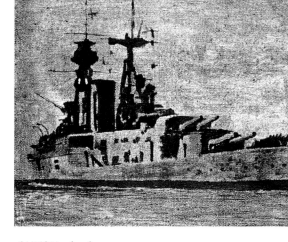

16 *HMS Hood*, 1964.

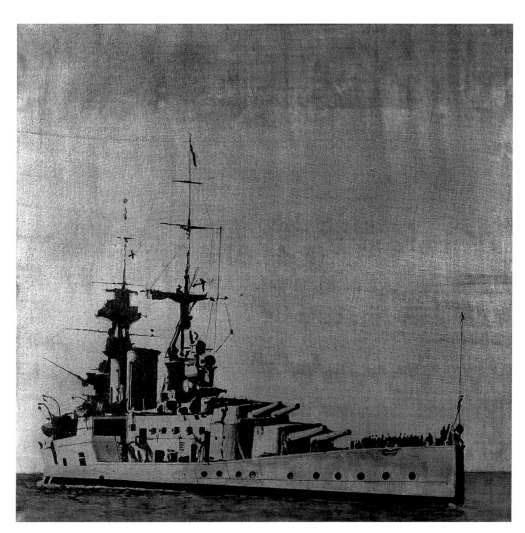

17 *HMS Hood (Friend)*, 1965.

(*Friend*) on red backgrounds, or rather under them. The latter two (from 1965) shared the same square format, measuring 106 × 106 cm.

One of these paintings from 1965, *Untitled,* done entirely in india ink, was included in Morley's Paris and Madrid retrospectives in 1993 and 1995. It is a small, square, untitled canvas, approximately 35 × 35 cm, on which a battleship seems to be emerging from a dark grey tonality structured by an irregular grid dividing the canvas into sixteen rough squares. Morley no longer recalls how it was executed; one has the impression that the artist folded his photographic model four times in each direction and ripped it up, summarily reassembling the pieces. In the upper quarter, he appears to have reproduced the shadow from the lower strip on the upper strip. The model's dual object – boat and photograph – is thus already present in this monochrome image.

OCEAN LINERS AND CABINS

He tried in vain to paint a boat from life:

> I went down to Pier 57, took a canvas and tried to make a painting outside. But it was impossible to comprehend it in one glance, one end is over there, the other end is over there, a 360 degree impossibility. I was in disgust – I took a postcard of this cruise ship called the Queen of Bermuda[5]

– but maybe it was the *Empire Monarch.* 'I went down with a canvas to paint a ship from life. Then I got a postcard of a ship. The postcard was the object.'[6]

He often visited with Richard Artschwager. One day in Morley's studio, Artschwager saw a large abstract painting and, suspended beneath it, four small separate vertical panels painted on the edges, together forming a picture of the *Cristoforo Colombo*; above their skies were four abstract surfaces in different colours, dark red, brown, light green and blue. Morley had painted the ship on a canvas which he had then cut up and fixed onto four wooden panels measuring 60 × 6.5 cm (the second one measured 9 cm) that he just happened to have to hand. Artschwager advised him to dump the abstraction and keep the boat, which he did (he claims he always does what he's told, though he now regrets losing the abstract painting). Artschwager used grids; Morley returned to this technique, which he had learned during his studies in London.

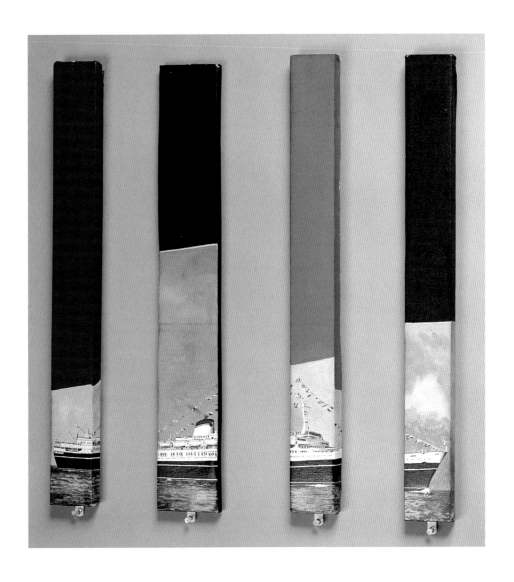

18 *Cristoforo Colombo: Bow, Bridge, Smokestack, Stern,* 1965.

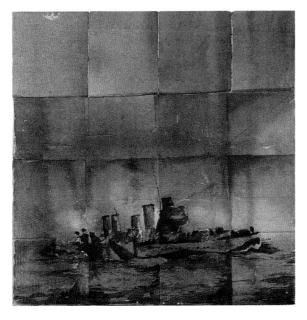

19 *Untitled,* 1965.

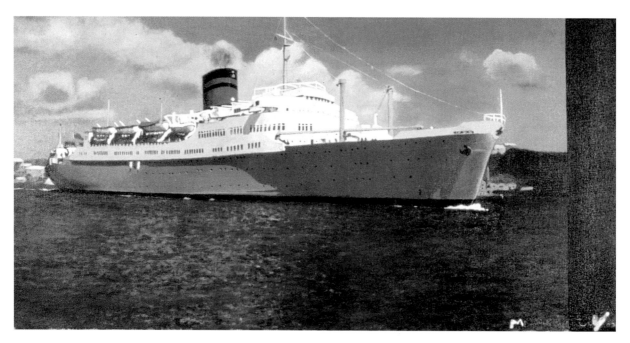

20 *Empire Monarch*, 1965.

Several paintings of ocean liners followed, in 1965 and 1966 – *Empire Monarch, United States with New York Skyline* (page 22), *S.S. Independence with Côte d'Azur* (page 30) and *Cristoforo Colombo*, which he redid from the same image used for the small panels in two versions, one 35 × 51 cm and the other 114 × 152 cm. The largest painting (157 × 213 cm), erroneously called *S.S. Amsterdam in Front of Rotterdam* (page 31) , would become, for the artist as for others, the recurring emblem of Superrealism, his black square.

Except for *Empire Monarch*, which is cut off at the right edge by a vertical black stripe (in fact an integrated mistake made while transferring the grid), these views of ocean liners, done from printed colour photographs, postcards or posters, are all surrounded by wide white margins. The image in *S.S. Amsterdam in Front of Rotterdam* (but not the white margin) is painted over an orange background: 'It gave me a big bang to paint on this orange.' The grid in all of these paintings was very fine; the squares are minuscule, and each was painted with a magnifying glass, sometimes upside-down or sideways, while everything the painter was not in the process of painting was hidden, except the neighbouring squares. Today he describes this as being like a surgical operation: 'Everything is in the now.'[7] The margin, in pure, flat white, was painted afterwards without the use of squares. By drying quickly, the acrylic allowed the artist to cover the painted zones he didn't want to see.

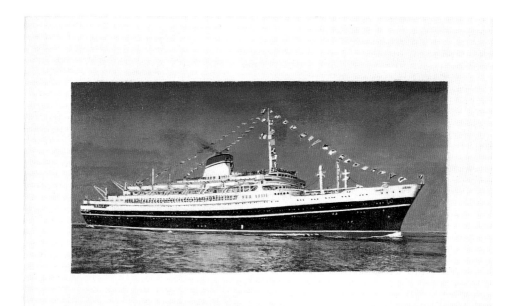

21 *Cristoforo Colombo*, 1966.

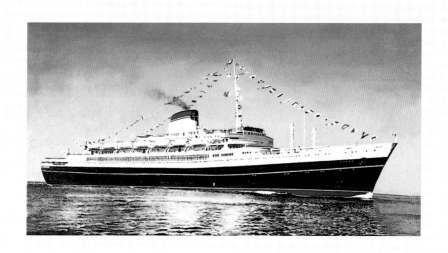

22 *Cristoforo Colombo*, 1966.

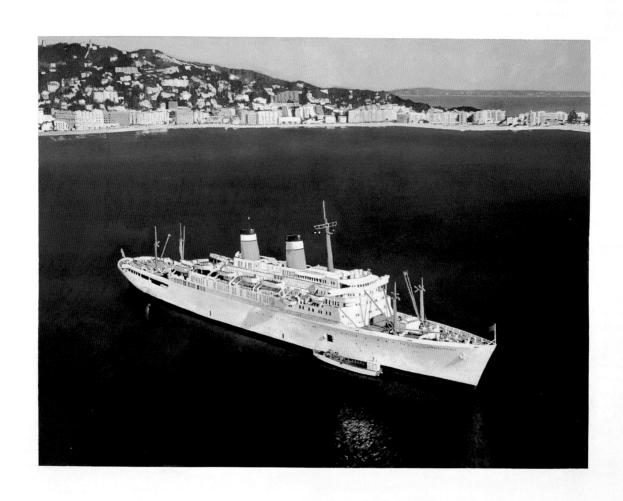

23 S.S. Independence with Côte d'Azur, 1965.

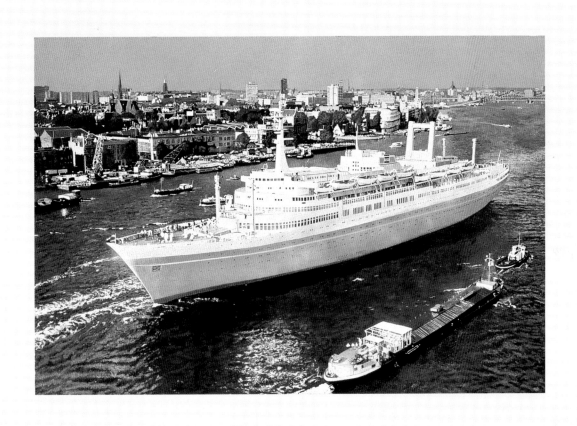

24 *S.S. Amsterdam in Front of Rotterdam*, 1966.

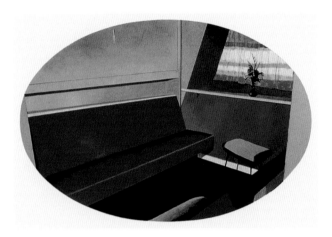

25 *State Room (with Port Hole)*, 1966. 26 *Another State Cabin*, 1966.

At the same time, Morley painted a series of ship cabins, most of them ovals with rectangular margins, just as they appeared in the advertising sources he used (*First Class Cabin, State Room with Eastern Mural* [page 34], *State Room* [*with Port Hole*], *Another State Cabin*), and some of them rectangles (*State Room, Day and Night Cabin* [page 35], the first of a series which presents the same cabin in paired day and night scenes). These paintings, close to Artschwager in style and barely known (they were absent from Morley's three retrospectives, and I haven't been able to see any of them), have strange surfaces, a strong, almost disembodied presence: 'The even colour, with a good deal of brown, pink, and buff has a texture somewhat between flesh and foam rubber.'[8] Morley thinks the walls of these luxury cabins resemble the padded cells of mental hospitals.

AMSTERDAM / ROTTERDAM

The publicity material for the *Rotterdam* also contained seductive images of life on board. From these Morley created two paintings in the same format (roughly 210 × 160 cm, approximately the same size as *S. S. Amsterdam* turned on its side), both containing the image in a rectangle with rounded sides: *On Deck* and *Ship's Dinner Party* (page 36). Both were painted in Magnacolor, the medium used by Roy Lichtenstein, then a close

27 *Another State Room*, 1966.

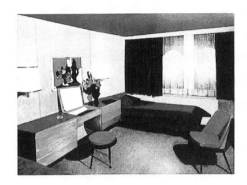

28 *State Room*, 1966.

friend of Morley who almost became his brother-in-law and who watched the development of *Ship's Dinner Party* with great interest. Morley describes Magnacolor as a polyvinyl acetate diluted in turpentine, a viscous medium difficult to manipulate.

Ship's Dinner Party is from any point of view a sensational painting characterized by formal beauty and contained violence, both ready to explode. Three pigs in tuxedos, somewhere between businessmen and gangsters, and their high-class sows are laughing with their mouths wide open in a revolting, almost mechanical manner, as a waiter brings them a repulsive creamy dessert with a servile smile. The scene provokes 'a response approaching nausea'[9] made all the more vicious by an empty armchair in the foreground that seems – in the manner of a Baroque painting – to invite the viewer to join in. Although the scene evokes the spirit of Grosz (a decorative motif in the background associates humans with frolicking pigs), Morley at the time denied all satiric intention, but he was certainly the only one to do so; today he admits that one could find this image 'obscene . . . incredibly disgusting. But the painting surface is not disgusting. I wouldn't want to make a painting like this again – because I want to take out everything but painting, without having to make abstract painting. That's my biggest problem.'

The human pig on the left has a kind of Hitler moustache; it's an illusion,

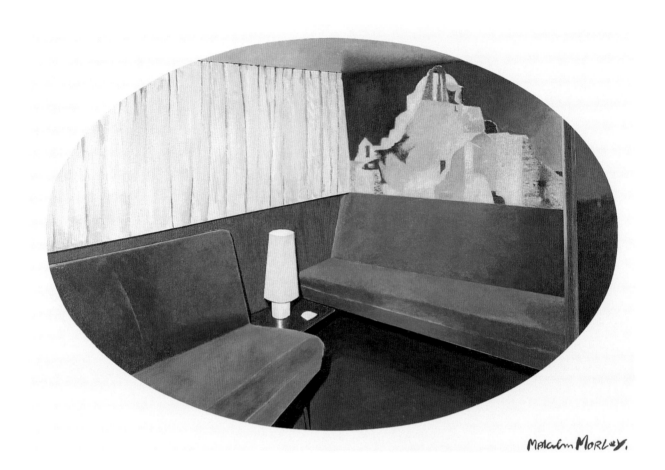

29 *State Room with Eastern Mural*, 1966.

30 *Day and Night Cabin*, 1965.

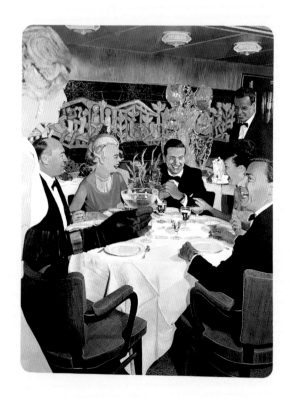

31 *On Deck*, 1966.

32 *Ship's Dinner Party*, 1966.

the shadow of a fruit just under his nostril, but at a distance of two metres the moustache reappears. The lady in blue has a few hairs (of the paint-brush) on her arm. A practically invisible detail attests to the artist's spatial sophistication: the bleached blonde in the left margin, in the process of joining the group, appears to have had her left arm cut off, the effect of superimposing, along the curve of her chest, the separation between her black-gloved forearm and naked arm. Twenty-seven years later, Morley revived this device in *Flight from Atlantis* and *Guardian of the Deep*, where the palm tree, as Brooks Adams has remarked,[10] seems to grow out of the broken mast of the boat on the left (it's an illusion). None of this appears forced, everything flows naturally, and it is the absence of caricatural intent – indeed, of any intention – that confers the essence of violence on the image. I would like to have seen the printed photograph that served as model:

> The great enlargement from the original photo gives the figures a caricatured, rather gross appearance, with overly white, toothpaste-ad teeth. Where the original photo was intended (as an ad) to convey vivacity and temporality ('Time flies when you're having fun'), the

painted scene seems suspended in time, in the manner of similar images by Lichtenstein and Alex Katz.[11]

(1993) Morley, when asked about the presence of the three pigs, swore to me that he had added nothing to the model. It's hard for me to believe it. I try to get confirmation from the Dutch company, HAL (Holland-Amerika Lijn), who owns the Amsterdam, and also from the documentation department of the Amsterdam Naval Museum, Kattenburgerplein 1, 1018 KK Amsterdam. The painter himself says he didn't keep the evidence.

His wife Lida, whom I spoke with today by telephone, says she received a letter from an old New Yorker assuring her that the boat was really called the Rotterdam.

And sure enough: a few days later I receive word from Diederick Wildeman, librarian at the Scheepvaart Museum in Amsterdam, including a large dossier on S.S. Rotterdam, an ocean liner constructed in 1958/59 and still in use: a brochure from 1959 with a picture that served as model for *S.S. Amsterdam in Front of Rotterdam*; a photo of S.S. Rotterdam leaving Rotterdam for New York ('Het s.s. ROTTERDAM vertrekt van Rotterdam naar New York'; the name of the transatlantic liner, visible on the photo, does not appear in the painting); and a fold-out from 1962 illustrating pleasure scenes aboard ship, including the model for *On Deck*, but not the one for *Ship's Dinner Party*, although one does see a restaurant scene ('Aan boord van de ROTTERDAM is elke maaltijd een culinair festijn').

P.S.: In February 1967, Lawrence Alloway reproduced an image of the painting without margin (it was not his fault) under the title: SS '*Rotterdam*' in Port of Rotterdam, only to reproduce it three months later with margin and the title '*Amsterdam*' in Front of Rotterdam.[12] Robert Pincus-Witten reproduced it with part of the margin and entitled it *S.S. Rotterdam*.[13] The same with Janet Daley,[14] and John Loring who in 1974 gives it the title *S.S. Rotterdam in Rotterdam*. But as of March 1967, Frederic Tuten, reviewing a one-man show at the Kornblee Gallery called the painting *Amsterdam in Front of Rotterdam*.[15] From then on the titles have vacillated, but since the 1983 retrospective Amsterdam has won over Rotterdam. Such shifting around is not rare for Morley, and sometimes has an aura of enigma.

The conceptual play on distance and violence is reproduced in the scene's visual detail. The opulent kitsch of the late '50s–early '60s – the decor of the dining room, the women with their bouffant hairdos, the pig frieze

33 Detail of *Ship's Dinner Party* (32).

34 Detail of *Ship's Dinner Party* (32).

anticipating the toy style that Morley would adopt a dozen years later, and the enigmatic ice sculpture – is sublimated by the painting's surface. The chromatic effects of *Ship's Dinner Party*, especially the still life on the table, are marvellous, especially the tinted white of the tablecloth with its soft nuances of rose and turquoise. The painting's general texture is strange; it has a refined sensuality and lots of abstract details: the blurry goblet of champagne in the foreground, the first glass of water on the table, the reflections in the spoon, the cream of the dessert. All of this, says the painter, was already present in the source – but not the painting's magic; upon reflection, as we discuss this, he says: 'The magic is the process, plus the concentration of the eye. There's a great song by the Four Tops, "The magic's in the music, and the music's in me." The magic is in the

painting, and the painting is in me. Magic is the idea of not knowing how something is done.'

> Richard Shiff wrote to me that he believed this was a song by the Mamas and Papas (though his memory, he said, might have slipped). Morley, to whom I mentioned this idea, said that Shiff was wrong. Morley was right: the song ('Do You Believe in Magic', 1965) was by the Lovin' Spoonful.

BAD YEAR

> By 1967 he had run to an end of the marine imagery . . . He tried, but without much satisfaction, a rodeo subject, a landscape with horses, and planned other works which never materialized. His problems extended from doubts about the choice of the original source photographs to skepticism about the handling of paint in the completed paintings. At the time he collected some large color reproductions of sport events from a Goodyear calendar, but for him Goodyear meant ironically 'bad year'.[16]

The Goodyear calendar nevertheless served as the basis for a few sport paintings, produced either that year or the year after: *Open Golf Championship (National Open)* (page 41), *The Regatta at Henley-on-Thames* and especially *Diving Champion* (page 40), where the white margin is activated by an element that underscores the fact that the painting's object is not reality but an image: the Goodyear logo, reproduced on a grand scale below the pool. This novelty would prove to be useful later on. Morley returned to the idea in 1968 in his painting after Vermeer and in *Marine Sergeant at Valley Forge* (page 41), where the margin is cut by two lines of red and blue paint echoing the colours of the American flag held by the Marine in front of the triumphal arch. (In 1971, he would paint another Goodyear painting, entitled *Goodyear*: a beach scene executed in oil and wax using his new technique of small, visible strokes.)

Morley would also do a few commissioned portraits – *The Ruskin Family* (1967) (page 42) followed by *The Perron Family* (1968) and *Portrait of Esses in Central Park* (1969–70) (page 42) – after photos he had taken for him. He says that he felt no pleasure in painting these. From *Ruskin* to *Esses*, the family members take on an increasingly sinister aspect, but one never has the impression that Morley is imposing his own interpretation on his sitters.

35 *Diving Champion*, 1967.

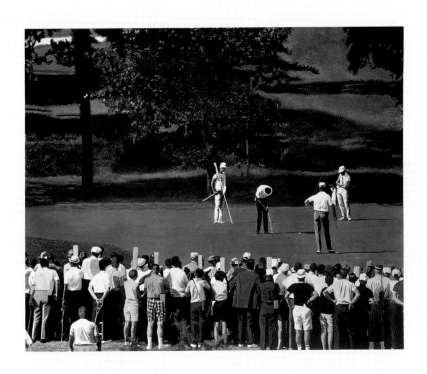

36 *Open Golf Championship (National Open)*, 1968.

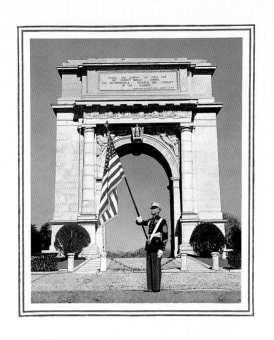

37 *Marine Sergeant at
Valley Forge*, 1968.

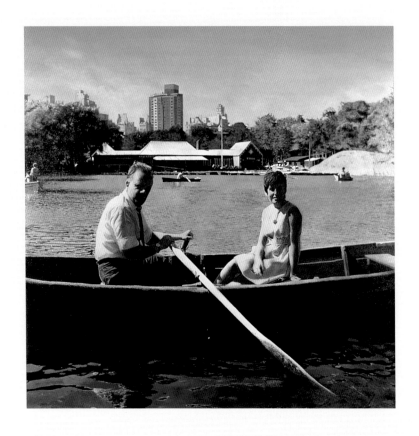

38 *Portrait of Esses in Central Park*, 1969–70.

39 *The Ruskin Family*, 1967.

VERMEER

In 1968 or '69 (according to the catalogue of the group show *Directions 2: Aspects of a New Realism* [Milwaukee Art Center, 1969] – though the catalogue of the Paris retrospective dates it to 1967) Morley painted *Coronation and Beach Scene* (page 45), one of the great Superrealist paintings and the first one in which two different images – a carriage with the Queen of the Netherlands and a beach scene – are incongruously associated, the narrow band of blue sky over the beach butting up against the carriage wheel and spectators' hair. But in fact, the association was present in the original Dutch tourist poster or brochure. This association, typical of postcard imagery though rather rare in modern figurative painting (Rosenquist comes to mind), would be of enormous importance to Morley's unfolding career.

This large square painting may also be (though this may be my fantasy) a secret homage to Vermeer. *Coronation and Beach Scene* reproduces the characteristic contours of Vermeer's figures (contours doubled by incomplete superimposition). In fact, one discovers such contours in all of Morley's Superrealist paintings, including, of course, the one he had just painted after Vermeer's *The Artist's Studio*. These two paintings were actually shown together at the Kornblee Gallery in February 1969 (along with the golf scene, a Florida beach scene and a picture of two horses). But the ultimate source of these contours was the poor-quality colour reproduction of the printed originals, which Morley rendered faithfully; he benefited a lot from these approximations and errors.

With *Vermeer, Portrait of the Artist in his Studio* (1968) (page 46), Morley turned for the first time to a famous painting, Vermeer's *The Artist's Studio* now in Vienna, which he has not actually seen to this day. His model was a poster purchased at the Metropolitan Museum of Art in New York, which he reproduced along with its caption; in the white margin underneath the scene, one can read, in black Letraset: 'ARTIST IN STUDIO

40 Horses, 1967.

by jan Vermeer, 1632-1675 / © by Kunstkreis Lucerne / *An Abrams Color Print* / Printed in Switzerland'.

The paraphrasing or reappropriation of paintings was a well-established practice among the Pop artists (Lichtenstein, Warhol, Wesselmann) and had been used by Rauschenberg. As for Vermeer, he was a godsend for Photo-Realists of all ilks, from John Clem Clarke and Dotty Attie to George Deem (who made him a speciality) and many others. But whereas these variations generally accompany a nod to Modernism, Morley's painting is literal ('deadpan'), modifying nothing at first sight other than the scale of the model. (In 1976, Morley made a second Vermeer, much less known, *A Mistress and Her Maid After Vermeer, a Ram and View of Amagansett by MM* [page 47], a small, rather strange painting modelled after *The Letter* in the Frick Collection, New York, in which the maid was cut by the grid and the image was accompanied by an elongated landscape in the guise of a predella, painted from nature from Morley's window [he had moved that year to the far end of Long Island], as well as a small picture of a plastic sheep.)

Morley's *Studio* (266 × 221 cm including the margin) is in fact larger than Vermeer's (120 × 100 cm), as would be the case for his *Last Painting of Van Gogh*. The empty chair in the foreground (a motif found in *Ship's Dinner Party*) is substantially larger than life. The painter, seen from the back, is just about life-size.

The painting plays with the association of three different textures: that of Vermeer, reproduced on the poster; that of the poster; and that of the painting itself. Vermeer's granular technique, particularly visible in the curtain, is reproduced flat, as in the reproduction, without any other density than that of the acrylic paint spread by the painter. The figures' edges simultaneously reproduce properties specific to Vermeer's edges and those of the four-colour printed reproduction: for the woman posing, a dark blue is laid over a light blue that shows on the edges; for the image of the painter, black is partially laid over the blue and red, also visible along the edges. The reproduction's poor registration is more clearly visible in the pavement, and red, green and yellow lines multiply wherever two colour areas meet up. The detail of the map on the back wall, states Morley, was executed Pollock-style with a palette knife. He would reuse this technique later, particularly in his rough seas of the 1990s.

The paint gives the impression of smudging the lines of the figure. In all of these canvases, the texture is almost hallucinatory, like a fine

41 *Coronation and Beach Scene*, 1968.

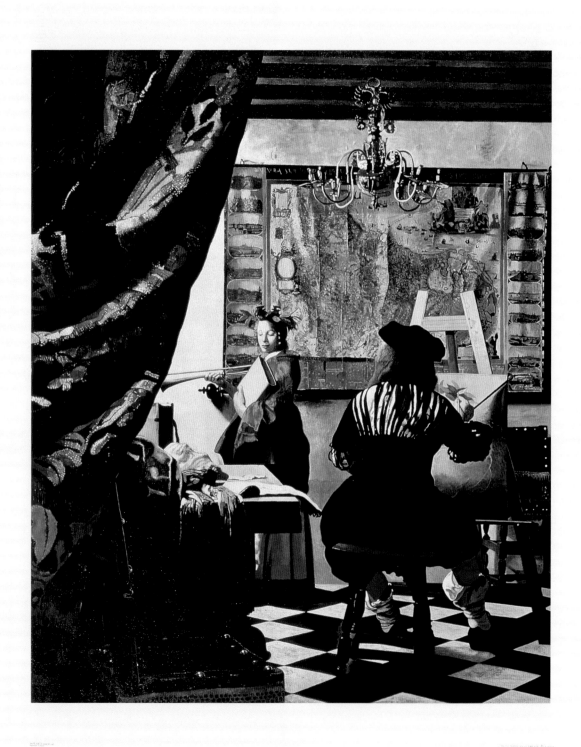

42 *Vermeer, Portrait of the Artist in his Studio, 1968.*

43 Vermeer, *Portrait of the Artist in his Studio* (42) in progress.

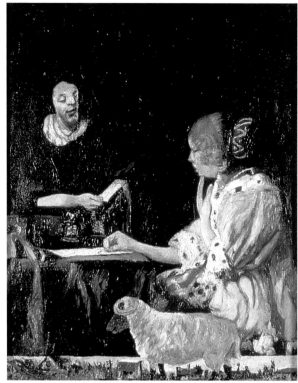

44 *A Mistress and Her Maid After Vermeer, a Ram and View of Amagansett by MM*, 1976.

curtain of paint placed in front of reality: 'Painting that doesn't hallucinate is not painting. That's a basic rule. I call it a *art-on*.'[19] 'Hallucinogenic' is Morley's word; it is a constant characteristic of his art and vision.

'SUPERREALISM'

The new photographic imagery soon attracted followers; its novelty and accessibility were striking. A name was sought for it: Post-Pop? Radical Realism? Sharp-Focus Realism? Photographic Realism? Ektachromism? In France and other countries, 'Hyperrealism' became the catchword, while in the United States 'Photo-Realism' took hold. Morley didn't like this term, coined by the painter Sylvia Sleigh, the wife of Lawrence Alloway, nor did he like the troop of new artists. He chose 'Superrealism' for himself (Mondrian had already used the phrase 'Superrealist art' in 1930); later, perhaps to maintain his distance, he spoke of 'fidelity paintings'.[20] A member of the English lower middle class, he sensed class-conscious snobbery in the term *photo-realism* which repulsed him:

> That was class warfare, pure and simple. It was a put-down . . . There is a class thing, implying that working class people couldn't possibly make paintings without copying photographs . . . but I liked the word 'super-realist' because it made reference to suprematism. Those

paintings were never about painting photographs at all, although as far as that idea goes, within a year or six months there were about sixty painters doing it. Zap! It was really awful. I remember de Kooning said that the people who cling to your back push you forward.[21]

The overwhelming success of this style was one of the reasons the painter abandoned it a few years later.

GRIDS

Many of the artists who fell in under the Photo-Realist banner painted by projecting a slide of their model onto a canvas; this was not the case with Chuck Close, who also used a grid from 1967 or '68 on while airbrushing his black-and-white portraits. Morley, following the traditional method he had learned, preferred to combine the grid and the paint-brush.

His innovation was technical, methodological and theoretical. He laid a grid over his photographic model and transferred it to the scale of the image he wanted to paint. He then painted a square of his model with a magnifying lens, often upside-down, hiding the parts he was not painting in order to eliminate all intrusion of the image's content into his field of vision; decontextualized like this, an ocean surface could take on an altogether different texture: 'So I would turn the painting upside down and a wave would become like green mouldy pumpernickel bread.'[22] He painted each square in its entirety without going over it, leaving only the adjacent squares visible so as to achieve a smooth, continuous articulation. Describing this technique, which he retained later (by enlarging the grid and leaving the parts already painted in oil uncovered, since oil doesn't dry as fast as acrylic), he explains:

> It's nothing unique, but my difference is that I treat each piece separately from the others. There's a grid, it's divided, you might have 36 quantums (I call these grid parts quantums), and they form a net which is placed over these forms. So you can chart exactly where it is. It allows for amplification inside each part.[23]

Morley's particular method seems to be the opposite of the one used by the Abstract Expressionists, who took possession of the entire surface without dividing it; he characterizes this opposition as analogue vs digital. Nonetheless, this fragmented procedure gives the paradoxical effect of

radicalizing a painting's all-over quality. The progressive addition of one particle after another intercepts a figurative perception of the painting and de-individualizes its parts. At the time, the art historian Arnold Hauser, a colleague of Morley at Ohio State University, where the painter taught in 1965–6 on Lichtenstein's recommendation, compared Morley's world-view to that of Robbe-Grillet: everything is jumbled together on the same surface with no hierarchy of parts: '"The problem is density of paint surfaces," he says. If "the parts can be reconciled on the surface" the painter is spared the invention of composition: design, as a matter of balance and contrast, can be by-passed.'[24] This very abandonment of composition and of difficulties in the balancing of parts had been one of the goals of American avant-garde painting since the end of the Second World War. In this sense, Morley's use of the grid, while seeming to recall an Academic procedure, echoes that of abstract painters and sculptors of the 1960s such as Carl Andre, Agnes Martin, Sol LeWitt and Brice Marden. Except that for him the grid disappears into the painting.

The world of Hyperrealism is a sick world in which artistic representation unpleasantly constitutes both symptom and relief.[25] The idea of recycling, common to Hyperrealist artists, takes on a particular depth when associated with Morley's fragmentary procedure: 'I am painting the world bit by bit by recycling garbage into art. Everything is useful, everything is a fit subject for art.'[26] Especially in the case of the paintings done after famous paintings: vulgarized by mass-media reproduction, their recycling through painting gives them a new life. (Later, it must all begin again, for once initiated, recycling never ends. The paintings Morley would produce in the 1970s from photos of his own works are, among other things, a statement on this endlessness.)

FORMALIST PARADOX

Morley's aesthetic position as a Superrealist is close to that of Flaubert. The meticulous banality of the content is, like the grid, a method for concentrating the artistic operation on questions of form to be resolved step by step:

> I have no interest in subject matter as such or satire or social comment or anything else lumped with subject matter. There is only Abstract Painting. I want works to be disguised as something else

(photos), mainly for protection against 'art man-handlers' . . . I accept the subject matter as a by-product of surface.[27]

This formalist paradox of a superlatively realist artist is like the reversal of Barnett Newman's paradoxical affirmation that '. . . the central issue of painting is the subject matter . . . For me both the use of objects and the manipulation of areas for the sake of the areas themselves must end up being anecdotal. My subject is antianecdotal.'[28]

One has the impression that Morley harboured a desire to confront Newman, whom he met around 1964 while working as a waiter in a New York restaurant. Newman visited his studio and voiced some astounding propositions (such as 'I am emptying Renaissance space')[29]: 'I learned a lot from him. Attitude. Stance.'[30] After Newman's death, Morley would say: 'I feel that Barney Newman emptied space and I'm filling it up again.'[31]

Another aspect of his confrontation with Newman is his political position. He has spontaneously told me how absurd he found Newman's declaration to Dorothy Seckler: 'Almost fifteen years ago, Harold Rosenberg challenged me to explain what one of my paintings could possibly mean to the world. My answer was that if he and others could read it properly, it would mean the end of all state capitalism and totalitarianism. The answer still goes.'[32] For Morley, '. . . that's pretension beyond egotism.' His own answer is categorically anti-messianic: 'The only thing that changes things politically are guns. Painting doesn't do that at all. When you look at Goya, you just see beautiful etchings. You don't see the horrors of war. You rather enjoy these limbs hanging from trees.'[33] If painting has the power to affect its viewer, this power is of a different order: 'It doesn't matter if you're Republican, Democrat, pervert or whatever. You're being affected by these paintings whether you like it or not because they're constructed in such a way that you have to get everything viscerally.'[34]

Morley, whose heart is on the Left, thus opposes a biological position on art to a political one:

What critics write is just propaganda. I'm for a biological response to art. In place of criticism one should measure the viewer's heart-beat, breathing, sweating and so on. Sensation is prelinguistic – we exist before we are named – and only exists in the present. You can't, for instance, remember pain.[35]

(Can't you? I'm sure Cézanne relived his pain when it rose from the depths of his memory. We have the evidence.)

When one objects that the frontier between biological and political power is perhaps not so clear-cut, he maintains his position as one of despair:

> ND: But isn't the changing of perception, or of established aesthetic codes, a political act in itself?
>
> MM: But new people become just as attached to new statements just as the others were, down to the last statement that has been destroyed. So art must always fail.[36]

AESTHETICS OF COLLAGE

The association of naval imagery and the grid was already in itself a form of collage or appropriation:

> Ships have had a very deep emotional meaning in my life, much deeper that I give credit for, and I made contact with that icon and connected it with the grid. So I opened up this whole thing, only I appropriate in a very different way from most people. Whereas in traditional grid making you take your drawing and put in this and that, and once you've got all your masses placed, pretty quickly you make the grid disappear.[37]

The logic of collage is one of displacement; once in place, nothing can stop it. To speak of Post-Modernism serves no purpose, unless one is willing to trace Post-Modernism back to Cubism, to Debussy's *Children's Corner*, to Lautréamont. What we've developed the bad habit of calling Modernism is full of such borrowings, which critics of an antiseptic bent are quick to dispose of.

Thus, incongruous assemblage soon made its first appearances. In *Coronation and Beach Scene*, two scenes of unequal size lacking any apparent thematic relationship find themselves superimposed: this would be the seed of an aesthetics of heterogeneity that would undergo ever vaster and more incongruous developments.

INVISIBLE ART

Morley's Superrealist canvases immediately provoked unease. What was the point of such a fanatical effort to present subjects of no interest through graphic means that appeared to be completely out of date in the 1960s? In

1969, Alfred Frankenstein described Morley's boat paintings as being copied 'with stunning precision and stupefying pointlessness'.[38] And in 1974, H. D. Raymond generalized this proposition: 'These New – er Newer – Realists depict a fallen world with a fallen technique.'[39] The apparent superfluousness of content and formal means aroused a feeling of absence which contradicted the displayed happiness of these postcard images. Suddenly, these blue skies and leisure scenes, this world of luxury, contained something terrifying but painless. If Morley, as he described himself, painted like a surgeon, the viewer of these paintings might feel like a patient under anesthesia.

The obsessive detail of these pictures had something in common with the workings of the great Dadaist machines of Marcel Duchamp, Johannes Baader or Kurt Schwitters. Morley himself declared some fifteen years later: 'My realist paintings were a Dada gesture, pure and simple; they were not literal in that American sense of literalism.'[40] And: 'I started from a ready-made, making a hand-made painting from a ready-made.'[41]

The absurdity of this effort is feigned, a kind of modesty or what Morley calls 'conceit'. Ten years earlier, he unmuffled his guns: 'In the recent ship paintings . . . the artist wanted to make an invisible painting in the spirit of Dada, to "tiptoe over the surface of the canvas without causing a ripple . . ."'[42]

> The idea of an invisible art was in the air around 1970, and already in the latest paintings of Reinhardt, or those of Rothko, which Brice Marden recently judged for this reason 'particularly important'. About his monochrome panels in the late '70s Marden himself stated: 'I was very carefully painting vertical strokes, which you can't really see unless you get down on the floor or take the work out in a different lighting situation. That technique came out of Rothko's paintings.'[43]
>
> In 1970, Carl Andre said of his flat sculptures: 'You can be in the middle of the sculpture and not see it at all – which is perfectly all right . . . I don't like works of art which are terribly conspicuous. I like works of art which are invisible if you're not looking at them.'[44]
>
> Two years later, Robert Venturi described the fire station no. 4 which he had constructed with Gerod Clark in 1965 in Columbus, Indiana as '"second-glance" architecture'; he cited the letter of an architect ironically congratulating the artists: 'They have succeeded in making this building conform to its surroundings. One can scarcely distinguish it from the barber shops, garages and delicatessens in the vicinity. They certainly have concealed the fact that an architect had anything to do with it.'[45]

In 1963, Andy Warhol had anticipated diverting the idea of invisible art. 'My next series will be pornographic pictures. They will look blank; when you turn on the black lights, then you see them – big tits and . . . If a cop came in, you could just flick out the lights or turn on the regular light – how could you say that was pornography?'[46] Two paintings of this type, *Bosoms I* and *Bosoms II* dated 1963, are catalogued by Rainer Crone. Another, entitled *Double Torso* and dated 1967, is reproduced in the catalogue of the 1989 Warhol retrospective. It belongs to Playboy Enterprises, Inc.[47] Shortly before his death, Warhol created an invisible sculpture at Area, a New York club: he stood for a while near a wall label, 'ANDY WARHOL, USA / INVISIBLE SCULPTURE / MIXED MEDIA 1985', then left.

In light of what would happen to Morley a few years later, one should recall that the prototype for invisible art was Raphael; in the 18th century, amateurs and painters who visited the Vatican told of passing in front of the Stanze frescoes, particularly the *School of Athens*, without seeing them, and then, as they were leaving the place, having to ask the guard where they were.

The invisibility of Morley's painting in his ship scenes is incomplete; the paint reveals itself to a patient, experienced eye. As early as 1965, Lawrence Alloway remarked of Morley's Liquitex paintings exhibited at the Guggenheim Museum in New York: 'Viewed closer . . . the detail is handled with a curbed, but very crisp touch so that the ship becomes a painting when approached. The painterliness, divulged after delay, is a syntax of dots, knots, and flicks, like Canaletto out of English tonal painting.'[48] Looked at today, these Superrealist paintings offer a richer, more varied pictorial texture than they did to their earliest viewers; in a similar way, Stella's black paintings, which exploded onto the scene in 1959 in the context of Action Painting, show supple, nuanced contours that were largely invisible 40 years ago.

SECOND DEGREE

Above all, it must be remembered that all of this (especially what follows) is a projection of my own fantasy. The painter's fantasy is that he saw nothing beyond the surface: about *Ship's Dinner Party* he tells me that he conceived of his canvas as a mirror, that he tried to make it as lucid as possible so that everyone could see their own imagination reflected in it.

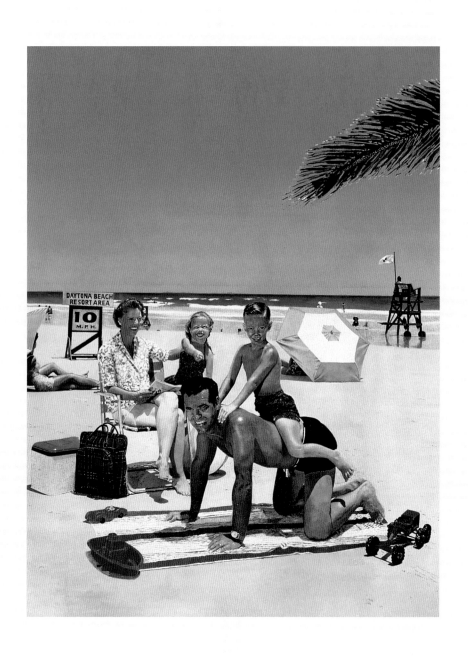

But this very neutrality evokes the notion of an indiscernible irony in whose hollow a mute violence lurks. His blue skies appear to carry a devastating storm. This effect was felt by admirers and opponents alike:

> Morley claims that his works contain no irony, that he is interested only in the formal properties of his images; I don't understand his claim: his works have so little formal interest. He works at the dead-end irony to be wrung from images designed, as I said before, to have neither a past nor a future.[49]

> He also disclaims a socially critical intent in such pictures as *Ship's Dinner Party* (1966) or *Beach Scene* (1968), in which everyone saw a clear resemblance to Richard Nixon; yet it was Morley who chose his subjects, and the acerbity of his portrayal of Americans at play reads loud and clear. Almost without thinking about it, most artists place themselves outside the social hierarchy, and thus constitute their own counter-culture; perhaps such a disaffirmation as Morley's is the mark of a true ironist.[50]

Indeed. In his Superrealist paintings, the irony, like his art, is hidden, full of a latent violence about to explode in the catastrophe paintings, where the cruise boats are knifed, smashed and tortured.

Ship's Dinner Party is the painting of this period whose atmosphere appears to be the most menacing, although this menace remains elusive. *Beach Scene* (1968), another smiling picture, leaves a similar impression of unease. It shows a Florida beach with an American family whose ready-made happiness evokes the same sort of ambiguous sentiment aroused by the family melodramas of Douglas Sirk. The figures in these paintings, Morley remarked that same year, 'look more like who they are in the painting than they do in real life'.[51] But as usual, this sardonic element is the reversal of what is actually a key to Morley's character – his nostalgic side – which we observe in the small unknown masterpiece of his Super-realist period, *Birthday Party* (1969) (page 56). He had never known the vile happiness of middle-class family life, and for a time this frustration was his Beatrice. This ironic-nostalgic component is like an unconscious memory of what Schiller, at the dawn of Romanticism, would call sentimental poetry.

Such second-degree irony finds its full expression in these paintings' iconic duplicity. In the tradition of Pop art, Morley's images are images of images. The image-sign refers to another sign, another image, specifically

45 *Beach Scene*, 1968.

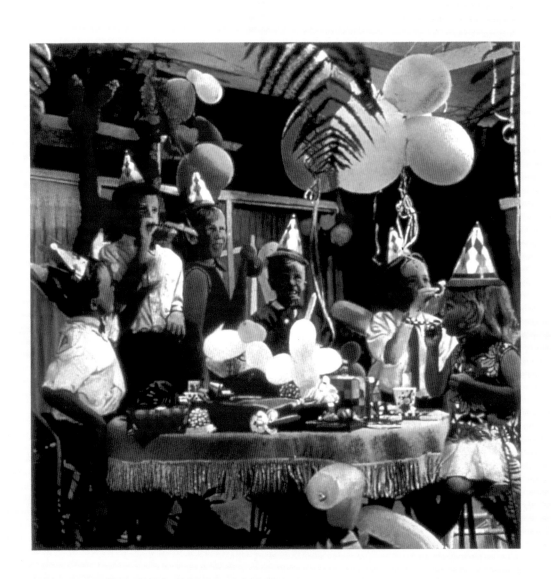

46 *Birthday Party*, 1969.

to an image that has degenerated through mass reproduction. The painted reproduction appears to be a faithful copy of its model; its own photographic reproduction resembles the original photo. Suddenly, the painting as such becomes unphotographable:

> Morley wants, and his art sets up, a double image, while preserving complete literalness . . . A reproduction (photographic, of course) of such a painting tends to return to its original source. Morley has observed that 'a reproduction of any work of art by Picasso, Matisse, or Rembrandt, tells you something about what the painting looks like', whereas one of his paintings looks like a facsimile of its source. 'This is a way,' Morley notes, 'of asserting the autonomy of the painting as an object because only the painting can tell you anything about itself.' The photographic image becomes a route back to the paint itself which, in Morley's usage, is always firmly sensuous.[52]

It is also a means, reinforced by the white margins, of producing a tension between two and three dimensions. This tension would remain the constant horizon of Morley's research.

Things become a little complicated when the original image is a classic painting. *Vermeer, Portrait of the Artist in his Studio* is the painted reproduction of a printed photographic reproduction of a painting in which a painter, with his back turned, reproduces in paint a female model allegorically disguised as Fame – in obvious tribute to the glory of painting. The situation remains fairly simple, however, since the multiple levels of representation are decipherably distinct from each another. Only the figures' double edges recall at once Vermeer and the photographic reproduction of his work. This barely perceptible confusion is the seed of upheavals to come: Morley's 1970s catastrophe paintings would *first of all* be a semiotic catastrophe, brought on by the collision of levels of representation. The violent juxtaposition of means of transportation – trains, boats, planes – would figure a disaster at once more profound and more playful, in which representational structure started to move and collapse in on itself. But maybe this is the real catastrophe of the modern world, waiting for better – or worse.

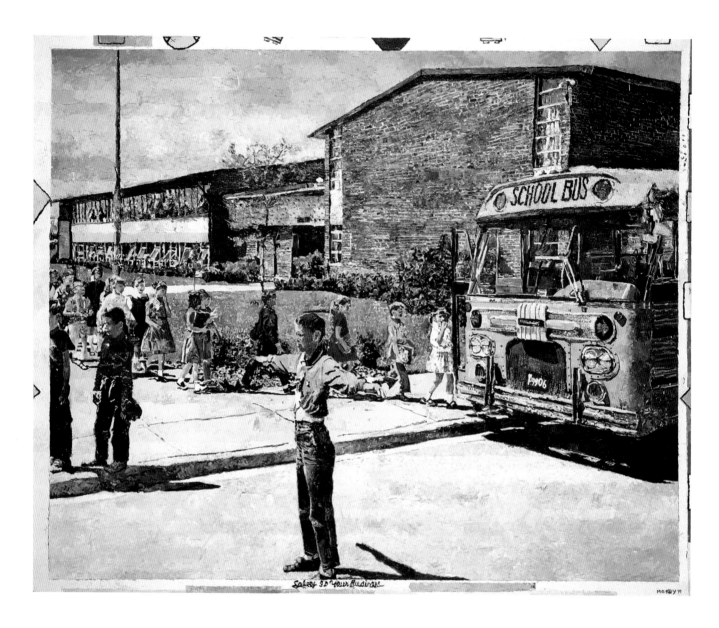

47 *Safety is your Business*, 1971.

4 Catastrophes

Race Track (page 60) is generally considered to be the painting that marks Morley's break with the Photo-Realist movement and his own style of the five preceding years. Rightly so; except that his symbolic 'X' was not premeditated, and the elements of the transformation that took place in his painting in the 1970s were already taking shape in Superrealist painting.

Race Track began like any other Superrealist picture; it was even meant to be the epitome of this style. Morley chose a poster representing a race track in Durban published by a South African travel agency. Containing the same elements as the posters he had used earlier – cloudless sky, leisure and sport scenes – it's a classic, readable, yet strictly non-artistic composition. A backdrop of vegetation and architecture frames a group of people almost as numerous as those in Altdorfer's *Battle of Alexander*, crowded behind a green race track where a dozen horses are galloping; at the left, there's a second crowd, less numerous, a rust-coloured road and tables with umbrellas: 'There were a lot of bunched-up things together, which then would make for a very rich brew.'[1] In short, Morley had prepared himself a super Superrealist painting: 'It was the most stunning illusionistic painting of all.'[2]

As in *Diving Champion*, the white margin carries an inscription; like Duchamp in *Tu m'*, Morley hired a sign-painter to copy it: **south africa/** *Greyville Race Course–Durban, South Africa*, with the SATOUR logo at the left. This was done with the painted image hidden from view.

Morley recounts how he saw *Z*, the film by Costa-Gavras, which so upset him that he decided to put an 'X' over his painting. He prepared several 'X's, painted in red on large sheets of transparent plastic, repeating the procedure with the help of Tony Shafrazi, and then laid the chosen 'X' where it had to go (the centre obliterating one of the horses) like a monotype or decal.

In appearance, this addition changed everything, destroying not just the image but also its neutrality. In reality, the painted image of the race track already carried its own destruction. The texture of the crowd is very abstract, intensely painterly and very different from the soft texture of the urban landscape in the background. The beauty of the paint surface creates a neutralizing effect on the political backdrop of this image, but the process of neutralization is so violent here that it destroys itself. It was certainly not neutral in 1970, in the era of apartheid, to choose a tourist

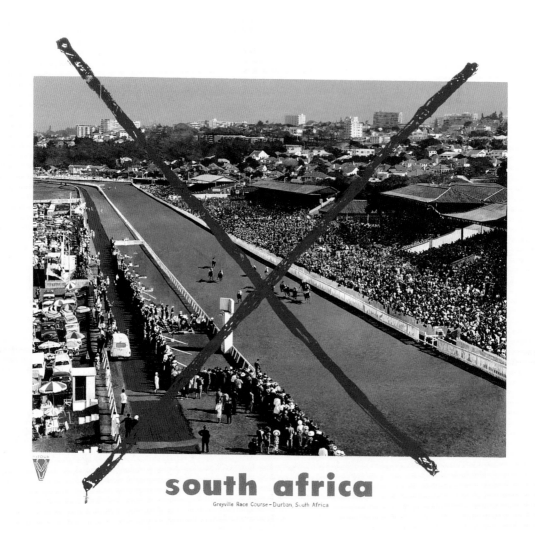

south africa

Greyville Race Course – Durban, South Africa

48 *Race Track*, 1970.

picture vaunting the charms of South Africa as an object to paint, especially when it focused on a track called Greyville Race Course, evoking the mixture of black and white explicitly forbidden in South Africa at the time. For Morley, who says today that he was not conscious of this pun, the 'X' alluded first and foremost not only to the 'Z' of the film but also to Malcolm X, the assassinated Black leader whose name the painter shared. And he was not even aware of the latter association when he put down his 'X': 'It was an unconscious pun, referring to Malcolm X . . . I didn't invent it. No human intelligence can arrive at that. But being open to this "twilight zone" between what your conscious and your unconscious is, you allow these things to occur.'[3]

Crossing out an image is not unprecedented. Morley thought of Richard Hamilton's X'ed-out Marilyn, but there are other examples such as Klee's *Struck from the List*. In 1915, Malevich had used an 'X' to cross out a small reproduction of the *Mona Lisa* in his *Composition with Mona Lisa*; his intention (to erase a classic realist image while at the same time leaving it visible) was not unrelated to Morley's. (By different means, Gerhard Richter's over-daubed *Table* [1962] produced an analogous effect.) But *Race Track*, and this is its novelty, simultaneously crosses out an image and the reality it represents: Photo-Realism and the space of apartheid. As if they were linked, as if the artistic vision of photographic realism and the depoliticized vision of tourism rested on the same middle-class perception of the world.

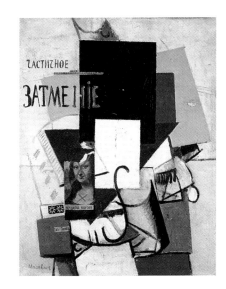

49 Kazimir Malevich, *Composition with Mona Lisa*, c. 1915.

What renders this association possible is what renders Superrealism itself possible: the double status of the painted image whose object is both reality (this race track, its vast space, its horses, its public) and image (this flat object, the white paper on which the illustration of that reality is inscribed, as well as the words that serve to explain it). The 'X' can cross it all out because it has all become one and the same thing through the crossing-out itself, which links the sign to its referent. In this sense, it is true that *Race Track* put an end to Morley's Superrealist paintings, because they maintained a dividing line between different levels of representation. The only exception, as we have seen, is located in the edges of the figures in *Vermeer*, but this was hardly conscious and in any case scarcely visible, while the large, bright red 'X' in *Race Track* is massively present. It renders the painting and the paper visible, the small strokes of the brush and the material support; the image is thus crossed out three times, by the paint, by the paper and by the 'X'.

As always with Morley, what motivated the change in tack was the need to maintain distance by taking risks:

> Currency of language forced the changes, because as soon as something I do is accepted and successful, I have to change it. You only really succeed by taking risks, and the artist who's interesting has to invent them. I felt that the next lot of pictures has to disqualify the value of the earlier ones; so that's why I started going rough after the fidelity paintings.[4]

But the painter calculates his risks even while improvising them. 'Things don't change all of a sudden with me – there's always a kind of transition,' he commented to Les Levine in a video interview recorded during his Paris retrospective in 1993 and shown at the entrance to that exhibition. (Besides Morley's air of imperious intelligence, I was struck by how his eyes constantly shifted from side to side: is it stage fright or the reflex of a hunted man, perhaps a lasting trace of his years as a thief?) In other words, the ruptures form a chain: 'One perceives as many breaks as links, and that was precisely what the artist intended.'[5]

What links rupture and continuity is not, as with Stella, a logical chain, but rather an organic element, something I would describe as a seed for lack of a better term, and because with Morley things proceed metaphorically and organically. The invisible strokes of his Superrealist paintings grow like a plant – witness the *malerisch* flowers of *Buckingham Palace with First Prize* (painted in the same year as *Race Track*), whose added decoration at the lower edge represents the seed of a third dimension soon to invade Morley's paintings, or the small visible dabs which later bloom into the disheveled brush strokes unjustly described as neo-Expressionist. He himself has noted quite bluntly: 'If you want to see the next movement, look in the left-hand corner of the last movement.'[6] The pig motif in *Ship's Dinner Party* comes to mind.

TINY BITS OF PAINTINGS

Another motive for change was impatience. Morley wanted to paint faster and therefore used bigger brushes, bigger grids, and stopped using a magnifying glass. In fact, using the naked eye, he started to paint the

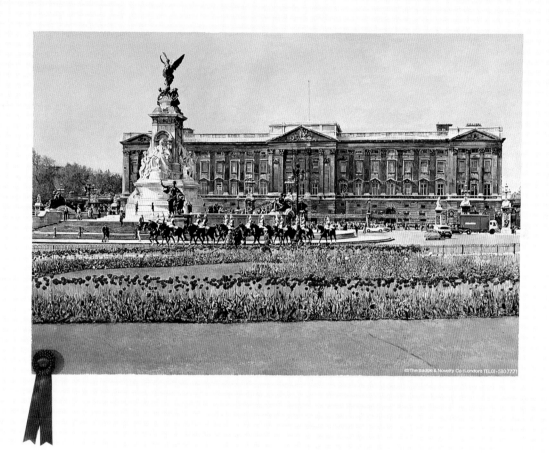

50 Buckingham Palace with First Prize, 1970.

blow-ups he had seen previously through a magnifier. The information transmitted became increasingly abbreviated. At the same time, just when Morley put an 'X' over his Superrealist imagery, his brushwork became more and more visible:

> I was in my studio with a friend looking at one of those Super-Realist paintings. We were really stoned and started looking at tiny bits of the painting through a magnifying glass – that's really where the energy of the painting was – in all those tiny strokes. I realized I wanted to see through and into, instead of across. I became more interested in the physicality of the surface. I mean, what are all those hairs on the brush for, anyway?[7]

One thinks of Franz Kline twenty years earlier looking at his brush strokes enlarged in a Bell-Opticon. But Morley associates these bits of painting with the hallucinogenic perception induced by drugs:

> After that, I started roughing it up. I started smoking a lot of pot. And then I would look at these grids, at these little bits of paintings under a microscope, and they'd get very hallucinogenic. So I started increasing the brush-stroke sizes, little by little. Coming out of that closet.[8]

51 Detail of *Buckingham Palace with First Prize* (50).

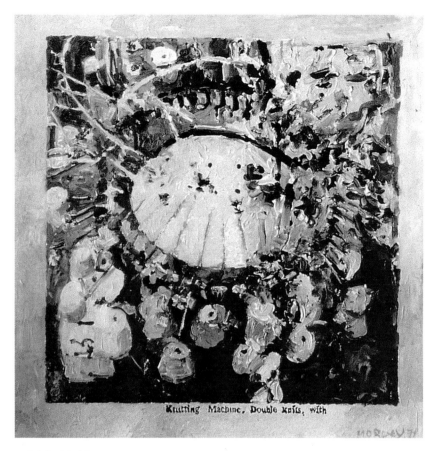

52 *Knitting Machine*, 1971.

Buckingham Palace with First Prize is perhaps the first picture in which this enlargement is actually visible. In the lower right corner of the image (but not in the margins as in previous works), one can read in white script © *The Badge & Novelty Co (London) TEL 01-5807771*. The picture was part of a collective commission by the association of F.T.D. Florists for paintings representing flowers. The flowers of *Buckingham Palace*, a bed of red tulips surrounded by green leaves, seem to be the place where the paint grows. The Dadaist gesture of the picture consisted of attaching a real equestrian trophy, a first-prize rosette, on the bottom left of the British royal palace. (F.T.D. sold the painting four years later, on which occasion the artist made one of his most spectacular interventions.)

In 1971 and '72, Morley's brush strokes became more and more visible to the point of rendering his motifs practically illegible (*Knitting Machine, Heroes of Suikoden* after Hokusai, and especially *A Death in the Family* [page 66]). Simultaneously, the margin came to interact with the image. In *Safety is your Business* (page 58) (a school kid directs traffic in front of a school bus), the margin is invested with fragments of road signs; in *At a First-Aid Center in Vietnam* (page 67), done from a two-page lay-out

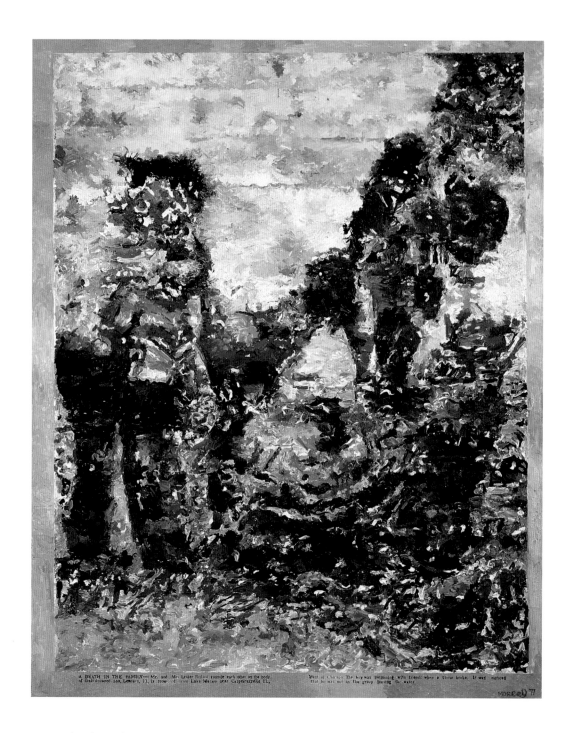

A DEATH IN THE FAMILY— Mr. and Mrs. Lester Heflin console each other as the body of their drowned son, Leonard, 11, is recovered from Lake Marion near Carpentersville Ill.,

West of Chicago The boy was swimming with friends when a storm broke. It was noticed that he was not in the group leaving the water.

MORRel) 71

53 *A Death in the Family*, 1971.

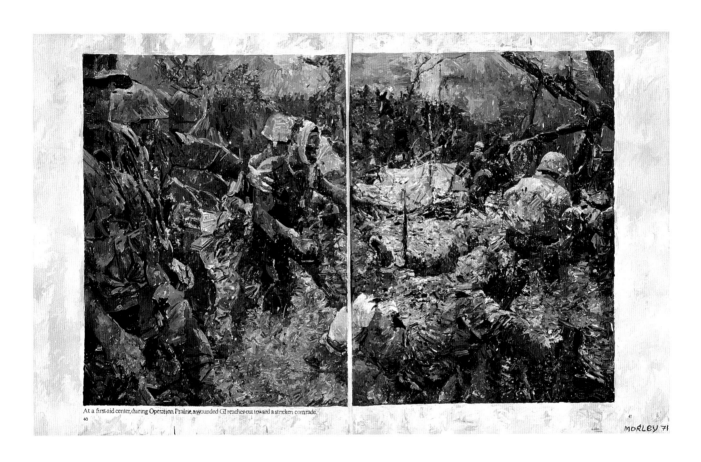

At a first-aid center, during Operation Prairie, a wounded GI reaches out toward a stricken comrade.

54 At a First-Aid Center in Vietnam, 1971.

55 *Regatta (Check #185)*, 1972.

in *Life Magazine* and whose paint, which he describes as *spiky*, looks like shrapnel, the white hollow between the two magazine pages is simulated by a piece of white canvas sewn from bottom to top over the middle of the painting. The printed legend ('At a first-aid center, during Operation Prairie, a wounded GI reaches out toward a stricken comrade') and the page numbers are copied in black paint. Accidents in the white margin echo Cézanne's coloured whites (Vollard's shirt or Vallier's profile portrait), no longer the soft texture of the tablecloth in *Ship's Dinner Party* but rather discontinuous patches of yellow, blue-green, salmon pink and lilac: 'That was my free space.'

Regatta (Check #185) is the picture of a cashed personal cheque whose printed image, a seascape with three sailboats, is doubly set apart: by the graphic signs of the material support (printed, handwritten and stamped in red: *PAID*) and by the paint, as if rippling or ruffled by the wind. The object and the method haven't changed – still the same double image, the same grid – but the support of the image and the painting have lost their semblance of neutrality and now appear animated. This double animation proceeds by means of a contrary movement: the painter moved away from the image, allowing traces of his support to be visible (letters, numbers, signs and marks), and got closer to the paint: 'Where there's less information in the cell, then there's more painterly invention to compensate.' This double movement would trigger the catastrophes.

Morley continued to reproduce images in paint, but now the parasite elements of the image became visible. Views of Madison (1970) and of the Eiffel Tower (1971) appear on the stained cover of a telephone book or on a calendar page; the white margin of the calendar representing the Eiffel Tower is now delicately textured and coloured. Postcards are invested with text: *Rhine Chateau* (page 70) is signed 'Elcé' at the bottom, and in its upper corner *Kodak Castle* (page 70) carries the Kodak logo, appearing behind the view and bending it towards the front like certain Baroque *trompe-l'œil*. But Morley remains literal here; he flatly reproduces a flat reproduction of the publicity logo's illusionistic effect.

The catastrophe arises when the bi-dimensional space of the model begins to take on thickness. In 1971, Morley painted *Los Angeles Yellow Pages* (page 72), the cover of the August 1969 Los Angeles Yellow Pages, showing an aerial photo of downtown L.A. with the directory's characteristic yellow border, letters and insignia. Morley used this cover as a palette; it was coated with pink paint, and a part of it was scraped away by the palette knife, displacing at one and the same time a corner of the blue Los Angeles sky, an area of the cover's yellow border, the white margin separating them, and the word *Area* (from 'Area Code 213'). A vertical tear rips the image of the city, with its sky, skyscrapers and highways, from top to bottom. The painter traced two circles around the tear in homage to Jasper Johns's *Targets*. The model is accentuated, not only on the surface (the double rings) but also in its thickness (the scrapes and tear). As slight as they are, the confrontation of the paper cover's thickness and that of the painted canvas would destroy the illusion of literalness that had had its heyday in the art of the 1960s.

The meeting of these two thicknesses causes different representational spaces to collide. These are no longer simply associated and distinctly readable: as with Francis Bacon, accidents on one level of representation contaminate others. The tear tears not only the page but the city; the pink paint reads not only as representing the paint on the cover but as the heavenly fire striking modern Babylon. The double rings now suggest the epicentre of an earthquake. Each mark represents the meeting of what until then had been held apart. The texture of the paint is agitated, stormy, filled with menace. At the same time, this miniature apocalypse is the amplification of a game without apparent consequence; even as it rips the

56 *Kodak Castle*, 1971.

57 *Rhine Chateau*, 1969.

58 *Madison Telephone Book Cover*, 1970.

59 *View of Paris (Eiffel Tower)*, 1971.

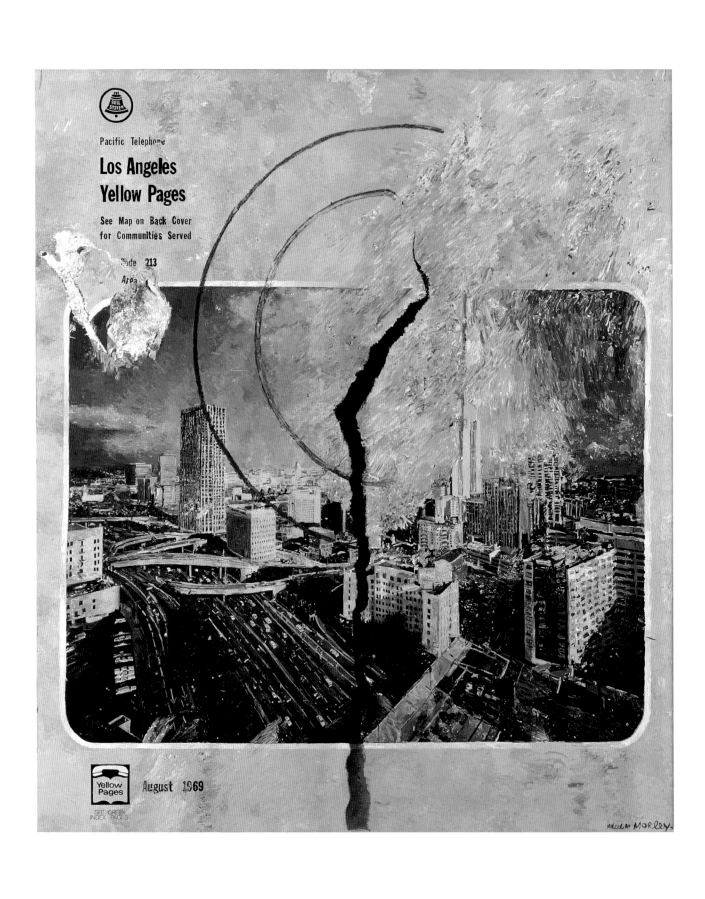

page and the city, the tear lightens lower down, inexplicably allowing the white margin separating the scene and the yellow frame to show through the black. This heterotopic game evokes Duchamp's *Tu m'*, where a real bottle cleaner stuck onto the canvas creates a painted fissure sealed by real safety pins; but it complicates and deconstructs itself, leaving 'reality' intact.

At least in appearance. A few days after the picture was completed, on 9 February 1971, a violent earthquake shook the Los Angeles area, causing 62 deaths, hundreds of injuries and considerable damage.

SCHOOL OF ATHENS

It's a well-known story. In 1972, asked to give a lecture at the State University at Potsdam in New York, Morley decided to begin a painting in public (this is a Chinese tradition): 'After all, why doesn't an artist just carry his studio wherever he goes, like a shell on a slug?'[9] 'I was dressed as one of the characters [in the painting], as Pythagoras. I had this canvas prepared for me by the university.'[10] He knew that Raphael painted himself into his fresco, but not that he had introduced other artists of the time into it in the guise of various ancient philosophers (Leonardo as Plato, Michelangelo as Heraclitus, Bramante as Euclid).

> The execution/performance was accompanied by the music of Scriabin[11] (or Monteverdi?[12] When I ask, he answers: 'I don't remember. Scarlatti?').

He had asked the university to prepare an arched, gridded-off canvas whose measurements he had given over the phone. In front of the audience, he painted the middle part where one sees the main philosophers' heads. Back home, he realized that he had gone one square over; the skulls of Plato, Aristotle and their most important followers had all shifted to the right: 'Morley accepts this accidental shift with pleasure, as "evidence of my lobotomizing philosophy."'[13]

Like *Los Angeles Yellow Pages*, *School of Athens* (page 74) creates a contamination of levels. The accidental shift is at once a game of painting without consequence and an eruption of the irrational into a founding *logos*. It was around this time that he remembered the episode from the Second World War when his model battleship was destroyed. All of Morley's art rests on this confusion of scale:

60 *Los Angeles Yellow Pages*, 1971.

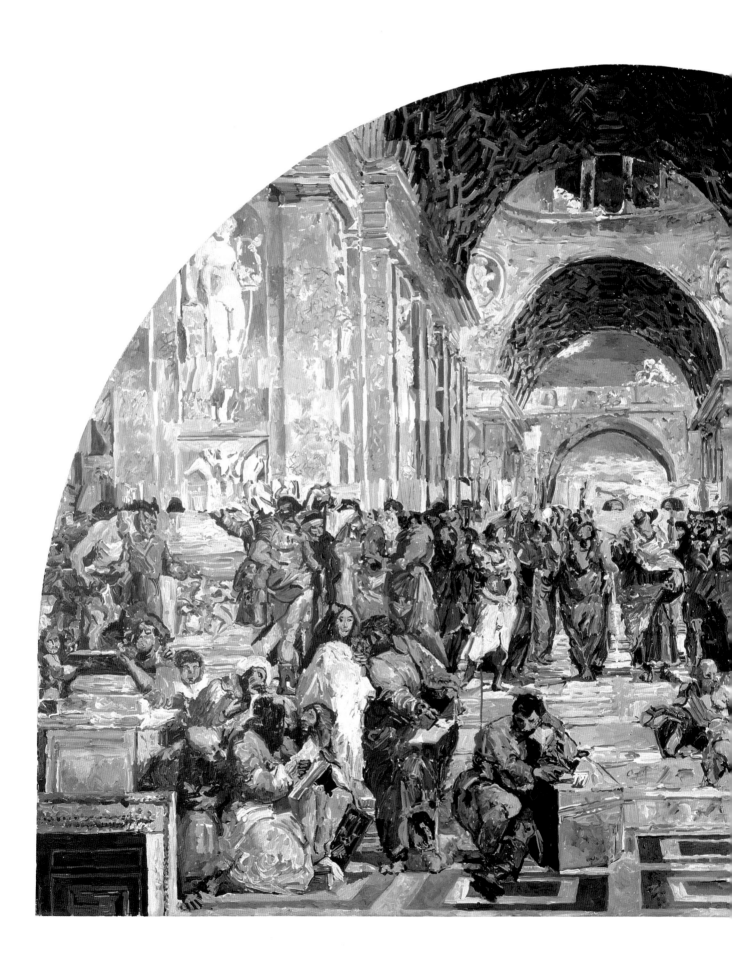

62 Detail of *School of Athens* (61).

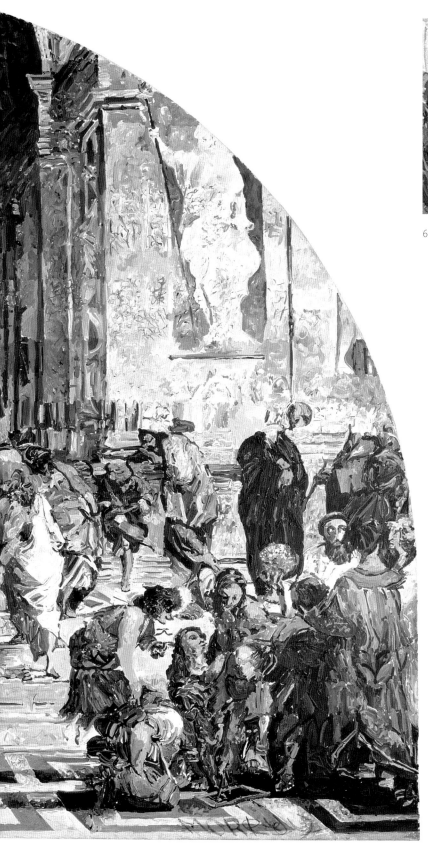

61 *School of Athens*, 1972.

So it was a mistake, or mis-take. I am not so quick in correcting a mis-take, but I rather welcome it. It also became a kind of conceit: it's a kind of reward for looking. I was very pleased by this development. I made the mis-take unconsciously, but later I had a choice – I could have corrected it and put everything in the right place. But I didn't. I encouraged it.[14]

School of Athens is very different from photographs of it, in which one can't see much of the vigour and turbulence of colour and texture, or of the density which, seen up close, drowns the figures; the same is true of *At a First Aid Center in Vietnam*. The discontinuous texture allows the grid to appear, if not in its materiality, at least through the break-up of modules: 'Leaving little pieces of it became an acknowledgement of a process.'[15]

In 1971 (*Kodak Castle, Los Angeles Yellow Pages*, etc.), Morley started to sign his paintings visibly again, not on the back of the canvas as in the period following *Empire Monarch*. In *School of Athens*, the (retouched) signature in charcoal is drawn in perspective on the ground, to the right, under Euclid's compass.

This paraphrase of Raphael, he tells me, was an outside inspiration. He was teaching at Stony Brook in New York State and one of his students, Valentine Tatransky (who later became an art critic), a brilliant young man who didn't like him because he was a modern painter, came to him one day with a big book on Raphael opened to the *School of Athens* and challenged him on the spot: '"You should paint this, Mr Morley." I looked at it and I said, "That's a very good idea." And I painted it.'

TRANSITION TO OIL

School of Athens is one of the last paintings that Morley did in acrylic; from 1971 to 1973, he alternated between oil and acrylic before abandoning the latter definitively for the former, sometimes mixed with wax: 'I changed from acrylic to oil. Oil allows more diversity, and it's denser and wetter. Modulation. I want modulation. Acrylic is for a more homogenized surface. I want to allow as much variety as possible.'[16] As the painter explains, the suspension of pigments in oil is not homogeneous and can pose problems. Oil thus became the medium of his new vision – modulating, sensual, difficult, heterogeneous. During this period, he also took up watercolours again.

He notes himself that his paintings in acrylic look like they were executed in oil and that the viewer is sometimes fooled. In 1971, *Safety is your Business* was painted half in acrylic (the top part) and half in oil, but the difference is imperceptible. This shift, he says, was motivated by 'fidelity to the model':

> According to Alloway, *The Ruskin Family* of 1967 was begun with magnacolor (on the right) and continued with oil 'for two reasons. The tonal range of the photograph was darker than usual and oil would suit this; also, he considered a change of technique would ease still further the problem he had partially solved by doing a contractual painting. Al Leslie happened to mention to him a medium that gave oils the properties Morley needed, litharge. Instead of being transparent, like oil, it makes the pigment both thin and opaque, without lessening its manipulative freedom. Morley described the medium as having something like the effect of "greasing instead of wetting the paint," and it is relatively quick-drying – two or three days . . . Morley finished the painting by spraying it, to unify any discrepancy between magna-color and oil areas and to subdue the variations inevitable in oily blacks. He sprayed two coats of grey-orange and grey-blue oil paint, thinned down with turpentine, and he introduced irregularities in these coats so that variables animate what might have been too smooth a veil. This was Morley's first use of the spray gun, but he is making increased use of it now, not as a substitute for varnishing, but structurally.'
>
> This detailed description was written just as the painting was finished, but Morley is convinced today (1999) that it is inaccurate, and that the painting was done entirely in oil, with an uncovered grid (as one sees in the photos of the painting in process, reproduced in Alloway's article).[17]

NEW YORK CITY POSTCARD FOLDOUT

Morley's logic, as imperious as it is spontaneous, brought him to consider another property of the support-image which served him as model: its situation in space. He thus began to tackle the views found on accordion postcards.

He started in 1971 with a small, flat version (157.5 × 595 cm) of *New York City Postcard* (page 78). Here he reproduced five-and-a-half views (counting the closing part) of famous New York sights – Central Park,

64 *New York City Postcard Foldout* (face A), 1972–3.

63 *New York City Postcard*, 1971.

65 *New York City Postcard Foldout* (face B).

Times Square, Rockefeller Center, etc. – in acrylic, as well as a handwritten address in Essen, West Germany: 'Morley made the postcard's flap as a separate shaped canvas, "the beginning of my moving away from Euclidean painting." The stamp, with a subtle resemblance to Madame Cézanne, and the airmail stickers, were also separate surfaces, stuck on.'[18] The picture, shown in the 1972 Whitney Annual, was a rehearsal for a larger version (180 × 817 cm) showing seven-and-a-half views on each side, including the same subjects but in a different order, plus the Empire State Building, the PanAm Building, the Statue of Liberty, etc. This time, the postcard is unused, without stamp or address, and without any other inscription than the signature on the 'Greetings from' side: *Malcolm Morley / 1972–3 / For John Chamberlain*. In fact, the painting has left the wall and stands on the ground like a folding screen, painted on both sides and reproducing the half-unfolded postcard. The painting is reversible like the postcard, and when it is laid on the ground, one of the sides is upside-down. This painting, Morley's largest to date, at least in width, creates a complex game of scales and spaces. As the enormous enlargement of small postcards depicting large structures, it is located halfway between these two models, smaller than the buildings but larger than the images. And it reproduces the half-folded images in space, zigzagging through space, small, flat images representing large, deep spaces. The oil paint itself is very thick. Globs of it are strewn over the Empire State and PanAm buildings, some in the shape of a crown. Newsprint appears transferred onto the thick, white paint (sometimes scratched) in some of the margins. The critic Kim Levin noticed a crumpled page from a pornographic magazine. The painting-screen tends to collapse under its own weight. 'I used to do it under a magnifying glass and I felt like a pigmy,' says the artist, adding, like Cézanne, 'Each bit represents this patch of sensation.'[19]

2D/3D

'All two dimensional surfaces are pornographic. You are controlled because you can't penetrate them.'[20]

The moment Morley said goodbye to Superrealism is the moment when he introduced 'real' objects (which is one way of affirming that the canvas, its stretcher and the paint covering it are also real objects, existing in the world and granted thickness). A whole Duchampian hardware store opened up: the first-prize rosette on *Buckingham Palace with First Prize*

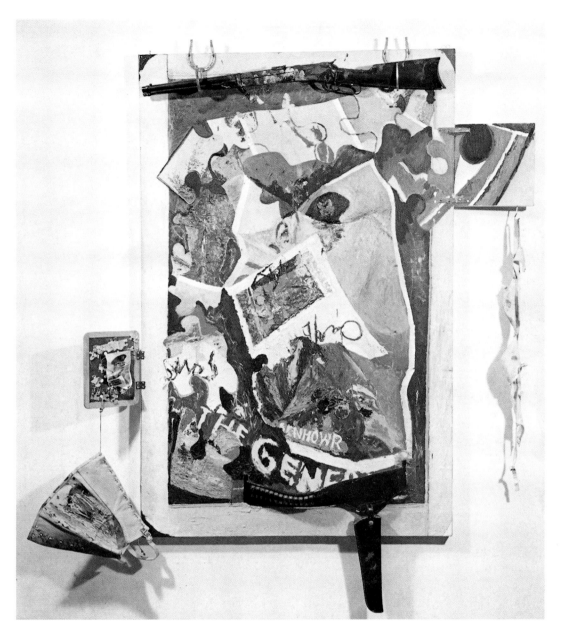

66 *The General*, 1974.

(1970), later accompanied by a water pistol; the bell and the section of plasticine in *St. John's Yellow Pages* (1971); in *Room at Chelsea* (1972), the key to the room at the Chelsea Hotel where the painting was done, suspended on a hook; the old postcard glued onto the comic-fantastic self-portrait *Belly* (1972–3) (page 86); the comb and the postcard in *S.S. France* (1974) (page 89); the assemblage in *Van Gogh's Last Picture* (1972) with easel, rag, palette, paint box and gun; the rifle suspended from horseshoes, the bra, the painted gaiter, the slate pierced by bullets which the canvas reproduces on a large scale, and the military belt in *The General* (1974); the cup with

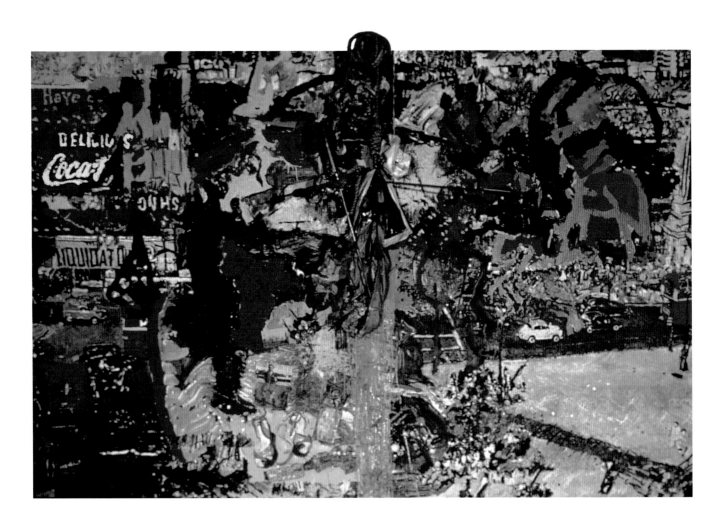

67 *Piccadilly Circus*, 1973.

tea-leaves in *Teacup* (1975), placed near a huge painted reproduction of it, a tondo three-and-a-half feet in diameter. (The paraphrase of *Wheatfield with Crows* presents an uncommon trait which the artist points out to me: the thickly layered paint reproduces the shadows created by the painted accents in van Gogh's picture as they appear in the photo that served as model – to which it adds, of course, its own layers and shadows. It is like the double double contours of *Vermeer*.)

These combine paintings owe less to Rauschenberg than to Jasper Johns, the American painter whose influence Morley freely admits. *St. John's Yellow Pages*, written ST. JOHNS on the painting with the apostrophe barely visible, is also a pun on his name – and an autobiographical reminder: it was in Newfoundland that Morley landed as an adolescent on his first transatlantic crossing.

This influence is most visible in the paintings where the object attacks the picture: the knife piercing the canvas in *Disaster* (1972–4) (page 91), or the arrows in *Piccadilly Circus* (1973). Morley often took drugs during this period, and his personal life was troubled. As he was separating from his third wife, he painted a view from a crumpled postcard of Piccadilly Circus, where he had hung out and worked as a waiter in his youth; the view is obstructed by all sorts of elements: large, pseudo-Expressionist blotches of paint, which the artist had placed in the centre beforehand, two women's shoes, a picture of a soccer player, etc. In the middle of the canvas, where the Eros statue should be as it is in the square, the painter hung a cord from which he suspended a plastic bag filled with grey paint; he had a visitor shoot arrows into the bag which emptied, spreading grey paint over the bottom of the canvas. One thinks of Picasso taking revenge on Olga through painting, but also of Johns's indexical paintings (*Device, Field Painting*, etc.), in which an object, through physical contact, produces an effect on the painting. The arrows are still planted in the canvas today.

SOCIAL SCULPTURE

During the years 1972–4, the painter let loose, navigating through dangerous waters. He took accordion postcards showing the houses of Hollywood stars as motifs and painted them on creased metallic supports (Chamberlain is glaringly present) with a twisted grid; he has since destroyed this painting. He created other strange combinations that didn't always work (*Fire Island with Two Endings, Crumpled Ship, Pythagoras's Shoes*, etc.).

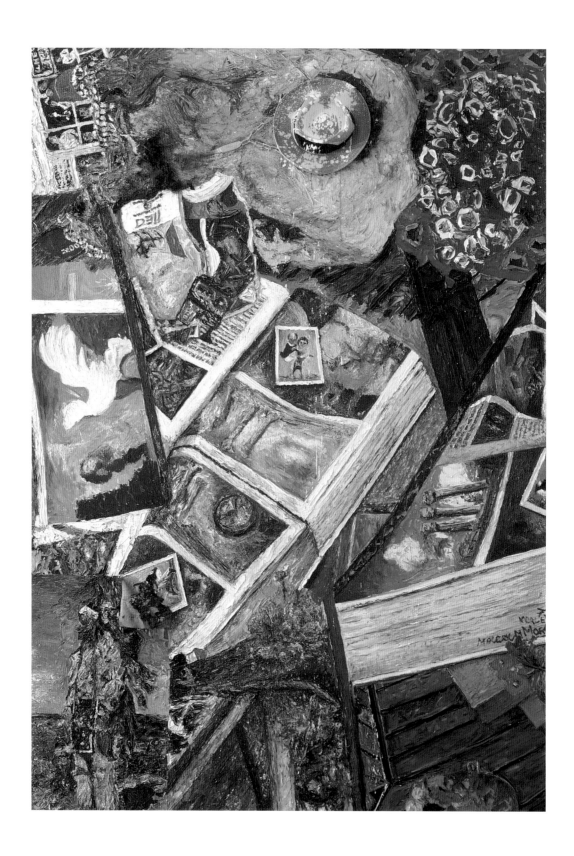

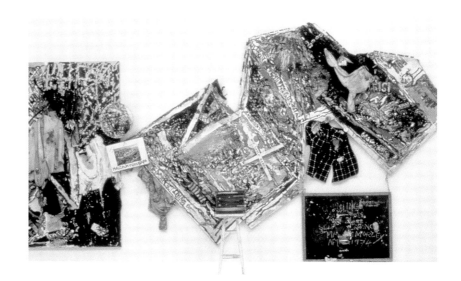

69 *Miami Postcard Foldout*
(A Painting with Separate Parts which
are Self-Generating), 1974.

He started to paint without a grid (*Untitled Souvenirs, Europe; Dave's Luncheonette*, a canvas with glitter). His paintings, as in *Miami Postcard Foldout*, a large shaped painting which he showed with *New York City Postcard Foldout* and *Van Gogh's Last Picture* at the Stefanotty Gallery in October 1973, took on a ragged quality, both inside and out. Some are frankly ugly and appear unresolved – but one would feel compelled to see them; others such as the two self-portraits, are successful but supremely grotesque. The second of these is *Untitled Souvenirs, Europe*, in which he painted himself nude from above, as if seeing himself but without a mirror. His head is hidden by a real straw hat daubed with white paint; standing in for pubic hair are bits of a Brillo pad crowning a thick dick extended towards a newspaper in the middle of a pile of pictures. (The Indian on the bottom is painted over an additional surface pasted over the canvas.) The first is *Belly*, in which he returns to the imagery of Baubo, commented upon by Freud ('Mythological Parallels', 1916) and painted in their own way by Klee and Magritte. Morley painted himself in a mirror, placing his facial features over his stomach – the crown of sparse black hair forming two tufts under his armpits – thus perfecting on himself the lobotomy begun in *School of Athens*, a corner of whose architecture one glimpses behind his right shoulder. The red signature with the missing letter, MALOLM MORLEY 73, echoes this self-decapitation.

During these years, he taught at Stony Brook alongside Lawrence Alloway. He started classes by declaring that he would give an 'A' to

68 *Untitled Souvenirs, Europe*, 1973.

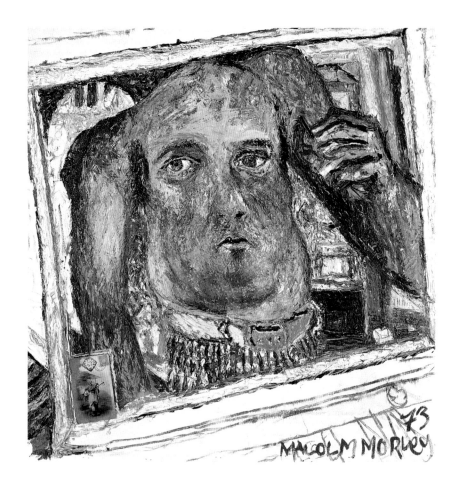

70 *Belly*, 1973

everybody, at which point most of the students left. This truly excellent manner of filtering students and his own drug-crazed behavior – he went to class dressed like Aunt Nellie, his pockets filled with phalluses – inspired academic disapproval. (Future researchers should consult the Dean's memos.)

His violence took a more spectacular turn: 'Attaching psychodrama to the visual had become something that affected me.' The concept of public painting begun with *School of Athens* would occupy Morley for some time. In January 1974, he prepared *A Painting with Separate Parts which are Self-Generating* (page 85) for the New Cultural Center of New York, an augmented version of *Miami Postcard Foldout*, which was supposed to be completed with audience participation throughout the duration of the exhibition and accompanied by a 16-mm film lasting roughly nine hours. The Center administration refused permission for this, and Morley

completed the painting in a truck stationed in front of the building on Columbus Circle.[21]

On 30 November of the same year in Paris, where he had a show at Galerie Piltzer, he tried (in vain) to paint the word *faux* (fake) on his painting *Buckingham Palace with First Prize* with a water gun filled with purple paint, the royal colour, during an auction at the Palais Galliera. At least he succeeded in disturbing the sale (declaring as he pointed to the hall: 'This is laundry money') and in nailing the gun onto the top right-hand corner of the canvas, diagonally across from the first-prize ribbon. He had bought the hammer and nail in the basement of the Bazar de l'Hôtel de Ville as an homage to Duchamp.

On Good Friday 1976, Morley painted a cross carried on the back of his assistant, who stopped at a series of 'stations' between his studio and the chapel that had commissioned the work. These actions, which Morley called 'Social Sculpture', aimed in part at showing that '. . . society makes art, not artists.'[22] Their context, during these years of unrest, lay in artists' confrontations with artistic institutions (Beuys, Haacke, Morris and others), artistic space (Land art) and notions of art and artwork (Conceptual art). Morley questioned the limits of the activity of painting in the social realm.

71 Morley (in top hat) at the Palais Galliera, 1974.

72 Morley painting *Peripatetic Cross (Paint Walk Cross Easter New York City)* in 1976.

As always, he worked alone; recalling this period still makes him feel bad today:

> I was creating a great deal of danger deliberately. I was flaunting the muses. I was saying, 'What can I do under the banner of art? I'll go as far as I can. I want to find out when do they say, "No!" When do they say, "You can't do that!"?' I wanted to find out what was the freedom of art.[23]

REMEMBRANCE OF THINGS PAST

During the '70s, Morley returned to his Superrealist ships. In 1975, he reversed and tore his 1965 *United States* up a bit; in 1976, he painted a fourth version of *Cristoforo Colombo* in his new painterly style and hung, in front of the image and almost parallel to one of the garlands of flags, a multicolour string of kitschy Gothic letters forming the words REMEM-BRANCE of THINGS PAST. In 1974, he made a triptych of *S.S. France*. As for the picture of the *Rotterdam/Amsterdam*, it suffered various insults: in 1974, it was taken up in a painterly way in *Onsettant Moie* (a deformation, Lida tells me, of the Dutch expression 'ontzettend mooi', terribly beautiful) and stabbed with a kitchen knife in *Disaster*; in 1976, an airplane, PAA N35021, crashed into it in *Age of Catastrophe* (page 94). This was a way of demolishing Superrealist perfection: 'It was like the Michaelangelo thing – you take a sculpture to the top of the mountain and roll it to the bottom and what do you have left?'[24] 'I call those early ship pictures my perfect period, and what followed an imperfect period – a tearing down of perfection.' 'The works are very anarchistic, but rather beautiful.'[25]

The triptych *S.S. France* looks like a double postcard, front and back, torn all over (through one of the tears appears a fragment of *S.S. Amsterdam in Front of Rotterdam* with a knife, probably a reference to *Disaster*). A green comb is glued onto the cruise ship. A third shaped canvas, glued onto aluminium, hangs from three chains in front of the first two, obstructing a good part of the message and the address, though one can read in reverse the words *Michaelangelo* and CAPTAIN . . . PIT . . . It shows fold-out cards of monkeys sent from Florida: change two letters and 'monkey' is identical to 'Morley'; this similarity evokes the old symbolism studied by Panofsky and Janson, the mimicking monkey as an emblem of painting. (The titles of these postcards, MONKEY JUNGLE, also recalls the Duke Ellington recording with Mingus and Max Roach, 'Money Jungle',

73 *S.S. France*, 1974.

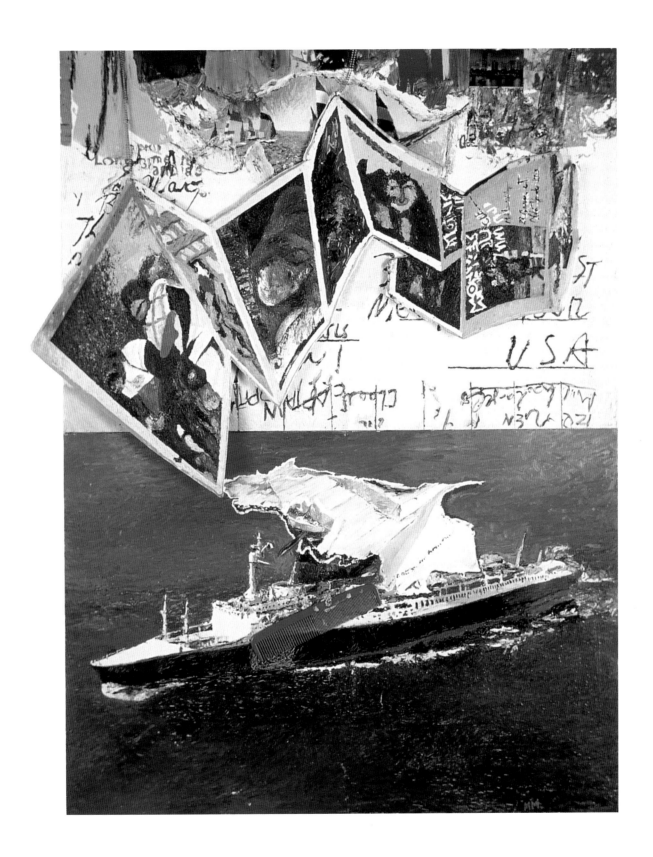

which Morley doesn't know.) The fold forms one of those spatial impossibilities that the painter would develop later on. A real postcard showing a twilight scene is glued onto the top of the picture. The image's fragmentation underscores the climate of enigma that Morley would favour and that disconcerted the critics.

> When I tell him I see the name *Michaelangelo* on the back of the card, Morley puts up an almost violent protest: he never meant to write that name, which is in fact barely legible, for it emerges from a series of indistinct graphic signs. It's as if I were accusing him of the egocentricism for which he reproached Barnett Newman, who declared in the semi-darkness of the Louvre: 'If I am talking to anyone, I am talking to Michelangelo.'[26] The next day, he thinks better of it: maybe . . . unconsciously . . . I remind him that he did, after all, address a watercolour postcard from Kansas City in 1975 to Vincent van Gogh with the message 'Wish you could come here.'

74 *Wish You Could Come Home*, 1975.

Disaster reuses the image of *S.S. Amsterdam*, but torn near the top; a real kitchen knife is pinned through the canvas, and on the spot where it enters the first time, the image has ripped apart, allowing a second support to show through covered with a red, blood-like stain. Bits of charcoal stick to the paint, and the texture of the white paint on the margin grows thicker and thicker the closer one comes to the 'crumbled' part of the picture. In the words of Lawrence Alloway, who presented the work at the Clocktower in New York where Morley was showing his catastrophe pictures, '. . . quotation becomes destruction.'[27] Like the violence of children and felines, this is both for fun and for real; its point is to bring together the serious weight of reality and the playfulness of fantasy. A knife draws blood from a sign.

These paintings heighten the second-degree effect of their Superrealist model. They are signs of signs, illustrating printed photos of painted works which illustrate printed photos. The object fades away, while the world, like the sci-fi films of the 1980s, is invaded by its own replicas. But the levels get confused. As with Novalis, the world becomes dream, the dream becomes world. We have entered the realm of pure melancholy.

SPATIAL GRIDS

After 1976, Morley renounced found objects, eccentric supports and social controversy to concentrate on the painted canvas rectangle. (The last

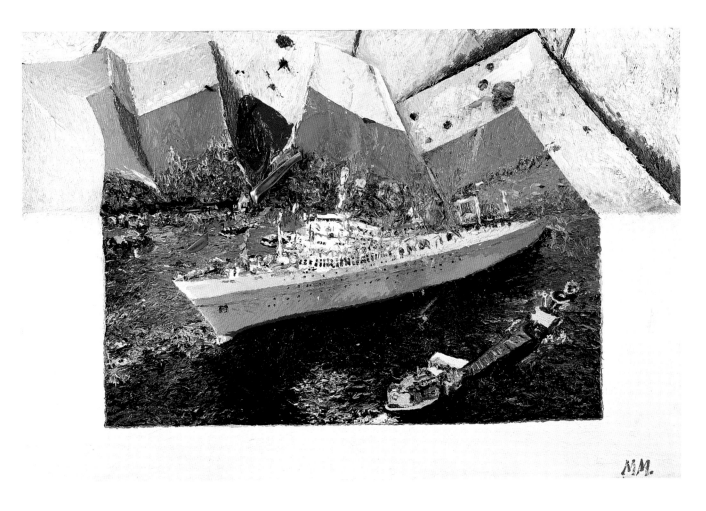

MM.

75 *Disaster*, 1972–4.

76 Giambattista Tiepolo, *Apelles and Campaspe*, c. 1725–6.

added objects, from 1976, are modest ones: the attached toy cow and frame of *Marine Pastoral*; the safety-pin in *Little Corner of Plane-Ship Catastrophe and Central Park*.) This step echoes a tendency found elsewhere to return to paint and painting. (In 1981, Morley's *Parrots* [page 112] appeared on the poster of the manifesto-exhibition at the Royal Academy, London, entitled *A New Spirit in Painting*.) But Morley would not abandon his attachment to three-dimensional form: he represented it in his pictures. Objects became motifs. To the flat images that served as models he added three-dimensional objects, usually scale models or toys, in other words still image-signs.

During his 1974 Paris exhibition at Galerie Piltzer, Morley had met Gérard Gasiorowski, an artist whose endeavour was not unlike his own and who gave him a sculpted composition of a derailed toy train. Morley copied it in reverse, like a mirror-image but without using a mirror. Placing himself between the model and the painting (like Apelles in the Tiepolo painting of Apelles and Campaspe in Montreal, he copied the image by direct translation. He added a pink flower at the lower right (an explosion of flowers is found in the 1976 tondo *Burial of Catastrophe*), a fragment of a playing-card and inscriptions in Chinese, Japanese and Russian, also reversed, which read '*Catastrophe*' and '*Train Wreck*'. The dense, unreproducible texture recalls the thick Pollocks of 1946 and '54. (From the painting *Train Wreck* Morley made a very large etching which reverses the reversal of the canvas.) The catastrophe theme and the collapse of depth on the painting's planar surface are related. It is by questioning painting as pure surface that Morley creates the collision of levels and spaces: 'For the first time, I'm actually painting space as something seen before I hit a surface. That's the ruse of the painting.'[28]

Still painting with a grid, he now, in the manner of Dürer's net, had to stretch a grid in space between his eye and his model which he then copied onto the canvas. He also combined different types of bi- and tridimensional images. In *Age of Catastrophe*, he took as a model a reproduction of the *S.S. Amsterdam in Front of Rotterdam*, laying onto it an out-of-service PanAm plane (a tin toy) and a tree branch with a little submarine attached, which (through a verbal paradox translated literally into image) shows up suspended *under* the waters of Rotterdam, as well as a bird that fell dead at his feet while he was riding his bike around Amagansett on Long Island. A piece of the same submarine seen from a different angle seems to emerge from the water itself and meet up with

77 Train Wreck, 1976.

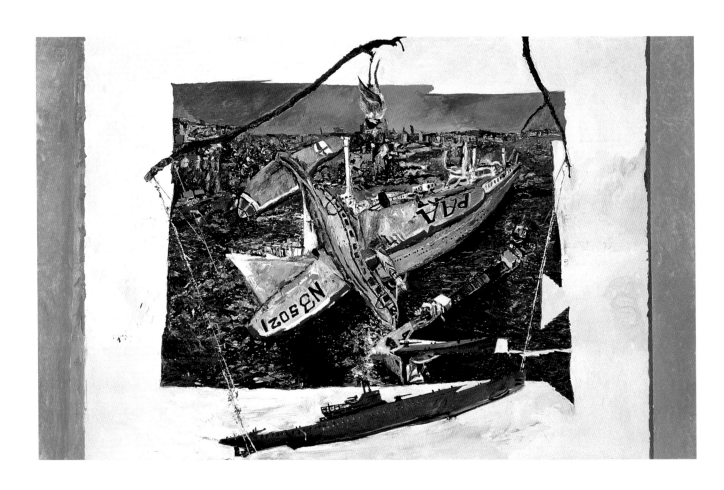

78 *Age of Catastrophe*, 1976.

the *Amsterdam*'s tugboat. The model of the image has become a still-life composition recalling the tables of Cézanne but also, as in the past, a small-scale panorama:

> I feel that what's good for painting is to have things close together and bunched up, so the models are often small and seen at close range. I want a lot of variety in a small space. You know I'll stage a tableau with a postcard and a toy train or blow up a toy Indian from two different sides or do a live parrot at close range. It gives me a great deal of freedom with scale, too.[29]

The actual painting of this image is very strange:

> The plane, PAA N35021, though a toy, is battered to the point at which its pathos seems the analogue of a real crash. The texture of Morley's paint – gritty, ridged and pressured – does not make the differentiation between the toy and the thing easy. The ship and the plane are presented with a smeared immediacy, somewhat like de Kooning's dirty, Lower East Side street-derived abstractions of 1954–56. The impastoed surface is freighted with traces of real-life use, like the plastic covers of drugstore counters or like accident sites before the glass fragments and spilled gasoline have been hosed away . . . It is as if being a wreck authenticates the image.[30]

The image of *S.S. Amsterdam* is submitted to a similar treatment. Its white margin is now lightly coloured and irregular, and doubled on the left and right by mauve areas, perhaps denoting the wall where the reproduction is hung. The edge between the image and its margin is jagged, not much on the left, more above, and very much so on the right, where diagonal indentations create an enigmatic effect recalling the lobotomy of *School of Athens*. This might be explained, Michael Compton has suggested, by the viewer's eye shifting over the net suspended in space between the painter and his model: 'The dovetailed form of the shifts on the right is due to the use of a diagonal as well as a rectangular grid.'[31] But perhaps that explanation is too logical; everything happens as if Morley, without really copying what he saw on the grid as his eye moved around, imitated the effect of these displacements through painting. (Which Morley confirms: except in his triangular paintings from 1975–6, inspired by Buckminster Fuller, he did not use a diagonal grid – at least as far as he can remember.)

I was testing always, what could this grid do – where, how far could it go. So long as I was true to it in a sense, if I was willing to be accountable . . . It was fair enough, because I'd made an agreement. It was always a correspondence. *Age of Catastrophe*, for example, where I'm actually moving on the grid, physically. I've got a three-dimensional grid, because this is now the beginning of an actual model, it's a tin plane.[32]

Morley exploited this way of making pictures, which favoured a new visual freedom:

> . . . his eye cannot remain still. By representing the literal case directly through its failure, Morley dramatizes the role of the artist in representing the world . . . The picture shifts and tends to disintegrate so that the flux and contradiction of the painting can be read as an allegory of the state of the world in which the painter lives.[33]

The painting which in 1977 synthesized these new experiences was *Day of the Locust*. The apocalyptic title was taken from Nathaniel West's 1939 novel, whose hero wanted to paint *The Burning of Los Angeles*, and the film version shot by John Schlesinger in 1975. Morley had received a German scholarship for artists and was then living in Berlin. He took as a model a poster of his first catastrophe painting, *Los Angeles Yellow Pages*, on which he superimposed a series of toys: boats, helicopters, ladders, a skier in a bathing suit jumping out of a small white Trojan horse, a pair of broken sunglasses (a reference, he says, to the famous episode with the nurse in *Battleship Potemkin*), someone throwing a lasso, an American Indian and an Eskimo with igloo, all released into the Los Angeles sky. In places, the black crack has widened, swallowing a figure; in others, it has disappeared. Above, in the yellow margin of the cover, the painter added a small reproduction of *S.S. Amsterdam* covered by a doll with a suitcase ('She disembarks in Hollywood'); below, a model of the Berlin Wall covered with inscriptions and, once again, tin soldiers, cowboys and Indians, a pig, bandits, etc., partially obliterated by a spatter of purple paint thrown from the second floor of the apartment block where he was living. A disturbing little brawl; most unnerving is the displacement (to the left) of the yellow margin onto the image of the city, and a rectangle of the city that grows in the margin. The shifting of the viewer's eyes in relation to the transparent grid between it and these complex motifs causes strange transformations but also evokes a modern tradition – that of the artist's moving gaze,

79 The Day of the Locust, 1977.

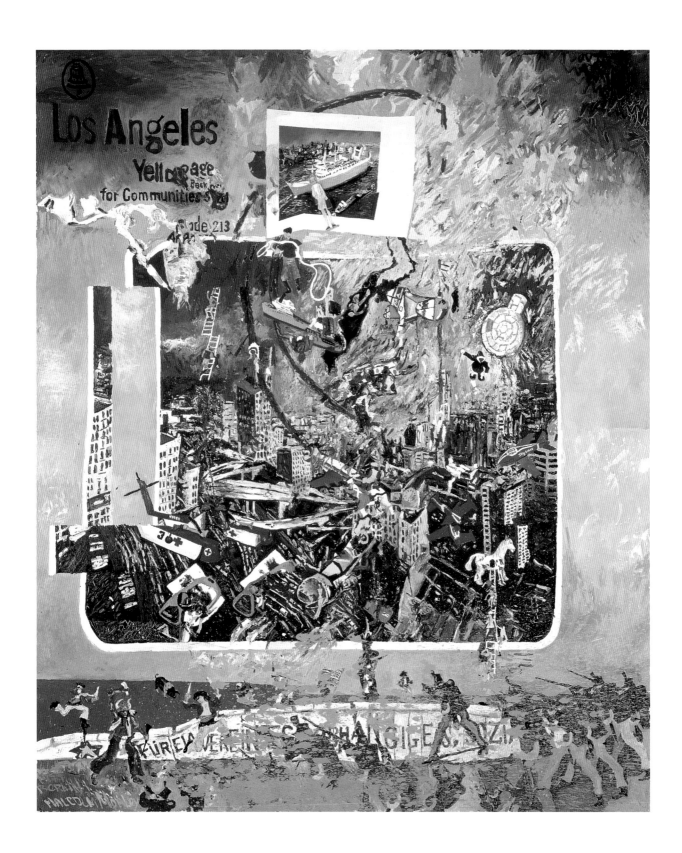

evident in Cubism, in Matisse's work of the 1910s, and in de Kooning, from whom Morley borrowed the key word *slippage*, lending the phenomenon a violent, discontinuous twist. The artist's fundamental reference was the letter Cézanne sent to his son on 8 September 1906, not long before he died:

> Here on the bank of the river motifs multiply, the same subject seen under a different angle, offers a subject for study of the most powerful interest, and so varied that I believe I could be involved several months without changing place, slanting now more to the right now more to the left.[34]

> (Saw *The Day of the Locust* again today, 12 April 1999, with Malcolm and Lida Morley in storage at MOMA. I was struck by the scale of the canvas, much larger than it appeared to me a few years ago when I saw it on the museum wall (the size indicated in the Whitechapel catalogue is incorrect), and also by the compression of the paint. The dark parts are cracked due to the poor quality of the base he used in Berlin. On the way home he told me: 'I'm glad I saw it – I wouldn't paint like this today. The surface is like a skin disease; it's like reacting to the world. Today my painting is more contemplative. I look at what I am painting. If I looked at that while I was painting it, I couldn't have painted it.')

ENTERS HISTORY

In 1978, back in America, Morley painted a final picture from a 'reproduced masterpiece': a postcard he had received of a painting in the Louvre, the central part of Guardi's *The Departure of the Bucintoro*, showing the Venetian Republic's official gondola from which the Doge would throw the ring symbolizing the city's marriage to the sea into the Adriatic. Over the *Bucintoro*, Morley painted a small image of a train which seems to erupt from the Salute; exceptionally, the train looks added to the painting, as is indicated by the pinkish mauve grid which provides its structure. The canvas recalls an earlier stage of the painter's career, completing the Vermeer–Raphael–van Gogh sequence but introducing a new element which would take on huge significance later: the collage, or rather the collision, of

80 *The Ultimate Anxiety*, 1978.

81 *Verrazano Narrows Bridge (Verrazano Naruues Brigge)*, 1976.

different temporal scales. The *Bucintoro*'s meeting with the toy train is made doubly incongruous by its anachronism and its dimensions; the train is too small in relation to the barge (as the plane in *Age of Catastrophe* is too large for the cruise ship covered or squashed underneath), and its image is also too small in relation to that of the postcard. The train is obviously an element transferred, not onto the source but onto the canvas.

Morley had already introduced a similar historical collision indirectly in 1976: in *10,000 Year Old Cave Painting With Steeple*, in the second *Vermeer* and especially in one of his strangest paintings, *Verrazano Narrows Bridge (Verrazano Naruues Brigge)*, a diptych painted half by Morley and half by his assistant Rick Brintzenhofe, who that same year lent his back for Morley's pictorial Way of the Cross (Morley no longer remembers who did what). The view of the huge bridge suspended between Brooklyn and Staten Island was based on a drawing Morley did with colour notes from the top of the World Trade Center.[35] The canvas presents a mirror image of the drawing, including illegible colour notes mixed with all kinds of similar scrawls. These notes are vague, and the two halves of the picture, intended to actualize them, do not correspond. Everything falls apart – the general impression is one of cataclysmic flood – the weeping angels from Giotto's *Pietà* in the Arena Chapel fly over Brooklyn. The scrawls in the sky look like menacing signs. One can almost make out charging soldiers at the lower right. Strangest of all is the large inscription in twelfth-century script, *UERRAZANO NARUUES BRIGGE* with the 'Z' reversed,

82 *10,000 Year Old Cave Painting With Steeple*, 1976.

which transforms this New York diptych into a vast Romanesque miniature. Past, present and an apocalyptic future coalesce in a vision in which time seems out of joint.

When Morley showed some of his catastrophes at the Clocktower in New York in October 1976, the reviews were mixed. A few years before, his postcards had been seen as lacking formal interest and content. The new works were interesting but off-putting:

> However interesting they are to interpret, Morley's pictures are undercut by numerous flaws. The most salient are the reconditeness of so many of the pictures and their generally poor craftsmanship. The former might not be a fault on its own (meaning can emerge with time) but in company with the latter it makes the pictures tangled, reclusive, and somewhat hostile to the viewer. Morley's failure of craft consists largely, I think, in the misapplication of his crude and thick impasto to minute details whose significance is already hard to fathom. This is one more way of making the paintings defy our understanding.[36]

This type of resistance tells us more than criticism that broadcasts enthusiasm while suggesting parallels with the work of David Hockney, 'the other giant Englishman of contemporary art'.[37] As Barnett Newman used to say,

> The art critics who maligned Cézanne during his lifetime had a better understanding of the revolutionary implications of his art than his English [Herbert Read and Clive Bell] and American defenders who hailed him as the father of modern art on the grounds that he was the great proponent of the art of Poussin . . . For it was in its revolutionary differences, in its radicalism, in its 'modernism', that this art was able to lay down the basis for a continued creativeness.[38]

The continual resistance aroused by Morley's painting is due to its aggressiveness and hermeticism. Especially during that period; Morley was living in a torn-apart, estranged state, close to madness, as is testified by canvases like *The Stallion Gallops Through Ocean While Red Jeep Fishermen are Returning Home* (1976) or *The Grand Bayonet Charge of the French*

83 *The Stallion Gallops Through Ocean While Red Jeep Fishermen are Returning Home*, 1976.

Legionnaires in the Sahara (1979) (page 125). 'I am creating a vortex in the cortex,' he explained a few years later to Michael Klein, who added: 'He sought to make paintings that are, in his words, "collisions of vision and thought."'[39]

Morley couldn't stomach his own paintings during this period:

When I was making my ugly pictures, ugly from the idea of doing something for yourself that you've never seen before, I used to throw up at the end of each picture, in front of it. It was so appallingly horrible and it was so appallingly true. It took me seven years to be able to look at them. Now I think they're beautiful.[40]

The mystery of what appears to such criticism as the intolerable ugliness of his painting may spring from its intensity and novelty. Just as Baudelaire found a nauseating stench, that of hashish for example, to be the odorous excess of a perfume which otherwise might seem tolerable or even pleasant, Morley's painting became too intense for critics who, I imagine, had seen much worse. Wasn't it Walter Benjamin who said in his essay on hashish that ugliness is the true reservoir of beauty? Morley's vision is a hashishified vision; marijuana, cocaine, LSD – he consumed lots of drugs during this period, and he painted with them.

The difficulty of these paintings, as with Cézanne, has to do with the way each picture, each stroke, associates a gratuitous act of pure presence with a buried memory, individual and collective. Making paintings is a game, as was making the models Morley constructed as a child, but a game in which universal violence takes concentrated form. The episode of the HMS *Nelson*, the childhood model destroyed in the world war of unparalleled barbarity, acquires its full disorientating force here; Morley's catastrophic playfulness resides in such an inconceivable collision of scales. If Morley's painting is mad, it stems from the world's madness.

VISUAL LOGIC

One could schematize the recent evolution of American painting in terms of spontaneity and planning. Abstract Expressionism, if the words mean anything, is the art, if not of improvization, then of immediacy, of spontaneity, lacking a model or defined programme, even when it is, in Newman's words, 'contrived spontaneity'.[41] By contrast, the cool art of the '60s – Stella, Pop, Minimalism – relies on detachment: each work is the execution of a plan. With Conceptual art, the creation of an artwork loses its importance in favour of the programme to the point of almost disappearing. In various ways, the art of the '70s combines '50s spontaneity with '60s planning: Brice Marden established a geometric, or more recently calligraphic, plan only to depart from it as the work took shape; especially after 1978, Morley, as Les Levine remarks in the catalogue of the Paris retrospective, slowly, methodically reproduced the spontaneous brushwork of watercolour. One goes from programme towards spontaneity, the other from spontaneity towards programme. And back again. Two ways of acknowledging an historical field.

But even when he copies a model, Morley doesn't have the end result in mind. His plan is not pre-established; he transforms it as he realizes it. The opposite of Chuck Close, who knows the outcome in advance, but not the process ('I know exactly what my picture will look like, but I don't know how I'll do it'), Morley cannot anticipate anything: 'In a sense, I'm doing the painting in order to find out what the painting is: It's truly a means of self-discovery.'[42]

Morley feels that, ideally, a new system or code should be invented for every painting and that each work should be the result of putting the

system into practice, avoiding as much as possible preconceived notions of its outcome . . . 'I construct a score and try to follow the score. Then it's a feedback like a tonological construction.'[43]

One thinks of what the painter Félix Vallotton said of Cézanne in 1907 – '. . . for Cézanne everything is a problem, and the never-settled question is posed anew each stroke . . . Each canvas represents an effort to begin again, from scratch'[44] – or of what John Constable wrote: 'Every original picture is a separate study, and governed by laws of its own.' On 16 June 1836, Constable also said at the end of one of his lectures on landscape painting: 'Painting is a science, and should be pursued as an inquiry into the laws of nature. Why, then, may not landscape painting be considered as a branch of natural philosophy, of which paintings are but the experiments?'[45] And Morley: 'I feel I work very much like a natural scientist – except the object is painting.' In the same interview, he added: 'I think I am the reincarnation of Constable.'[46]

5 Tropics

While staying in Berlin, Morley fell seriously ill from blood poisoning caused by an injection of cortisone. He was hospitalized in Zurich, returned to the United States and in late 1977 took up residence in Tampa, Florida, where he remained for a year and a half. There he painted a large number of watercolours from life or from toys and other models.

Since roughly 1971, Morley had returned to watercolour, which had been his very first medium. In Sweden in 1972, he showed *Hawaii*, a series of five watercolours. He painted his girlfriend, a box of watercolours (*Safety* [1971] [page 108]), a California pool, a television screen (*Watergate* [1973] [page 109]), beach scenes and hats.

To speak sensibly of Morley's watercolours would require another book; I will limit myself to a few comments. Watercolour is a traditional medium of British art, perhaps the most interesting, in any case the most experimental medium of the so-called Golden Age of British painting, *c.* 1750–1850. However, despite the example of Cézanne, watercolour in the 1970s seemed incompatible with the heroic willfulness of American Modernism: 'Watercolour painting seems to be much too sissy. In the so-called modern New York scene, no one does watercolour painting.'[1] (The Kurt Badt book on Cézanne that I found in Morley's library traces the Cézannian use of watercolour back to the English school by way of Delacroix, who had learned the technique from his friend Edouard Soulier, Soulier having learned it from Copley Fielding in England: 'In water-colour painting, therefore, Cézanne may be said to have been a "grandchild pupil" of the English painters, until the time when, having formed his own artistic judgement, he radically transformed their methods.'[2])

Thus it was during his stay in Florida that Morley began to produce a large number of watercolours which would have all kinds of uses, models and techniques. As with Cézanne, they would also be experimental. On a windy beach in 1984, for example, Morley painted a kite on a metre-wide sheet of paper: the sheet itself became a kite which the painter had to steer 'with, and against the wind'[3]:

> I now had this resource – many different ways of putting material on the surface. You know, you move away from the idea of the brush. At one point, I would hold the brush still and let the paper bounce on the brush according to the wind . . . Once, with a friend, I painted from his description. He was above me in a trench looking through binoculars

84 *Macaws, Bengals, with Mullet*, 1982.

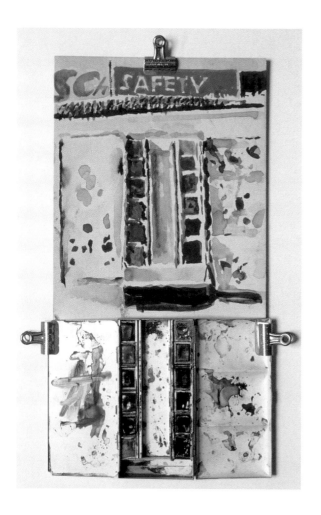

85 *Safety*, 1971.

86 *Pier*, 1950.

87 *Watergate*, 1973.

88 *Kite*, 1984.

and we were playing World War I. I'm on a grid and he'd say, 'A little lemon yellow to the right-hand side of the left-hand corner' . . . It was something I'd always wanted – to paint something without seeing it.[4]

Morley cites as an example the telephoned pictures of Moholy-Nagy, but one also thinks of the drawings that de Kooning or Twombly did with their eyes closed or in the dark. Or that phrase of Picasso: 'They ought to put out the eyes of painters as they do goldfinches in order that they can sing better.'[5]

ANIMALS

In 1978, at the Tampa Zoo, Morley began to paint a series of animal and flower watercolours – magnolias, fuchsias, hibiscus, parrots, fish, flamingos, tigers – and then, in the south of France, where he spent the summer of 1979, camels, goats and miniature hens, *poulettes naines*. Exotic as well as ordinary animals with a dose of something offbeat, whimsical or wild: 'He did them from life and calls them his "getting healthy" pictures.'[6] Later on,

89 Parrots II, 1978.

when he had moved to Long Island, a journalist from the *New York Times* described his private menagerie as follows: '. . . a small dog that looks like a cat, a large cat that looks like a dirigible, and one unexceptional cat'.[7] The first cat, Ruby, had been abandoned and rescued by Morley; the other, Tiger Eyes, was a wild stray adopted by his wife. The dog, Max, a small black Pomeranian, has since been run over by a car. The mere mention of his name makes Morley wince; he refuses to sell *Titan* (1994), in which the dog is shown asleep near a sailor's outfit.

It is interesting to consider these animals – so ordinary looking, yet more exceptional than the *Times* journalist realized – alongside those that kept Brice Marden company: Rex cats, a Shar-Pei, thoroughbred animals with an appealing oddness. Morley's relationship with animality seems much more empathetic: another sign of the child in him. Speaking of the reasons that propelled him to paint animals, he says:

> It took me a long time to figure out, but arabesque marks feel better to me than straight lines. That somehow led me to animals because they represent arabesque and movement. Of course, animals are very esthetic to begin with. You see a zebra and it looks as if the stripes have been freshly painted – those glistening stripes and that beautiful pink belly, in the sunlight.[8]

90 *Parrots*, 1979.

91 *Tigers*, 1978.

92 *The Leopard*, 1997.

These are painter's reasons, what he calls 'a plastic need'. The animals represent the arabesque, not vice versa; and the zebra's belly has a freshly painted quality, *as if* the world were made of paint. The phrase is his – '. . . it is as if, in Morley's words, "the world were made of paint."'[9] However, Morley adds: 'Also, that deep feeling you may have had with animals as a child. Everything comes to rest, and there's not even a personality problem. You kind of let go . . . I feel I can let go.'[10]

Childhood and painting are linked through this *as if*, which, as he says, gives him permission to let go. The *as if* acts as an abstract formula for the arabesque, the animal curve along which Morley glides his brush,

93 *Flamingos*, 1979.

94 *Camels*, 1979.

his hand, his body, his mind. It is the central thread that directs his wandering gaze, even his mis-takes. Abandonment, the state of semi-consciousness or of empathy that the child experiences for animals, is perhaps the key to the animal charm of these animal paintings. As with the great animal artists – cave painters, Assyrian sculptors, Tang ceramists, Pisanello, Stubbs, Rousseau, Géricault or Delacroix – Morley's representation of animals has something telepathic in it, a kind of visionary exchange. As with Géricault's horses or Delacroix' tigers, Morley's *The Leopard* (page 113) strikes me as a self-portrait, down to the asymmetry of the eyes (as a child, Morley was bitten in the face by a dog he tried to play with).

OUT DARK SPOT

Soon he was transforming some of his animal watercolours into canvases (*Parrots* [1979]), integrating them into complex compositions (*Out Dark Spot* [1978] [page 116]; *Christmas Tree* [1979] [page 120]) and associating them in a whimsical way (the triptych *Camels and Goats* [1980] [page 117]) or symbolically, as in *Macaws, Bengals, with Mullet* (1982) (page 106), in which parrots, airborne animals, tigers, terrestrial animals and saltwater fish are superimposed. The blue of the ground on which the tigers lie runs into the green of the fishes' sea. Only the parrots reproduce their model, the watercolour *Parrots III* (page 117), in a mirror-image.

Out Dark Spot combines different types of models: the flamingos were painted from a watercolour done at the Tampa Zoo; in the midst of their tropical green domain, a Russian warplane – a toy painted in an almost identical grey-green – makes a motionless nosedive on the corner of a burning white and grey street where fragments of a tank and streetlamp are seen from above. Below, a kitchen knife appears to stab a fragment of a red swastika armband; *Durban* can be read on the blade. On either side are large images of Indians with bows, obviously the same toy, but the right one was painted directly from the model while the left one was done from a pastel whose blurriness and marks Morley replicated: always the same fidelity to the model. The picture appears to be halved vertically, and the image of one of the flamingos is cut off by the airplane. This complex association suggests a symbolism that opposes the natural, primitive violence of the bow-toting Indian with a modern violence backed by destructive technology. Morley was then reading Norman O. Brown's *Life Against Death*, still one of his favourite books; Brown's ideology of the struggle of the vital

95 *Out Dark Spot*, 1978.

96 *Camels and Goats*, 1980.

97 *Parrots III*, 1978.

instinct against social repression gave direction to the large compositions Morley would paint in the following years, from *Christmas Tree* to *The Injuns are Cuming*.

One could find this message simplistic, and the allusion to the *Nelson* episode of Morley's childhood is obvious for once. But the manner in which the many sources melt together in this painting and see their figurative connotations modified renders the meaning of the whole ultimately elusive. Is the rich green where the red feet of flamingos stand aquatic or vegetal? Why are those feet painted like dripping blood? The Nazi armband, found in Berlin, is fragmented and multiplied; 'Durban' is the brand of the knife, but, since one cannot help but think of the Durban of *Race Track*, it's hard to interpret this attack of one racism by another. (One is reminded of that other enigmatic swastika of contemporary art, in Bacon's 1965 *Crucifixion*.) The fragmentation and confusion of scales, recalling movie posters of the '50s, accentuate the enigmatic character of the painting as summed up in its title: *Out Dark Spot*, a variation on the 'Out, damned spot! Out, I say!' of *Macbeth* (another example of a title whose reference is modified; the poetic 'damned' is translated into painter's language). The tropical atmosphere, underscored by the green mangoes hanging to the right above the Indian's bow, is thick and murky, like Lady Macbeth's hell. (Incidentally, one might remember that Shakespeare's play ends with the announcement of the coronation of King Malcolm, the son of the assassinated Duncan.)

THE LONELY RANGER LOST IN THE JUNGLE OF EROTIC DESIRES

Christmas Tree (The Lonely Ranger Lost in the Jungle of Erotic Desires) treats the same elements with a denser texture and at a slightly larger scale. Shortly after painting it, Morley described this picture as 'very personal. It sums up 20 years of work. It let me break away from the anxiety into the kind of reconstruction that's going on now.'[11] This initiated a turning point for the artist; it forced him to take into account painting's erotic element, which the Superrealist canvases had repressed and which the catastrophe paintings had allowed in only if modified by the nightmare that had been his life, somewhat in the manner of the Sabbath in Berlioz's *Symphonie fantastique*.

As in *Out Dark Spot*, the eroticizing of painting took a symbolic turn while still using the same models, watercolours of animals and toys. The

98 Detail of *Christmas Tree. . .* (101) in progress.

99 *Christmas Tree. . .* (101) in progress.

100 Detail (with model) of *Christmas Tree. . .* (101) in progress.

rich but undifferentiated green of that composition became a thick jungle of trees and cactuses peopled with multicoloured parrots; at the bottom, a cobra (painted from a stuffed snake) raises one head and then another; behind it, a small goods train with one wagon marked *SHELL* seems derailed in a bed of pink, barely recognizable gladioli; at the top, we see three pairs of female legs in high heels like those in the windows of discount shop, hanging above a red sun and bluish moon. The main figure, a cowboy on a horse, is a Lone Ranger toy – the black-masked avenger – and his horse, Silver; Tonto the Indian, his faithful companion, is also present. As a kid, Morley had seen the short weekly *Lone Ranger* episodes at the cinema, 30 in all, filmed in 1938–9.

The Lone Ranger toy had already been used in 1978 for a watercolour (*Untitled [Man with Sombrero on Horse]*), but the painting was copied directly from the toy. The lead hand pointing the revolver was broken off; in the painting, Morley replaced the missing gun with a symbolic stand-in, a dildo called Squirmy purchased on 42nd Street in New York City: '. . . that was the name of it on the box . . .'[12] The toys and pairs of legs, the sun and crescent moon, especially the horse and train, were painted with contours like cut-outs in a manner that Morley would use frequently during the 1990s (a photo in which the gladioli can be seen laid on a board in front of the picture shows that the train was first outlined on the canvas), while the background, and the parrots copied from watercolours, were painted with more fluid strokes. To this collage of different elements Morley added a

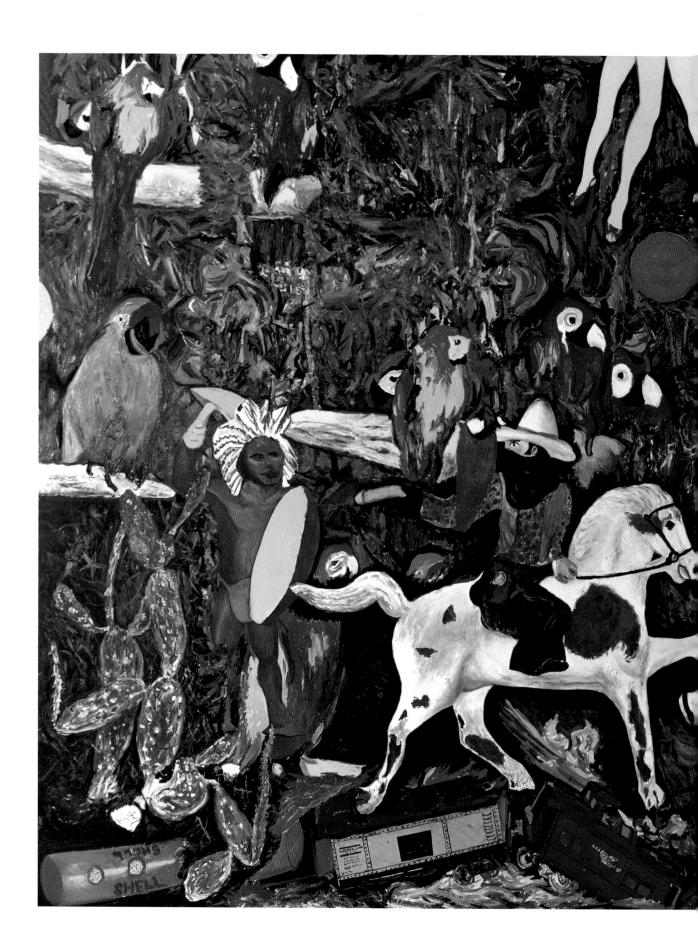

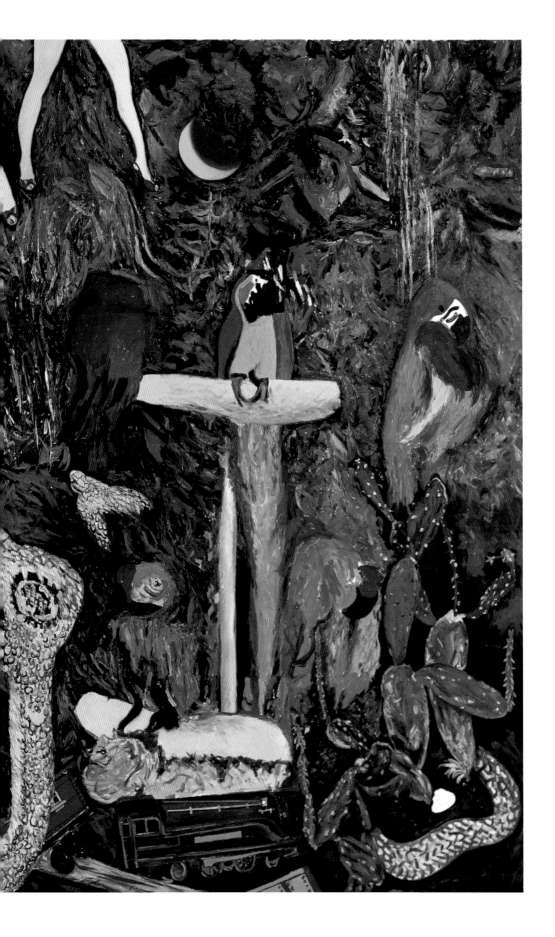

101 *Christmas Tree (The Lonely Ranger Lost in the Jungle of Erotic Desires)*, 1979.

collage of pictorial textures. *Underneath the Lemon Tree* (1981) accentuated this heterogeneous combination of styles and textures. It was a way of folding back onto the rectangle of the canvas the multifarious, torn-up forms of *Miami Postcard Fold Out*: 'He has returned to compact rectangularity, but preserved the ecstatic discontinuities internally as scale-changes and spatial jumps.'[13]

Having transformed (through an obvious identification) the Lone Ranger into a Lonely Ranger charged with erotic fantasies, Morley adopted as a second title a remark made by the model who held the dildo: 'It looks like a Christmas tree.' Which it does, though the green background evokes tropical vegetation rather than an Alpine fir. This impression rests largely on the combination of disparate elements and scales, the greenery, toys and parrots symmetrically framed by inverted images of the same cactus. Was Morley perhaps recreating a past for himself, one he might not have had, in the same way that Picasso claimed he had painted a bullfight in exchange for an entrance ticket: 'A guitar! Do you know that when I painted my first guitars I had never had one in my hands? With the first money they gave me I bought one, and after that I never painted another.'[14] Such paintings have the magical, ghostly, one might say

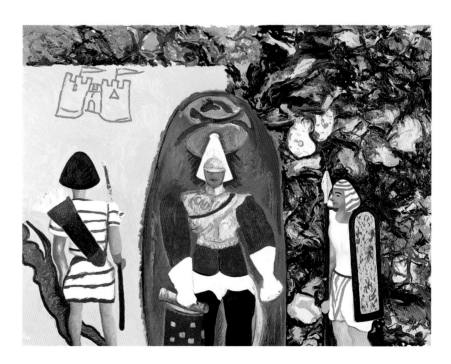

102 *Underneath the Lemon Tree*, 1981.

Orphic, charm of everything that evokes an absent, vanished, longed-for world, or a world that never existed, to which the power (but also the powerlessness) of art gives some kind of existence.

SENSATION WITHOUT MEMORY?

During this period, Morley was fascinated by toys, especially the lead toys he had known as a child, collecting them and reproducing their style on a monumental scale. Today, in a glass case, he preserves a collection of toys and paper models that have served or could serve as models: unfortunately, the Lone Ranger, Tonto and the French Legionnaire are missing. In sum, an impressive collection of figurines and miniature models of trains, boats and planes. The style of the lead figurines – Indians, cowboys, soldiers, soccer players, animals and so on – is very specific and so astonishingly close to Morley's style that one wonders for a moment if in fact he has a style. Yes, if the word *style* means something (though he himself objects to 'that silly word called style');[15] he does have one, but it's the same as the toys'. He picks them because they have his style, though this style is no doubt the trace left in him by his own childhood toys. Didn't Baudelaire write that '. . . the toy is the child's earliest initiation to art'? One of Tatransky's numerous articles cites precisely this passage.[16] (Morley tells me he identified with Baudelaire's 'solitary child who controls and leads into battle two armies all by himself'.)[17]

The toys also have mnemonic, plastic and anthropological powers. 'They make it possible to set up panoramas on a small scale,' Morley says, explaining his interest in them, but he also recalls their symbolic value: 'All toys are icons to begin with.'[18] 'Toys are to teach boys how to be aggressive, and girls how to be mothers.'[19]

> I don't call them toys, I like to call them models. The thing about so-called 'toys' is that there is an unconsciousness in society that comes out in its toys. Toys represent an archetype of the human figure. So I can have more as-such-ness of a French Legionnaire from this figure than by getting a model and dressing him up. I discover that there is actually an archetypal activity going on in these figures, because it is the underbelly of society of which it is not aware. So it is unguarded. These things are more than toys. The other factor is their scale in relation to you. Your perception of yourself in relation to these figures is that you are giant, like a God with an omnipotent view.[20]

And Morley gives the example of *The Grand Bayonet Charge of the French Legionnaires in the Sahara*, for which a single figurine was moved up and down, to the right and to the left, and painted repeatedly:

> I painted it by holding it between my eyes and the canvas. In a way, this is a variation on the flat plane. For me it was to have something to look at while painting. You don't have to change your gaze. It is all in one thought. One of the things I don't want to do is to paint from memory, because memory is not sensation. This was very true for Cézanne. Ideally, I want to look at it with one eye, while painting it with the other – without stopping. How close can I get the model to the painting? With photographs, I used to cut them up into pieces, and I put each one beside every square in a grid which I was painting. I painted like playing music.[21]

The idea of bringing the model closer to its painted reproduction thus motivated Morley to cut up the gridded photos serving as his models and to fix each square on the canvas just above the area he was painting. He no longer knows when he started doing this, thus replacing the masking of the model in his paintings from the '60s, but towards the end of the Superrealist period, Nicolas and Elena Calas described Morley's procedure as follows:

> His next step consists of cutting one strip of grid from his model, having, as often as not, inverted it or turned it sideways so as not to be detracted by the subject. With the aid of a magnifying glass, he reproduces by hand the model square by square in Liquitex colors.[22]

Moreover, Norman Dolph, who visited Morley during the *Race Track* period, assured me that Morley did cut the image into pieces which he attached next to the area he was painting.

Morley's comments just cited suggest a few observations. First, can one really say that for Cézanne memory was not sensation? Or, as he says elsewhere, that 'memory has nothing to do with sensation'?[23] Cézannian sensation was drenched in memories, and, in spite of all he says, Morley is just the same, another *passéiste*; when he paints, '. . . everything is in the now' (and in this regard his grid is equivalent to Cézanne's brush stroke), but this present moment is pregnant with the memory of an entire life, especially his early years. (When I say this to him, he answers: [I] that perhaps memory is like death – though we may want to fight it, it always

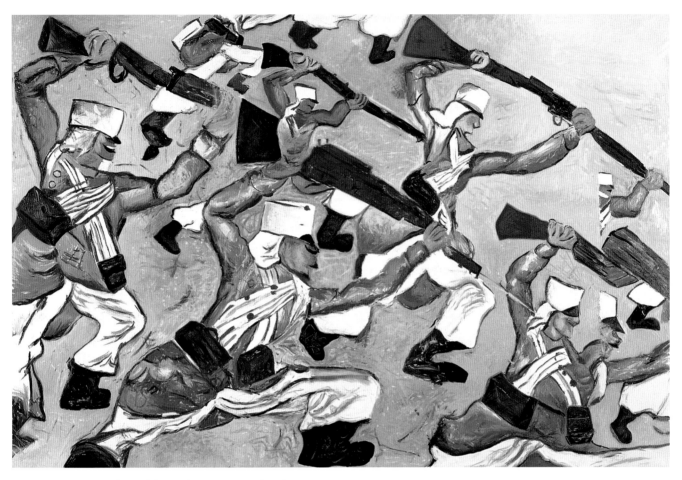

103 *The Grand Bayonet Charge of the French Legionnaires in the Sahara*, 1979.

104 Detail of *Grand Bayonet Charge*...
(103) in progress.

105 *French Legionnaires' Bayonet Charge*, 1977.

wins; and [2] that the memory he's talking about is that of his motifs. An obvious point – and the indispensable presence of these models suffices to disqualify him as an Expressionist or Neo-Expressionist.)

As for *The Grand Bayonet Charge of the French Legionnaires in the Sahara*, this picture was not done directly from a toy model, but rather from one of the many studies of it. The 1977 watercolour *French Legionnaires' Bayonet Charge* reproduces the Legionnaire six or seven times in the manner of wallpaper, always in the same position but at different heights and scales. The painting was done from this watercolour which Morley had copied faithfully except for one thing: since the painting was wider, the painter transferred a strip of the central area onto the right side, lowering it a bit in such a way that the blue sleeve holding the bayonet appears fitted into another bayonet: 'I had space left on the canvas and I had no space left from the watercolour that I was painting it from and so I repeated it, another section, and I call that plastic drift . . . For example, Burroughs cuts up paragraphs and rearranges them, and another sense may occur,' said Morley two years after painting the picture.[24] Seven years on, his memory has slipped.

This transfer of Legionnaires, more violent than the one observed in *Day of the Locust*, arouses contradictory sentiments: one has the impression that a sheet of wallpaper was hung there by mistake, but this mistake gives the impression of a serious disturbance in the artist's head. On the other hand, the latter almost appears to play with his own madness. (An

inventory of the Nancy Hoffman Gallery, with which he was under contract during this period, notes a small canvas, 50 × 61 cm, dated 1979 and entitled *Gone Bananas*. I haven't been able to track it down.)

VOYAGES

From 1978 on, Morley used more and more of his own drawings and watercolours as models for his new oil paintings. They therefore fulfilled the same function as the postcards and posters of the late '60s: 'I've become my own camera.'[25] And as he did with printed photographs, he squared the watercolours off, either by using a copy which he cut and fixed on the canvas or by placing a grid in front of the model, with the area around the section to be painted masked in order to concentrate the gaze; only once did he have the nerve to cut the watercolour itself into pieces.

This new practice produced a stylistic change: for the first time, Morley copied his own 'hand' in a curving, spontaneous, sensual, pseudo-childlike manner, thus accentuating the erotic element he was seeking in his painting at the time. His style took on a cartoon-like character, which, associated with his rather saturated colours and charged textures, led some to describe his work as Neo-Expressionism; he welcomed this new label as unenthusiastically as he had that of Photo-Realism: 'If I had known that I was going to invent horrors like Julian Schnabel, David Salle and those people, I would have cut off my hands. You see, the superrealist thing never went that far.'[26]

> Once, I said in an interview that if I inspired that work, I wished I had cut off my hands. I felt pretty bad about that, but when I spoke about it with my shrink, he said it was okay. It was better than saying I wished I had cut off their hands.'[27]

This labelling did however give Morley the advantage of being brought back into the limelight after seven lean years of banishment from the art world.

There is much to say about Morley's critical reception (which I'll return to later) and about how he has managed his successes and failures. One day, I saw him leave my bathroom in tears; he had just read something Picasso had said to Brassaï (but also to himself):

The majority judges a work of art in relation to its success. So why leave success to 'successful painters'? Each generation has them. But

where is it written that success must always go to those who flatter the public taste? For myself, I wanted to prove that success can be obtained without compromise, even in opposition to all of the prevailing doctrines. Do you want me to tell you something? It is the success of my youth that has become my protective wall. The blue period, the rose period – they were the screens that sheltered me . . .[28]

Success gave Morley the itch to travel. He spent the summer of 1979 in Saint-Jean-Cap-Ferrat on the Riviera; in 1980, he returned to England and travelled in Scotland; in 1981, he visited Arizona and, the following year, Greece and Crete. After 1983, he travelled extensively: to the West Indies and then on to Egypt, Kenya, back to Greece (1985), the Bahamas, Spain, India (1986), Costa Rica (1988), Jamaica (1990), the Canary Islands (1992 and 1998), the Azores (1994) and, more recently, South Africa (1997) and Cuba (1999). On these trips, he accumulated drawings and watercolours which would serve later on as the basis for compositions on canvas. Since the 1960s, Morley's work had involved a visual metonymy: different means of transport – boats, planes, trains – have been transferred thematically to the parts of the world they permitted the artist to reach. The world, at least the world to be painted, had become an exotic place for a him, tropical: 'Oil painting is essentially a tropical art form.'[29] 'Tropic' means 'turning', the sun turning at the solstice. Florida was definitely the starting point.

Morley's 1980 trip to Great Britain, which he hadn't seen in over twenty years, was like a return to Constable and the English landscape painters. He painted a series of watercolours which he transformed upon his return to New York into pastoral scenes with an undertone of panic: *Landscape with Horse, Landscape with Bullocks, Till the Cows Come Home* (painted with his fingers) and *Indian Winter*. England was a springboard for rediscovering the world.

In the summer of 1981, after England's cool humidity, Morley visited the hot, dry state of Arizona (for Morley, 'Arizona' means 'arid zone'). He painted watercolour landscapes – *San Francisco Peak, Sunset Crater* – and bought two kachina dolls, probably in a tourist shop, that he would use for many years. Starting from two watercolours (page 131), he painted *Arizonac* (page 130) – apparently the Indian root of the name Arizona (the *Encyclopædia Britannica* states that it derives 'from two Papago Indian words meaning "place of the young spring"', but the *World Book Encyclopedia* states that '. . . no one is sure what it means'); when I show him the results of my

106 *Till the Cows Come Home*, 1981.

107 *Landscape with Bullocks*, 1981.

108 *Arizonac*, 1981.

research, he says with a false air of surprise, 'I thought I had made it up!'

Arizonac shows two kachinas advancing over a reddish landscape; their scale is menacing, blown out of all proportion by the minuscule cowboy on a horse in the foreground. More so than in *Christmas Tree*, there is a strong contrast between the smeared brushstrokes of the landscape and the sharp, volumetric style of the figures. This contrast, associated with the reddish harmony of the whole, creates a hallucinatory effect recalling late Malevich, an increasingly apparent influence (clearly visible in the red crosses of *M.A.S.H.* [1978] and something Morley likes to evoke in interviews).[30] This effect can also be seen in an intensified way in *Still-Life with Mangoes* (page 132), a watercolour from 1979. The precision of the drawing, the modelling and the texture of the fruits is contradicted by the ultra-Cézannian break along the edge of the napkin produced as the viewer's eye shifts before the grid. The effect is very much that of an intense hallucinatory presence.

109 *Untitled (Study for Arizonac)*, 1981.

110 *Arizonac*, 1981.

111 *Still-Life with Mangoes*, 1979.

The kachinas reappeared in two watercolours (page 143) which provided the basis for two large compositions, *The Injuns are Cuming, The Officer of the Imperial Guard is Fleeing* (1983) (page 141) and *Night on Bald Mountain* (1987) (page 143); this was during Morley's Greek years. Their themes suggest a link between Morley's interests and those of the art historian Aby Warburg, with whose work he was not familiar, however. Both men were intrigued by the eruption of Dionysian forces in Western culture, a motif that recurred in Morley's work beginning with *School of Athens* and that took on greater clarity in 1980 when he imagined painting historical themes.[31]

CRADLE OF CIVILIZATION

A trip to Greece became imperative. 'It was like my PhD,' says the painter, symbolically representing this encounter in his painting *Alexander Greeting A.B. Seaman Ulysses M.A. Evans, Jr., at the Foot of the Colossus of Peanigh*. Greece to him was Classical Greece, which he associated with Picasso:

> I was looking at Picasso a lot, and I thought this was my opportunity
> to see how Greek culture would affect my pictures. I started by using
> classical iconography to construct a personal drama, but then all

Greek mythology is personal drama – that's the beauty of it. What I am looking for all the time is painterly inspiration. I am looking for a world that is made of paint; then I'll paint it.[32]

This is Morley's constant motto. He had used it before in a discussion with Michael Klein:

In his paintings of the past five or so years, images have been piled one atop the other. The surfaces look as if they had been put under such intense pressure and heat that they almost seem to be melting . . . In these newer works it is as if, in Morley's words, 'the world were made of paint.'[33]

Once again, one recalls the aging Cézanne, overcome by sickness and heat, writing to his son on 3 August 1906: 'I get up early and only between 5 and 8 can I live my normal life. By that time the heat becomes stupefying and exerts such a strong cerebral depression that I can't even think in paint.'[34]

Seeing in paint, thinking in paint, is what connects them:

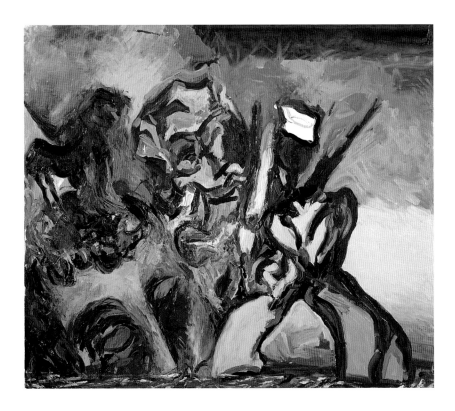

112 *Alexander Greeting A. B. Seaman Ulysses M. A. Evans, Jr., at the Foot of the Colossus of Peanigh*, 1982.

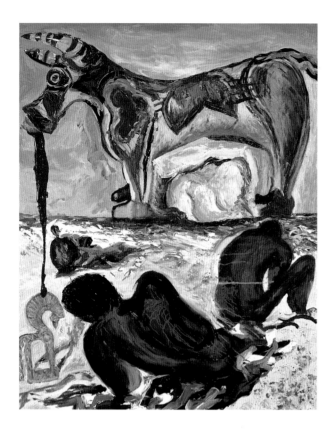

113 *The Palms of Vai*, 1982.

> I feel that I'm really a metaphysical philosopher expressing it in a
> visual sense, because philosophy itself has no means of expression, no
> intrinsic form. You've got to decide on the form to express it: writing,
> music, whatever . . . So in a sense what I am doing is a form of natural
> philosophy.[35]

The summer of 1982 in Greece and Crete became the time and place for
an intense burst of activity. Morley stocked up on drawings and water-
colours for compositions that would unfold over the next six years, from
The Palms of Vai to *Black Rainbow Over Oedipus at Thebes* (page 153). The
first two of these, *The Palms of Vai* and *Cradle of Civilization with American
Woman*, combine beach scenes with ancient statues – a bull, a horse and
human fragments – to which is added, in *Cradle of Civilization*, a large
female nude whose wild abandon is laid over the foreground, though
behind a broken statue, a collage of a head and a headless body. A giant
black horse straddled by an empty Greek helmet strides in the water,
where an ancient galley drifts. The entire scene, except for the left side,
reappears in *Farewell to Crete* (page 136) – a huge collage of *The Palms of
Vai, Cradle of Civilization* and the watercolour of the phallic statue – in
other words, a collage of collages:

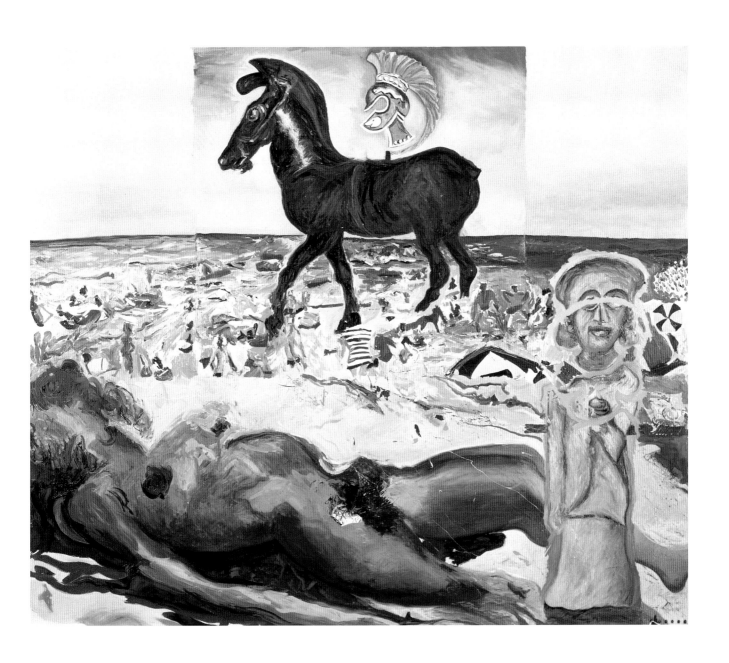

114 *Cradle of Civilization with American Woman*, 1982.

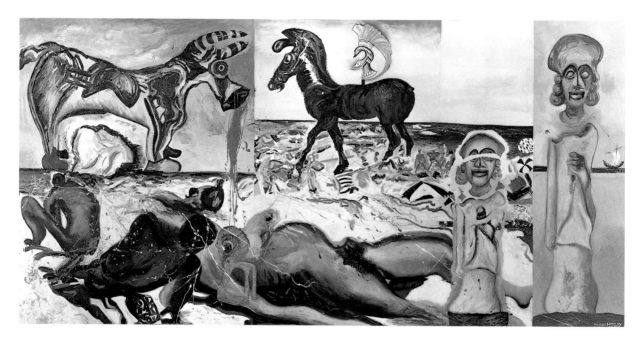

115 *Farewell to Crete*, 1984.

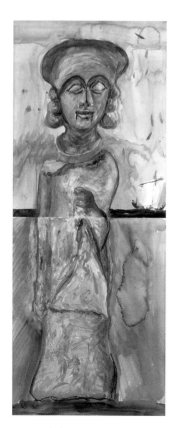

116 *Untitled (Statue)*, 1982.

. . . it's a horse that we've all seen in those art books. It looks very big in reproductions, but I saw it for the first time and it's actually very small. It was one of four horses drawing a chariot that a despot had given to the Olympic games. The legs are broken, so to deal with that I put it in water . . . there are various scales within the picture. The horse is an icon in our unconscious. I am a great believer in the unconscious: something not known that becomes known. The horse becomes Pegasus. There is a helmet on top, as though it is the rider of the horse. That helmet was made in Bermuda. It's from a British Navy museum; the battleships and destroyers have names like Ajax and Achilles, and in the officers' boardroom there is a shield – Ajax's or Achilles'. I made a watercolour of Ajax, and I'd had it for years. It looked rather corny. But when I put it on top of the horse it worked in a wonderful way . . . There is also a Minoan ceramic bull-shaped vessel. It was used originally with blood, then with wine, then with cadmium red; from my point of view it was cadmium red in the first instance, and the iconographic meaning comes later . . . and the background was a pure watercolour that I made on the beach in modern Crete . . . All these things get woven into my oil paintings one way or another.[36]

The logic behind this complex collage is such that it becomes necessary to show the parts: one sees that it's glued, even the sky and the sea; cracks appear everywhere – Minoan and modern Crete erupt in myriad attempts at continuity. A new mistake in the montage perfects the disaster. The

painter traced the top of the statue in blue, representing the sky or the sea, and realized that he had traced it one grid strip too low, exactly where the eyes should have been. He retained this error and, to even it out, added a break over the chest, cutting the phallic hand in two. The turquoise paint looks like the glue of the collage: it can only fix the pieces in place, masking the statue's eyes. As if civilization were obliged to blind itself to its own decomposition.

A similar atmosphere of danger hangs over *Day Fishing at Heraklion* (page 138), whose title is an homage to Picasso's *Night Fishing at Antibes*. The picture was based on two watercolours, one of the same motif done in Crete and one of fish done in Florida. (The fish resurface in *Macaws, Bengals, with Mullet* [1982] and *Aegean Crime* [1987] [page 150] and make an appearance in *Albatross* [1985]; their scale is so enlarged that one has the impression, the painter observes, that they are going to swallow the boat.)[37] The fish resemble grotesque monsters with protruding eyes. Painterly energy is made incandescent; the variety of inventiveness leaves one flabbergasted. In Morley's paintings of this period, all tones are intensified by micro-contrasts, somewhat like the Fauve Mondrian of *Mill in the Sun* (1908). Together with *The Injuns Are Cuming*, the other great painting of 1983, *Day Fishing at Heraklion* (page 139) initiated one of Morley's most intense periods, characterized by a display of naked, almost provocative painterliness.

117 *Untitled (American Woman)*, 1982.

118 *Untitled (Horse)*, 1982.

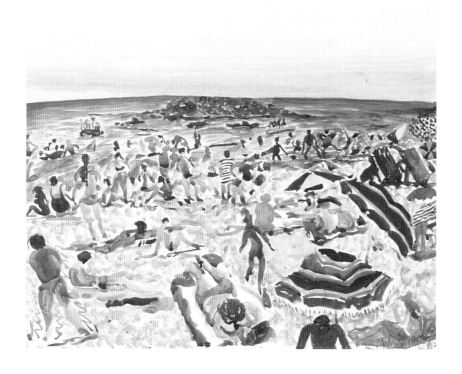

119 *Beach #3*, 1982.

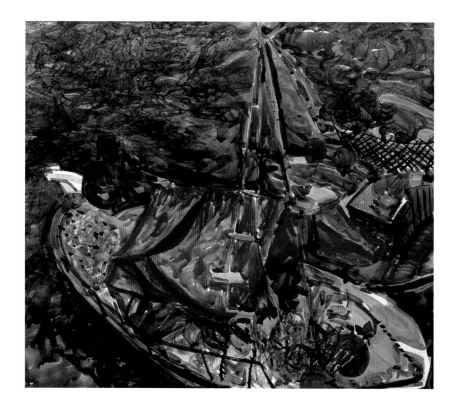

120 *Day Fishing at Heraklion*, 1982.

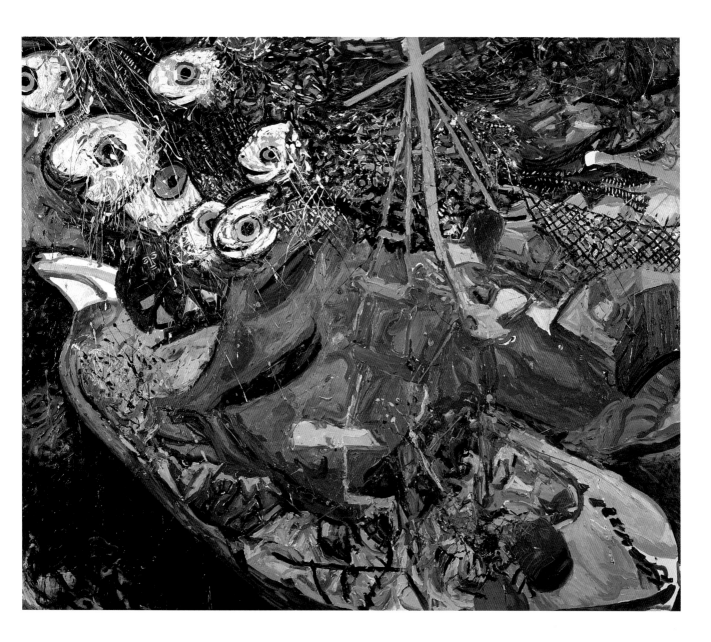

121 *Day Fishing at Heraklion*, 1983.

122 *Géricault II*, 1978.

123 *Géricault III*, 1978.

124 Théodore Géricault, *Officer of the Chasseurs of the Imperial Guard Charging*, 1812.

During the 1980s, Morley worked simultaneously from Greek, Cretan and Native American motifs; in both cases, he used small, more or less authentic sculptures at menacing scales. I see these works as counterparts to the Indian or Cretan mythologies (*Pasiphae, Male and Female*, etc.) that Pollock painted around 1943 in figurative kitsch versions, betraying the kitsch already inherent in Abstract Expressionist mythographies and their Jungian ideology. The inlay-like construction of *Farewell to Crete* recalls that of *Guardians of the Secret*. (There is much to be said about underground links between Morley and Pollock. The title of Morley's 1993/4 canvas *Guardian of the Deep* [page 206] resembles an homage to Pollock, a collage of two of his titles, *Guardians of the Secret* [1943] and *The Deep* [1953]. But this collage is unconscious, he assures me – unlike *Fathoms 04*. He has recently started to make a painting of Pollock's floor, though not without a certain reluctance, which he has had to overcome with the help of friends.)

Parallel to the Greek compositions, Morley began two large Indian paintings, once again using the two kachina dolls: *The Injuns Are Cuming, The Officer of the Imperial Guard is Fleeing* (1983) and *Night on Bald Mountain* (1987). Both combine kachinas, not with Creto-Grecian motifs (he worked such a combination into *Cradles of Civilization* [1984], a colour aquatint from a group of six etchings entitled *The Fallacies of Enoch*) but with nineteenth-century European military figures. Two tiny Cretan figures do appear in the lower right-hand corner of *The Injuns Are Cuming*, but they are barely recognizable and seem to be there merely to lend a sense of scale to the scene.

The Injuns Are Cuming offers one of the most astonishing thematic transformations to be found in Morley's work. In 1977, he bought a 3-D reproduction of Géricault's 1812 *Officer of the Chasseurs of the Imperial Guard Charging* in a New York shop. Besides the copy's beauty, what attracted Morley's curiosity was being able to see the hidden face of the moon: the great chasseur's invisible backside. He drew the figure several times, rotating it, in *Géricault I* and *Géricault III* presenting it in stronger profile than Géricault himself had done, in *Géricault II* approaching the painting's point of view. In 1979, he integrated a clearly recognizable fragment of the equestrian figure into *Day of the Locust III*, a painted variation of *Day of the Locust*. This interest is all the more remarkable in

125 *The Injuns are Cuming, The Officer of the Imperial Guard is Fleeing*, 1983.

126 *Day of the Locust III*, 1979.

that Morley was unaware that Géricault, according to those who knew him, worked in a similar way, bit by bit, without worrying about the whole and without returning to the parts already painted, producing effects of discontinuity rejected by his contemporaries, including Delacroix.

In the large composition *The Injuns Are Cuming, The Officer of the Imperial Guard is Fleeing*, the two kachinas look like disheveled giants approaching with menacing intent; the paint, in opposition to *Arizonac*, has an unbridled appearance: a fury of vivid colours and globs of white paint which one can read as the equivalent of the sexual discharge evoked in the title. The symbolism remains the same – the opposition of primitive humanity's vital forces to the repressive forces of the West (even the Imperial Guard's sabre has gone soft: 'fleeing away from libido', the artist calls it). One must look closely to recognize Géricault's officer: his dappled grey horse has turned brown, and his riding outfit appears in primary colours, the dolman blue, the knickers red and the saddle yellow. By pivoting horse and rider 80 degrees, Morley achieved a metamorphosis, transforming the chasseur's charge into a punishing rout.

Four years later, Morley painted another, even larger composition (198 × 331.5 as opposed to 203 × 280 cm), *Night on Bald Mountain*, from a 1983 watercolour. In a nocturnal landscape, two drum-beating High-landers confront a rifleman seen before in multiplied form at the bottom of *Day of the Locust*. The kachinas have become gigantic spectral presences floating over the mountainous landscape like Goya's colossi. The title comes from a piece of music Morley had heard in prison.

In the watercolour, the kachinas and the blue sky just above the mountain are scratched with a razor blade, allowing the white paper to reappear and signal the dawn that, as with Mussorgsky, might perhaps break the spell. In the painting, long brush strokes laden with white paint simulate these scratchings. Such methods appear in almost every work Morley made from watercolours, as well as the stormy beach scenes of 1986–8, *Seastroke* (page 144), *Gale Warning*, *Lifeguard*. At the same time, Morley imitated the non-mimetic elements of his model by translating them into the language of oil paint: 'I pick up all the splashing and spontaneity of the washes into opaque, structured oil paint. There is another illusion – the illusion of splashiness – because I am painting tonally[,] it looks transparent, although it is opaque.'[38] 'Colour is tonally realised, yet the illusion for transparency is due to the fact that I am literally painting a watercolour as if it were a two-dimensional still-life.'[39] But when someone suggested that

127 *Night on Bald Mountain*, 1987.

128 *Kachinas*, 1982.

129 *Night on Bald Mountain (Kachina and Drummers)*, 1983.

130 *Seastroke*, 1986.

he was trying to reproduce the effect of watercolours in his oil paintings, he replied: 'I don't think about it as "reproduce", that gives me the willies for some reason. I'd rather think of it as an invention.'[40]

'INTENSELY BAD, FAILED NIGHTMARES'

The 1980s were a time when the artist's ambition and desire for recognition appeared to be rewarded. For the first time, he explained himself, granting numerous interviews which he had been rather stingy about before – though he claims no-one had asked him until then. The one he had with Klaus Kertess, published in *Artforum* in June 1980, constitutes a veritable poetics. In 1985, the BBC did a documentary about him. He showed in prestigious galleries: at Xavier Fourcade in 1981, 1982, 1984 and 1986, at Pace Gallery in 1988 and 1991, and at Anthony d'Offay in

London in 1990. In 1983–4, the retrospective organized by Nicholas Serota, then Director of the Whitechapel Art Gallery in London, travelled to Basel, Rotterdam, London, Washington, Chicago and New York. When it was shown at the Brooklyn Museum, Gary Indiana declared Morley to be 'the best'.[41] In 1984, he was the first beneficiary of the Turner Prize: 'The award is for the person who, in the opinion of the Jury, "has made the greatest contribution to art in Britain in the previous twelve months."' This award provoked bitter reactions in London:

> Mr Malcolm Morley . . . is an artist who has not lived or worked in this country for twenty years [26 in fact]. Why then should such a prestigious award, made in the name of British art, go to a man who is better known in his adoptive land, America? Would it not have been better to award the first Turner Prize to a person who has done something noticeable for contemporary art here in Britain?
>
> Would it not also have been better for the committee to have chosen an artist whose work is more easily understandable and accessible to the general public than that of Mr Morley? The Tate, after all, has no work by Morley in its permanent collection.
>
> I hope, Sir, for a better result next year.
>
> Yours faithfully,
> P[atrick] BOYD-CARPENTER,
> Director,
> The Church Gallery,
> 34 Bryanston Street, W1.
> November 9.[42]

> . . . in 1984, the first Turner Prize organized under the [Tate] Gallery's auspices, and intended to honour the individual who, in the opinion of the jury, had made the greatest contribution to art in Britain in the previous twelve months – was awarded to Malcolm Morley: an ex-convict, and sometime photo-realist, turned new expressionist, who possessed no visible ability, let alone talent. Morley had not lived in Britain for a quarter of a century; and, during that time, had held only one one-man show here. His latest pictures were incoherent and overblown canvases based on his masturbatory fantasies – and yet the Saatchis acquired fourteen of these execrable works for their collection, which, in 1985, was put on view to the public in a converted cinema in St John's Wood. [43]

131 *Michael's Cathedral*, 1988.

This moment of international recognition, spiced with controversy, could have been one of personal gratification. Yet everything happened as if the painter was sensing the utmost danger. Instead of enjoying his dearly reacquired fame, Morley began to test it, forcing the enigmatic, aggressive and resistant side of his work. It unleashed itself like a raging sea, especially in the variations on the neo-Gothic towers of Barcelona Cathedral (*Barcelona Cathedral as a Blood Red Orange*; *Michael's Cathedral*). The beach scenes grew stormy: Morley invented for one of them, a painterly delight, the word *seastroke*. The second version of *The Sky Above, The Mud Below* (1988) (page 149) is larger, muddier, stranger than the first (1984) (page 148); the mare with her colt evokes a cave painting. In 1984, *Farewell to Crete* is a *faux adieu*, like those of opera singers; his largest classical compositions – *Aegean Crime* and *Black Rainbow Over Oedipus at Thebes* – were still to come.

The critics' reception of these pictures was not exactly favourable. When Morley had his first exhibition at the Pace Gallery in 1988–9, his impenetrability was deplored once again; no sensual enjoyment seemed capable of salvaging it, and his intensity had a desperately ugly look:

> Some paintings here are intensely and unbearably bad, particularly the ragged Barcelona-cathedral series . . . Morley's meandering is not supported by clear intentions or clear gesture . . . Some pictures are so

132 *Barcelona Cathedral as a Blood Red Orange*, 1986–7.

134 *The Sky Above, The Mud Below*, 1988.

133 *The Sky Above, The Mud Below*, 1984.

out of control that it is almost embarrassing to admit that one or two are quite good . . . But just when you begin to imagine he's back on top, he breaks into serious schmaltz, as in the case of a blue horde of Legionnaires being swallowed by a yellow hailstorm that resolves itself into a lion – a failed nightmare and also, perhaps, a desperate attempt to rescue a failing painting.[44]

There's something oddly oblique about Malcolm Morley's art – it projects a certain inscrutability . . . a reckless inconsistency of form and content makes a unifying thread of intention nearly indiscernible . . . There's little painterly beauty in Morley's work – it's too raw, funky and 'bad' for that. (*Barcelona Cathedral as a Blood Red Orange* starts to look like a LeRoy Nieman.) . . . Finally, though he is never an uninteresting artist, one wishes Morley would make more inherently meaningful – more psychologically engaging – images . . .[45]

A more warmly disposed critic, while acknowledging the artist's work and technical knowledge, accepted his blood-red-orange cathedral but rejected his obscure, sanguinary mythologies:

The paintings, for all their look of spontaneity, are carefully considered productions . . . There is a queasy, vertiginous sense to the pictures, a palpable anxiety. They function best when they mask and deny it, when they affect an insouciance and lightness that is against their nature . . . This is the stuff of myth. It's powerful, familiar and unsettling: just what myths should be. Unfortunately, when Morley decides to go at the subject directly, the results are not so convincing. Paintings like *Black Rainbow Over Oedipus at Thebes* or *Aegean Crime* seem to be overladen and ponderous, stretching for significance.[46]

When I first saw it, though, during the Paris retrospective in 1993, *Aegean Crime* struck me as one of Morley's masterpieces, definitely one of the masterpieces of the 1980s. This composition, one of the widest he has painted (195 × 398 cm; like Henri Rousseau, he feels more at ease the larger the painting surface is), constitutes a summit of his art, for it marks one of the times he achieved a purely abstract intensity by means of figurative imagery. While *Albatross* (1985), another Cretan composition associated with a kite, doesn't quite manage to rise above patchwork, *Aegean Crime* is instantaneously unified by a terrifying chromatic energy. The violence here is extreme, but extremely contained in the paint, in its

135 *Aegean Crime*, 1987.

136 *Aegean Crime*, 1986.

intense colour, texture and movement – the green-yellow-orange zone below the small boat, the dissonant accords of three blues or three yellows. Working from two colour aquatints done in 1986, *Trojan Cavalcade* and *Aegean Crime*, this image gathers together a sailboat, ancient fragments, the fishermen's boat at Heraklion with their giant mullets and a Romanesque Christ without arms or feet. Though there is nothing here that indicates a crime per se, the atmosphere is thoroughly poisoned. Under the influence of Warhol, the eyes of the Cretan head in *Cradle of Civilization* have turned fluorescent green and its mouth blood-red. Peter Krashes pointed out to me that the left side, compared to its aquatint model, is compressed horizontally, a bit like a film in CinemaScope that goes through a projector without a widening lens. This effect of compression is not immediately visible, but it adds to the density of the whole. It is obtained by modifying the proportions of the grid in this area, which become nearly square instead of rectangular.

137 *Trojan Cavalcade*, 1986.

David Sylvester has told how, seeking to understand this painting, he tried to interpret the figurative elements: the heads became those of Clytaemnestra and Agamemnon, the boats Agamemnon's fleet, Christ a sacrificial symbol:

> It was all as obvious and inevitable as the solution of a crossword clue once it is found. When I next saw Morley, I congratulated him on his portrayal of Agamemnon and Clytaemnestra. Politely he told me that he could not remember having heard of them. Three cheers for the collective unconscious.[47]

Morley politely does not recall (it's probably true), but I seem to hear him silently saying that, if his painting is indeed a mirror, it is not a crossword clue. To interpret it in this way, by naming the figures, absorbs its violence, setting it within an accommodating historical landscape. But no. The violence is contained in the paint, and in the puzzle of its message. What must have seemed unbearable at the time was that this violence, which previously had been unleashed, was now leashing and unleashing itself simultaneously. 'I translate violence into another realm, which really has to do with the process of painting itself,' he told the dealer who exhibited *Aegean Crime* and *Black Rainbow*.[48] Already in 1982, having briefly described his trajectory, Morley explained:

> Now I'm doing these visionary pictures – Blake – that sort of feeling. It's a process of self-discovery. It used to be that each of my pictures

138 *Oedipus at Thebes*, 1982.

139 *Rainbow Over Mount Kenya*, 1986.

was some realization of a state of anxiety. In the new works, the anxiety
is far more controlled and weighted, put into something more solid
than having to be expressed in a fleeting 'can't wait' way.[49]

As Richard Kalina has noted, it is present nonetheless.

Black Rainbow Over Oedipus at Thebes is Morley's real farewell to Crete
and Greece; it sums up his work of the 1980s just as *The Lonely Ranger*
summed up the previous decade's. Its origin goes back to his 1982 trip, when
he drew a scene from *Oedipus Rex* during a performance (in Greek) at the
amphitheatre of Epidaurus; in 1988, he made a large colour print (lithograph
and silkscreen) by combining this drawing with a 1986 watercolour, *Rainbow
Over Mount Kenya*, done from a smaller watercolour painted in Kenya which
did not have a rainbow. Under the influence of Constable, one was added to
the large watercolour: six watercolour arcs arranged in order from red to
violet. Moreover, a watercolour of a beach, *Alex's Boat with Ingo and Daniel*
(1988), depicting a sailboat at Bellport and two bathers, was worked into two
other watercolours, *Rite of Passage* (page 154) and *Rite of Passage with Comple-
mentaries and Tertiaries, Tondo*. From this last watercolour, Morley later made
a print and a tondo in oil. It was with *Rite of Passage* (the rectangular version,
gridded and visible next to the work in progress) that the lithograph, of which
there are three states in eleven, five and four colours, was combined. One
can see in it, as in the drawing faithfully reproduced, a procession of five
or six figures, with Oedipus no doubt in the foreground, amongst vague
architectural forms. To this was added the rainbow and the Greek title, both
in colour in the eleven-colour state. In the print, one can also distinguish
delicate brown arcs traced with a compass.

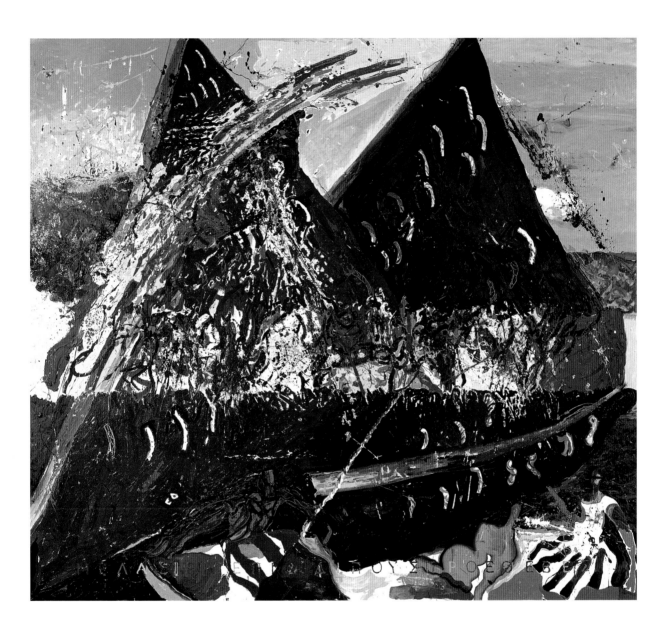

140 *Black Rainbow Over Oedipus at Thebes*, 1988.

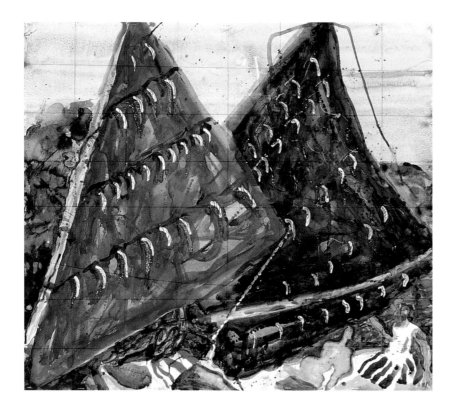

141 *Rite of Passage*, 1988.

This new way of combining his sources on different levels of elaboration, like the branching of a tree, produced a visually perplexing result. Practically nothing remains visible of Sophocles' tragedy and Morley's drawing of it: as in Turner's *Regulus* without Regulus, perhaps the blinded Oedipus has taken the spectator's place. What one sees is an immense sailboat whose two brown sails resemble mountain peaks. A rainbow, irrational in its colours and perspective, crowns the composition. At the bottom, in pidgin Greek, a multicoloured inscription – *BLACK RAINBOW OVER OEDIPUS AT THEBES* – echoes the rainbow. The only trace of the Oedipal scene is a large abstract band in the middle of the picture that cuts the sails in two. The tragic figures are reduced to yellow, practically invisible phantoms lost in the ultra-chromatic mess, recalling Pollock's unleashed style. This band was painted first, then the rainbow, whose name in Greek, IRIS, is written in colour at the bottom of the picture; both can be read as a metaphor for blindness, signalled by the narrow black blindfold covering the eyes of the bather at the right.

For Morley, a painter, analysand and believer in the psychoanalytic creed, Oedipus blinded is not just anyone. In his mind, this picture is linked to his first (possibly blocked) childhood memory, that of the blind man at Folkestone: 'The man is wearing black glasses and the reflection of the boats is on his glasses but he's not able to see them. *Black Rainbow over Oedipus at Thebes* is a metaphor for blindness.'[50]

142 Detail of *Black Rainbow Over Oedipus at Thebes* (140) in progress.

143 *Black Rainbow Over Oedipus at Thebes I*, 1988.

144 Detail of *Black Rainbow Over Oedipus at Thebes* (140) in progress.

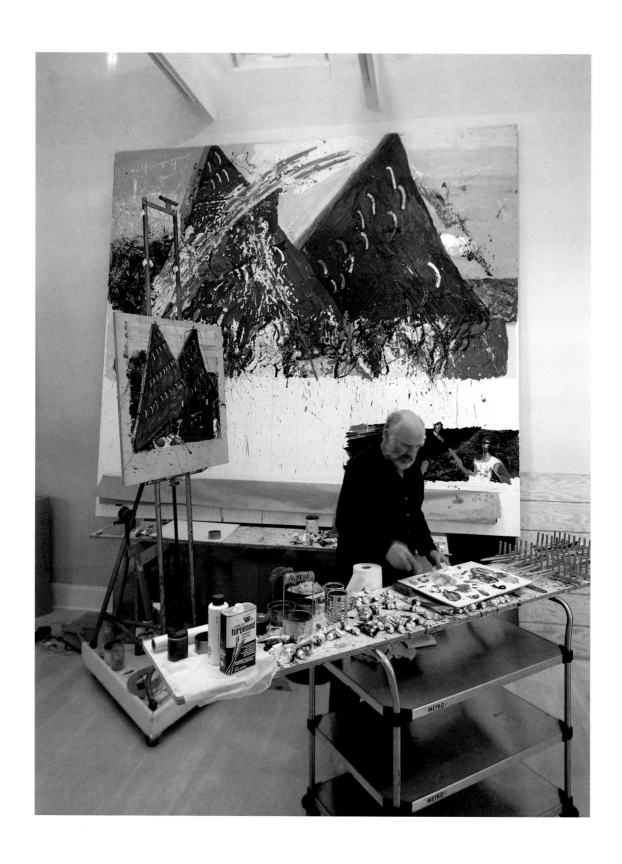

'YOU'LL SING IT TILL YOU LEARN IT!'

Morley summed up his work in the 1980s in the following way:

> Talking about the new pictures Morley said it wouldn't matter if he were to expire after making the first mark; the essence of the painting would be there in the mark. Whereas in the case of the earlier pictures there was really nothing there until each square was filled and the process completed. 'In a sense their content was about how they were made.' He tells the story about the opera singer performing in Palma, where they really know their opera. After singing badly (he has a sore throat), he is called back for encore after encore, thinking to himself – this is funny, I thought they really knew their opera here. Finally he croaks – 'I can't sing anymore!' And a voice from the back of the theatre is heard: 'You'll sing it till you learn it!'[51]

One thinks of what Picasso (and others, starting with Renoir) said of Cézanne, and of the Modern tradition:

> 'The main thing about modern painting,' says Picasso, 'is this. A painter like Tintoretto, for example, begins work on a canvas, and afterward he goes on and, finally, when he has filled it and worked it all over, then only it is finished. Now, if you take a painting by Cézanne (and this is even more clearly visible in the watercolours), the moment he begins to place a stroke of paint on it, the painting is already there.'[52]

As for the parable of the singer, I don't know where it comes from, nor if Morley invented it; I've heard him repeat it, each time varying the places and letters: Palma, Parma, Palermo.

145 Morley in his studio at Bellport, New York, at work on *Black Rainbow Over Oedipus at Thebes*, 1988.

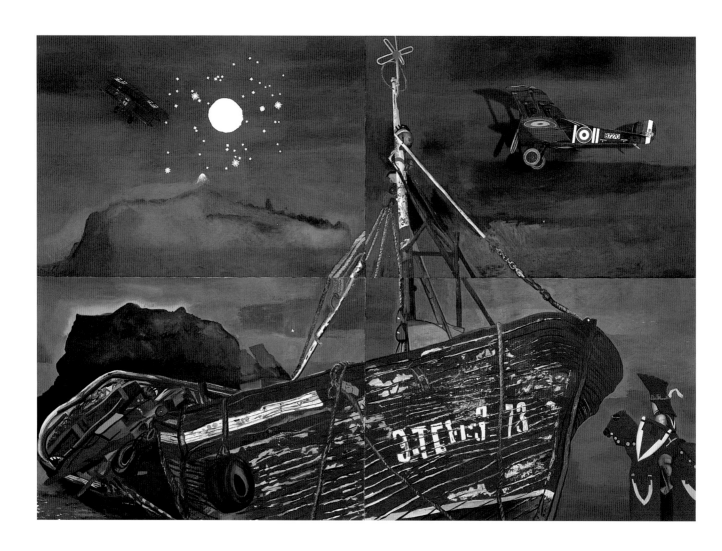

146 *The Oracle*, 1992.

6 Open Sea

Making watercolours offered Morley a way to connect with a tradition of his native land, but he remained a Briton in exile. When the controversial award of the Turner Prize attracted the attention of the British press, he took pains to place himself apart:

> Like other ex-patriot [*sic*] artists, and most obviously Joyce and Beckett, Morley's feelings for the country he left behind are a complex mixture of loathing and longing which found some kind of focus in the Turner prize. 'The London art world's a bunch of losers,' he can say, slapping a *faux naïf* hand over his mouth.[1]

When David Sylvester asked him about his origins, Morley replied: 'I don't feel I belong in England or America . . . The nationalistic aspect of art is something I don't care for; and I rather like to think of myself as a world artist.'[2]

In November 1989, his mother, whom he had seen five years earlier on the occasion of the Turner Prize, died of throat cancer in Exeter just before he could join her. In the cathedral there, he saw a recumbent statue on a medieval tomb which he painted from life and integrated into the triptych *The Boat, The Knight, The Tank*. For him, this image represented one of his most distant ties to England, ties he was trying to reconnect just as they were severed: 'Incredibly modern, and very robust – it was then that I thought of a connection to British art. The connection is that I have a background; it had an effect of encouragement. As if I had in my genes a memory of this knight.' But Morley remained in exile, far from his roots. A few years earlier he had said: 'This is *English* painting, but it could only have been made in New York. The whole background of my work is questions of identity.'[3]

Like Johns's or Warhol's paintings in the 1980s, Morley's recent works present an element of palpable nostalgia:

> His intention is not to create a historical space in which to recall real events. Rather, it is to conjure up a nostalgic space containing memories. In their childlike simplicity there is something almost Proustian about these moments salvaged from a boyhood spent in an England threatened with doom. The artist is careful to separate memory from history; memory, he knows, is not a record of the past but a story about the past based on how it turned out.[4]

147 *The Boat, The Knight, The Tank*, 1990.

But these allusions to childhood nostalgia threaten to become a new critical cliché, and Morley is still on guard, still exasperated by the common places others try to pin on him ('talismans of childhood', 'rejuvenating, manic innocence'.)[5] This exasperation acts like a motor propelling him towards new horizons. Although he has certainly played around with his childhood, real or imagined, and realized in work the full implication of the Baudelarian precept according to which 'genius is nothing more nor less than childhood recovered at will – a childhood now equipped for self-expression with manhood's capacities and a power of analysis which enables it to order the mass of material which it has involuntarily accumu-lated,'[6] the critical vulgarization of his game suffices to make him change his course.

In 1991, Morley turned 60; he obtained American citizenship that same year. His life found some stability: after an eight-year affair with an American woman, and then a brief marriage to a red-haired beauty, a Brazilian painter, he became engaged in 1989 to a young Dutch woman, Lida Kruisheer, whom he married a few months before his mother's death. In 1985, he bought an abandoned Methodist church on Long Island which he renovated on his own, drawing the attention of *House & Garden* magazine:

> I've never lived right. It's taken me a long time to find a way. Like the dog who turns round and round before he lies down. I've never addressed myself to the problem-solving of making a space to live in with the same amount of concentration that I use to make a painting. Before, I always thought, 'I'm renting this place – why bother?' So this is really wonderful because I've discovered the space by doing it the same way I make a painting. I don't make the painting because I know what it is. I make it to find out what it is.[7]

Profiting from his position and comfort, he travelled further and further, allowing discomfort to enter increasingly into his painting.

Morley is one of those painters whose reviews never stop repeating that it was better before. De Kooning remains the most durable example of this; when he painted his aggressive women of 1950–54, Clement Greenberg pined for his all-over abstractions of the postwar period; his melting women of the '60s provoked a chorus of laments; his abstractions of the '70s were seen as completely out of phase; and his paintings of the '80s looked like the senile product of Alzheimer's disease.

In the same way, Morley causes postponed effects; apparently, it takes time to assimilate his reversals. One finds an abundance of commentaries of this kind: 'Some of the most recent works, however, stagger';[8] or, following his show at the Pace Gallery in 1991, which was received rather poorly: '. . . these recent Morley paintings and sculpture were really lousy – uninspired, insipid, just plain boring.'[9]

The abruptness of the shift doesn't explain everything; as if the artist didn't trust his own success, his paintings have a tendency to become increasingly difficult, 'hard to look at',[10] sometimes frankly unpalatable – in the manner of Beethoven's late quartets, which Morley loves to listen to while he paints. The Superrealist paintings, once the first moment of stupefaction was over, caused an overwhelming sensation which forced the artist to tear his own style to pieces, for it was no longer his own; the catastrophes, once accepted, obliged him during the 1980s to penetrate even further into a self-destructive violence. And towards 1990, he dropped the vigorous brushwork that had lent his previous paintings such seductiveness. The stroke appeared to freeze up, recovering a hard, smooth texture, closer to his Superrealist paintings but without their photographic delineation. He started to make sculptures, which collectors and critics can't come to terms with even now. What does his art want? Does it demand serious attention, or is it pulling our leg? 'Advancing deliberately unskillful work as "high art", Morley mocks high art's pretensions without offering anything substantial to take its place.'[11] Reviewing the Paris retrospective of 1993, a *New York Times* critic wrote:

> Some of these paintings have an undeniable seductive lushness. But the latest works, and especially the sculptures based on models of boats and biplanes, on the whole are not Mr. Morley's best. The scale is bigger and bolder than ever, but one senses something unresolved and unfocused, as if the artist is again in the process of changing. There's a certain emptiness at the core of giant works like 'Oracle,' something gimmicky about the attachments of model planes to these canvases, even though the models are made with admirable skill.[12]

Morley continues to combine watercolours in his new canvases, though playing increasingly on the disparateness of elements. For example, he combined a still life and a landscape in *Erotic Blando Fruto* (page 163) and in the tondo *Watermelon of Monkey Beach* (1989) (page 164), creating a spatial disjunction in the manner of Delacroix's *Still Life with Lobsters* (1826).

In *Erotic Blando Fruto*, the most tropical of Morley's compositions based on the watercolours *El Palenque* and *Erotic Blando Fruto: La Mariposa*, the effect is accentuated by a break along the bottom of the still life; although a big canvas, the painted surface was too short, and a second panel had to be added at the bottom; its painted fragments do not coincide with those above. Morley doesn't like these tropical still lifes; he finds the fruit obscene (*too* erotic), overlarge and overripe, too glossy: 'This was over the top.'

Morley has repeatedly exploited these combinations of elements collected on various trips. *Asia Minor* (1991) links two panels of unequal height based on a watercolour done in India, which shows a family of musicians seated in front of a brick wall (1986) – each member of the family, except for the baby, signed his or her name on the page – and a double watercolour (already a collage) of Egyptian pyramids (1985). The title can be read as the geographical joining up of two sites. *Caribe-Afrique* (1990) presents the most remarkable case; instead of juxtaposing images, this painting superimposes two watercolours of Jamaica done in 1990, *Our Room, Tensing Penn Jamaica* and *Jamaican Fishermen thru the Binox*. The fishermen are seen here breaking through the slats of a bungalow, which take the place of binoculars and frame the view. The painter proceeded by superimposing two colour slides of the watercolours.

150 *Erotic Blando Fruto*, 1989.

148 *El Palenque*, 1988–9.

149 *Erotic Blando Fruto: La Mariposa*, 1988–9.

151 *Watermelon on Monkey Beach*, 1989.

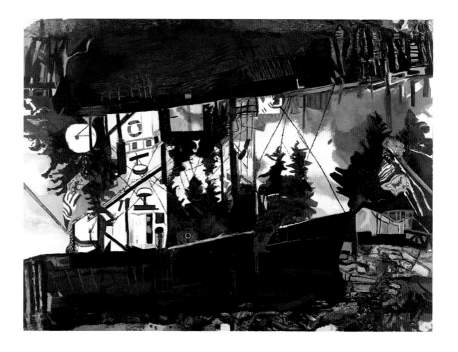

152 *Kristen and Erin*, 1991.

The common denominator is the sea, whose intense blues unify the two motifs.

Kristen and Erin (1991) is another variation on the theme of the super-imposed image. Morley began a watercolour in 1988 of a fishing boat in Maine; when he went to finish it, the captain had brought the boat around. Morley repainted the scene by turning the sheet upside-down; he then did a canvas from it, which is reversible, signed both above and below (in the manner of a certain untitled watercolour by Rothko from 1944–6). At first sight, one thinks that one is looking at a boat and its reflection, but this image turns surrealistic; the hull of the boat on top lifts into the sky, which together with the mast in the centre of the canvas provides the unifying elements of the two scenes.

Speaking of *Gloria* (page 166), a tropical beach scene in which First World War warplanes invade the sky (to allow for colour contrasts, the artist claims), Morley associates collages of diverse places and times with a form of self-discovery and -construction:

> I paint in order to develop my character. It's a means of integrating one's psyche, getting the fragments together, achieving a holistic persona. The watercolour for 'Gloria' was from Costa Rica. The

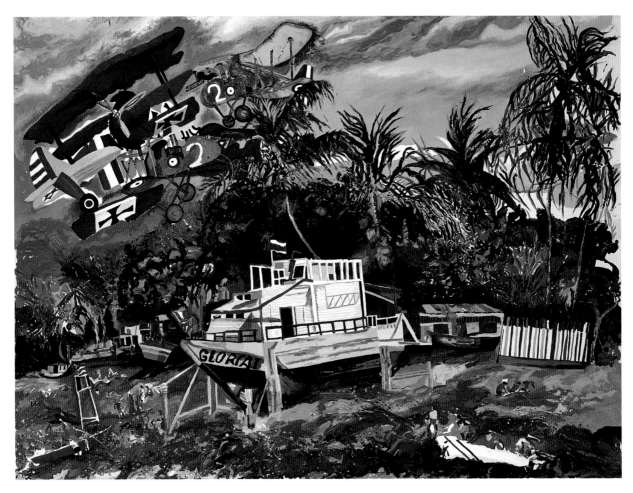

153 *Gloria*, 1990.

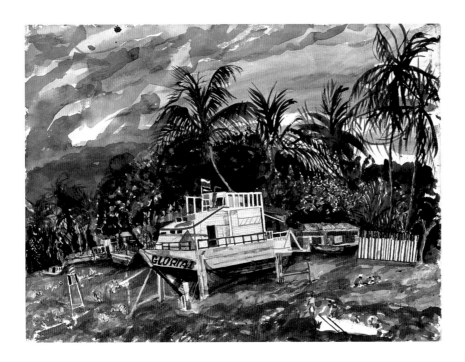

154 *Gloria I*, 1988–9.

aeroplanes were from an air show in Maine. I put experiences together like a bee pollinating flowers. I call it parleying.[13]

(This last comparison is a classical one, to be found in eclectic art theories, notably those of Félibien in the seventeenth century and Reynolds in the eighteenth.) It's an idea Morley has often returned to:

My [recent] paintings are made as a means of – you may laugh – developing character. Through working things out in the paintings, you evolve a reality that's got some kind of moral structure because the work has employed you from head to toe. While I'm painting, I'm feeling it all the way through. It's not just a job for the hand . . . painting affects you through the central nervous system, not through the intellect.[14]

The pictorial body reconstitutes the painter's, just as a dream is said to reconstitute the dreamer's psyche. But at the same time, each painting becomes an emissary of its creator, his representative in the world:

The whole idea of the body. And I love the language, you know, 'a body of work.' After all what are we doing? We're making surrogates of ourselves. We're producing bodies. So we can be there without being there: Victor Mature, as quoted by Henry Geldzahler, once said that he wanted to be the star of a movie in which he never appeared. That's really what the visual artist is doing all the time.[15]

Or, summed up in a lapidary phrase, 'The painting is a body of myself.'[16] A detachable body: 'But I feel like a snake who has shed a lot of skins. And I want to shed even more.'[17] 'Each picture is a skin.'[18]

This comparison becomes all the more striking when we recall that it is not properly Morley's. He certainly didn't know that it had already been used in 1913, but with a completely different connotation, by Kandinsky, to describe the difficult genesis of *Composition VI*, one of his most ambitious paintings: 'I thought of a snake not quite able to slough its skin. The skin itself looked perfectly dead – but it still stuck.'[19] Nor did he know that the French poet Francis Ponge described the activity of the painter as follows (though with a somewhat different metaphorical resonance):

And to which activity does he then devote himself? Quite simply (and tragically) to his own *metamorphosis*.

Pardon us if, once formulated, this idea just as quickly seals our lips. For it's certain that we could go on for hours, showing how, with

the help of such spindly, scattered limbs, those ladders, easels, brushes and calipers, thanks also to those small secreting glands known as tubes of colour, the artist (such is the name of this human species, and he requires royal nourishment: still lifes, nudes, a landscape now and then) laboriously, and sometimes frenetically, molts and quivers and casts off his work. To be considered from then on as skin.

But that's enough. There's nothing left to uncover . . . and we are no circus horse.[20]

AQUATIC DEMON

What dictates the artist's metamorphoses, as with primitive peoples, mystics and madmen, is a voice. Morley hears voices, or at least acts as if he does:

> MM: . . . Let's pretend it was possible to hear voices and these voices told you what to do. They say, 'Go, do this.' Now, everybody knows that people who hear voices are mad. But we know artists are mad, so it's okay. So the voice says, 'Go and do this'.
>
> LL: Did a voice say, 'Go and do this'?
>
> MM: The voice of painterly integrity. Cézanne spoke to me.[21]

The voice of Cézanne! Is this the recreated voice of the missing father? Child of an unknown father, Morley has created his own, which in this instance borrows the name and voice of Cézanne. Although the product of proper training in the most academic of establishments (Morley loves to relate how, at the Royal College, he was scolded by Carel Weight for aspiring to be 'a modern painter'[22]), he became an autodidact by necessity, using all means available to him. He hasn't submitted to learning the rules, not of writing or of painting: he can't spell and possibly can't draw, despite his evident virtuosity as a painter. But when Morley doesn't know how to draw, he resembles Cézanne when *he* didn't know how to draw: 'Clumsy confidence is a virtue,' he says, citing Cézanne as an example.[23] As it did for Mondrian, the human figure poses problems for him; in my opinion, Morley is generally not a great portraitist, except in those empathetic cases where his model has the necessary savagery (*Cimi, the Turk* or the baby in *Asia Minor*). He does sometimes feel the urge to draw or paint people, but his lines appear timid then, even awkward; he doesn't really seem to be at ease with people despite the cordial appearance of his social interactions. What is remarkable are the self-portraits, the only human representations in

155 *Cimi the Turk*, 1977.

which he seems free to capture the audacity and guile that are the lifeblood of his work. I rather think that he has more affinity with animals, especially wild animals, which, he says, live in perpetual fear.

So he hears voices – in his shower. Or he acts as if he does (he's not mad). And this is no mere embellishment: his parables, his hoarse opera singer, his voice in the shower illuminate his metaphorical, indirect way of proceeding. Morley is indeed, as is often deplored, an oblique painter, oddly oblique, like the Delphic oracle. Which is to say that he is a painter, if to be a painter means thinking the world in images rather than in words and ideas. His voices are there to point the way – of painting:

> One day, while I was taking a shower, a voice came through the shower-head. Amazing! It said, 'You have been a turpentine painter, you are not an oil painter' . . . The voice said, 'It's okay to use turpentine as a wetting agent, but that's all.' The voice continued, 'what about the as-suchness of the painting that's you?' The as-suchness is the word in terms of the essential quality of something, the isness of it. What I wanted to do was to remove all the many stages within the painting process. First you start thin, then you paint thick, then fill it in. It is the whole sequential European thought which is political. It's all hierarchy. It all comes out 'saying' that one thing is better than another thing. Without knowing it, it was against my grain.[24]

It's interesting that Morley, like Socrates, has his demon. And that it takes an ironic-aquatic form. The voice comes from above but not from the sky: 'I was taking a shower and a voice came through the showerhead; BE AN ADVENTURE PAINTER! FUCK MODERN ART! Wonderful –.'[25] 'That was another thing that came through the shower head: "Go be an adventure painter. Forget about esthetics. Get out of SoHo, get out of your navel, be a 19th-century Victorian explorer-painter."'[26] It's as if he heard the voice of his English past fantasized at the death of his mother: 'In a way, I was cashing in on the British inheritance of the British travelling abroad. The whole idea of the exotic as a subject is a quality that had become very pronounced in the work. I also associate that with libido and sexual desire –'[27]

SIMPLY A FLAT PLANE IN SPACE

During the 1990s, Morley reintroduced three-dimensionality into his paintings. No longer in the manner of the combine paintings he had done

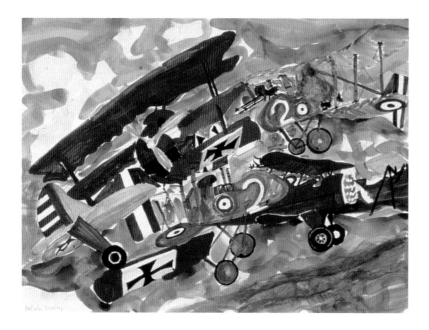

156 *Air Show with the Red Baron Plane*, 1989.

twenty years earlier, he now made paper models which he painted with watercolour. In 1980, he stated:

> I myself have no interest in making the model. I'd feel that I was breaking the magic of it because it's the idea that somebody else made the model that gives it authenticity, that connects it to the outside. I feel that children always make their model by having them.[28]

Nonetheless, starting in 1991, Morley began to make his own models, or rather to remake them on the basis of existing ones with paper and water-colour paints sometimes covered with encaustic. At the age of 60, he recovered the childhood brutally interrupted by the bombing of the *Nelson*.

The first example is *André Malraux Flying the Spad-Herbemont S20 Bis over Gustavia*. This canvas was painted from a watercolour done in 1988 which shows a view of Gustavia on St Barts in the West Indies, a fashion-able vacation spot for the New York art world. A fantasy inspired Morley to add to the sky of this French colony an antique airplane piloted by the Spanish Civil War aviator who ended his adventurer-writer career as an art critic and ex-Minister of Culture. Yet in contrast to *Gloria*, the canvas was entirely covered, and the artist didn't allow himself to paint over an already painted surface:

> I only want to paint in oil on canvas, not in oil paint on oil paint. I'm not an oil painter on oil paint, I'm an oil painter on canvas. And I must have that ground all the time to paint upon. I feel horrible when I start to paint on top of paint which is still drying underneath at different levels, with skin on top.[29]

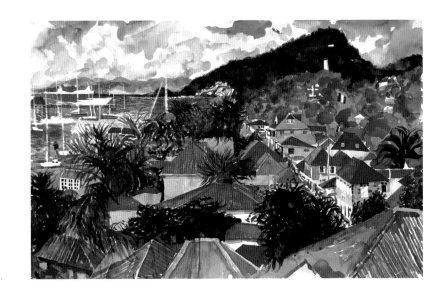

157 *Gustavia St. Barts*, 1988.

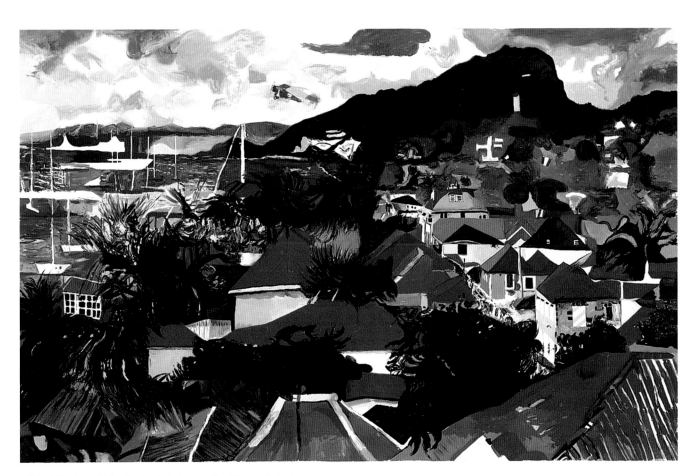

158 *André Malraux Flying the Spad-Herbemont S20 Bis over Gustavia*, 1991.

(A particularly clear example of this can be seen in *Maasai*, where areas of the canvas are reserved for scattered inscriptions.) He resolved in consequence to make a small paper model of the airplane, which he painted with watercolour. Attached to the canvas by means of a magnet, it could be moved about in the sky above Gustavia.

The decision to add this small object to the painting was most likely made easier by the fact that in 1989 and '90, Morley had made a series of nine bronze sculptures, with patina, on the warrior theme – soldiers, tanks, a battleship – cast from cardboard-and-wax models and mounted on disproportionate stands *à la* Brancusi. The most impressive ones include *Navy* (page 174), with its spindle-shaped stand that appears cut from the sea, 'a column of water in its own image'[30] (though an unhappy critic qualified it as a 'William Tucker-like excremental mound')[31]; *Sentinel* (page 174), a soldier armed with a bayonet and mounted on a elongated prism; and *The Chariot of Darius II* (page 174), 'a toy tank that seems to have suffered some sort of nuclear meltdown'.[32] Morley sees in this Persian

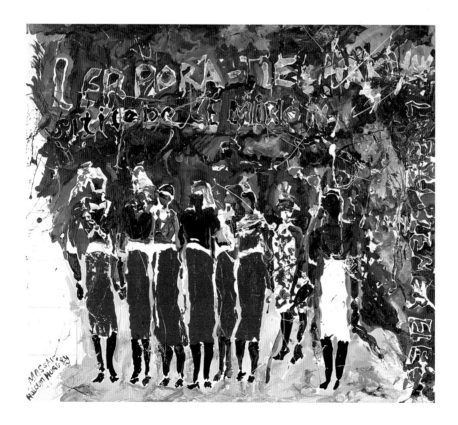

159 *Maasai*, 1985.

160 *Geronimo*, 1991.

tank, whose wax model he softened in a sauna, a kind of premonition of
the Gulf War. In 1990, he made a tenth bronze, *Port Clyde* (page 175),
which resembles something halfway between a sculpture and a painting.
A small light grey, yellow, black and red rowboat is posed on a fragment of
window casing, an allusion to Mondrian says Morley, and a clear reference
to the *Nelson*. As in the case of *The Flying Dutchman* (page 175) from the
same year – a small three-dimensional sailboat also posed on a window
casing – this shallow relief is entirely painted with encaustic.

 In 1991, after *Gustavia*, Morley painted *Geronimo* from a watercolour
made ten years earlier in Arizona, *Sunset Crater*; the same airplane appears
twice, painted in oil and in a three-dimensional watercolour attached
above with a magnet. Below, four tepees in the form of painted water-
colour-paper bas-reliefs are laid on a wooden base covered with earth and
real pebbles; at the left, the head of an Indian chief (a bit of airplane decor)
has been pasted onto the canvas at the top of a ghostly vegetal body. As in
Arizonac, the painting opposes the hard-edged texture of the Indian imagery

161 *Sentinel*, 1989.

162 *The Chariot of Darius II*, 1990.

163 *Navy*, 1990.

164 *Port Clyde*, 1990.

165 *The Flying Dutchman*, 1989.

with that of the landscape, but this time it consists of foreign bodies cut up and applied to the body of the canvas.

The three-dimensional airplanes appeared subsequently with more frequency and in greater detail. There's an untranslatable play on words in English: the paradox of a three-dimensional plane. Morley says that he saw the double meaning immediately, but immediately *after* its realization: 'You make it in order to find what it is.'

> JCL: So the pun came after the making of it?
>
> MM: Yes. Because I couldn't reveal the pun till after it was made. I couldn't know what the pun was in order to make it.
>
> JCL: You could have. You could have thought it would be a good idea to make a three-dimensional plane.
>
> MM: Yes.
>
> JCL: But it was the other way around.
>
> MM: Yes, it came the other way around. I started to see cross-references.

The pun actually lies within the word *airplane* or *aeroplane*. In the *Shorter Oxford English Dictionary* in Lida's office, I read:

> **Plane** . . . *sb.*[1] late ME [- (O) Fr. *Plane* :- L. *Platanus* - Gr. Πλάτανος f. Stem of πλατύς broad.] 1. A tree of the genus *Platanus* . . .
>
> **Plane** . . . *sb.*[2] ME [- (O) Fr. *Plane*, var. (Infl. By *planer* vb.) of *plaine*:- late L. *Plana* planing instrument . . . 1. A tool resembling a plasterer's trowel, used by plumbers, bricklayers, etc, for smoothing the surface of sand, clay in a mould, etc. . . .
>
> **Plane** . . . *sb.*[3] 1646 [- L. *Planum* flat surface, subst. use of n. of *planus* PLAIN . . . 1.a. A plane superficies . . . b. A flat or level surface of a material body . . . c. *Cryst.* and *Min*. Each of the natural faces of a crystal . . . e. *(a)* = AEROPLANE . . . 2. *Mining*. Any road in a mine, along which coal, etc., is conveyed in cars or trucks 1877. 3. *fig.* in ref. to thought, knowledge, moral qualities, social rank, etc.: higher or lower level, grade, degree 1850 . . .
>
> **Plane** . . . *a.* 1570 [refash. of PLAIN *a.*[1] after Fr. *plan*, fem. *plane*, which was similarly substituted for *plain, plaine* in tech. senses . . . 1. *Geom*. Of a surface: perfectly flat or level . . .
>
> **Plane** . . . *v.*[1] ME. [- (O) Fr. *Planer* :- late L. *planare* plane, make smooth, f. L. *planus* PLAIN *a.*[1]] . . . 1 To make (a surface) plane, even, or smooth . . . 2 *fig*. To make plain or intelligible; to explain, display, show -1659.
>
> **Plane** . . . *v.*[2] 1611. [- Fr. *Planer*, f. *plan* plane, because a bird when soaring extends its wings in a plane.] *intr*. Of a bird: To be poised on outspread motionless wings. b . [f. PLANE *sb.*[3] 1 e.] To travel in an aeroplane; *esp*. to glide *down* 1909.

> **Plan** . . . I. 1. A drawing, sketch, etc. of any object, made by projection
> upon a flat surface . . . 2. A scheme of arrangement; *transf.*
> disposition of parts; a type of structure (viewed as designed);
> configuration (of a surface) 1732. 3. A scheme of action, project,
> design . . .
> II. After Fr. *plan.* a. *Perspective.* Any one of the numbers of ideal planes
> perpendicular to the line of vision passing through the objects
> represented in a picture 1678 . . .
> **Planet** . . . Gr. πλανήτης wanderer . . . f. πλανᾶν lead astray, wander . . .
> **Airplane** . . . [alter. of AEROPLANE, after AIR *sb*] = AEROPLANE 2.
> **Aeroplane** . . . 1866 [In sense 1, f. AERO- + PLANE, *sb.*[3]; in sense 2 - Fr.
> *aéroplane*, f. grec ἀερο- , ἀήρ AIR *sb.* + - πλανος wandering.] 1. A
> plane for aerostatics experiment; the plane of a flying machine -
> 1905. 2. A heavier-than-air flying machine having one or more
> such planes (*monoplane, biplane, triplane*) and driven by a motor.

Thus *aeroplane* goes back to the plane (*planus*, flat) and to wandering
(*planân*, to mislay, *planasthai*, to wander), and it is related to planets which
roam through space. One of Morley's major references comes to mind, the
aerial Suprematism of Malevich, which had as its objective the interaction
of plane and space. A monoplane (biplane, triplane) is a plane (two planes,
three planes) which plane(s) through space. From Braque and Delaunay to
Tatlin, the plane is a trope crisscrossing the sky of Modern art.

The painted watercolour paper is, nevertheless, very much, in one
sense, a plane, which from flat becomes twisted and curved – like the post-
cards of the 1970s. Morley has compared his watercolour airplanes to
origami, the Japanese art of folded paper, rather than to sculpture, which
he himself perceives with a painter's eye:

> . . . sculpture is not sculpture. It's simply a flat plane in space. The best
> proof of sculpture not being sculpture is to take a napkin, which is flat,
> and do what Chamberlain does which is to take it in your fist and to
> screw it up and now you've got this sculpture which is this flat plane
> which has been folded.[33]

In 1992, Morley spent time in the Canary Islands, where he painted
watercolours of seascapes, including *Puerto de La Luz, Las Palmas* and
Nocturnal Canarias (page 178), the last on four juxtaposed pieces of paper.
When he transformed these watercolours into canvases, he added to each
of them two large airplane models from the First World War, attached to
the canvases by wooden rods. To *The Oracle* (page 158) he added a German
triplane (the Fokker DR 1 of the Red Baron, Manfred von Richthofen) and

166 *Icarus*, 1993.

167 *Nocturnal Canarias*, 1992.

168 Oblique studio view of *The Oracle* (146).

a large British biplane, the Sopwith Camel; to *Icarus*, two British airplanes, one revolving once per hour, on a balsawood structure, and the yacht *Pamela*. He was thinking of a savvy critic who could say: 'At 12 o'clock it's a terrible painting, but at 7 o'clock it's terrific.'

Of course, this is a mistake: if the plane's revolution takes an hour, it is in the same position at 12 and at 7.

The Oracle, a four-panel work measuring 437×610 cm, nearly the size of *The Raft of the Medusa*, combines a view of the Canaries with a dark red boat stranded in front of a purple sea and sky, the two planes, a moon and its cortege of stars painted in a decorative manner with yellow and white gold leaf (on a visit to the Louvre in 1992, Morley was impressed by Uccello's *Battle of San Romano*, but the model for these celestial bodies came from the ceiling of the Morley house in Port Clyde, Maine), and a bright red medieval knight with ceremonial horse, based on a lead model and treated in the tight, almost cut-out manner Morley would adopt for the next six or seven years. This collage of different times and scales (Morley sees the pilots of the First World War as modern knights) is accentuated by the painting's monumental scale and its large stretches of purplish blue, finely nuanced and very light-sensitive; the painting looked different at the Paris retrospective than it does at the museum in Kansas City where it is now housed.

Between 1992 and 1995, Morley attached numerous sculpted models to his seascape canvases or watercolours. An extreme case is the 1995 *Flight of Icarus* (page 180), in which a red Fokker, 2.31×2.87 m and made of painted watercolour paper with a coat of encaustic over a thin wood-and-steel structure, appears to dive into a canvas sun, a disk painted in red-orange wax with purplish edges. The wax makes reference to the material that bound the feathers of Icarus. Together with Johns and Marden, Morley is one of the great encaustic painters of our time, despite the fact that he only uses the medium infrequently (*The Flying Dutchman* [1990]; *Reverie* [1994] [page 181]; *Freighter with Primary and Secondary Colors* [1995], the latter a panel 213×30 cm). *Reverie* is like a first inkling of the solar disk found later in *Flight of Icarus*: a small oval canvas with a three-dimensional trawler in paper and string attached at the bottom. The coloured texture of this reddish purple and orange surface, with its drops of orange wax projected and solidified onto a vermilion background, is extraordinarily sensuous.

169 Model knight used by Morley in *The Oracle* (146).

170 *Flight of Icarus*, 1995.

171 Studio view of *Flight of Icarus* (170).

172 *Reverie*, 1994.

As for the Fokker, which already appeared in *Gloria* and its Maine watercolours, it points back to another childhood memory, or rather to the difficult passage from childhood to maturity:

When I was at the naval college, there was a boy there who lived near me in a place called Richmond, Surrey, and I lived in a place called Whitton, in the High Street, on top of the shoe store. I made a model of the Fokker – the three-winged aeroplane – out of balsa wood. This boy, who was maybe 15, had invited me to his house, so I took over this model, which I was very proud of, to his house. When I arrived, he was in a tuxedo going to a dance with his girlfriend, and I felt very embarrassed. I was there maybe just ten minutes, and he left, and I stayed there with his mother, sitting on one chair, his mother sitting on another chair, and I was holding this aeroplane in my hand. And I felt very silly, because here he was with a tuxedo, being a young gentleman, and going off to a dance to this hotel with this very beautiful girl –

After the airplanes, Morley started to make paper scale models of other kinds of objects, a whole assortment of boats, lighthouses and other buildings.

He bought model kits but replaced the materials included in them with watercolour paper, which he painted with watercolour either before or after putting the model together, sometimes adding a coat of encaustic:

> I make all the models for my work out of watercolor paper painted with watercolor. They take the form of ships, airplanes, and lighthouses set in a still life format, except in my work apples are sailing boats circa 1920. The drapery with folds in the still life are waves, and even they are made of watercolor on watercolor paper.[34]

Since his Superrealist years, when he gave up painting an ocean liner from life and replaced it with postcards, Morley has essentially been a painter of still lifes whose objects are scaled-down images observed close up. Even the postcards were envisaged as 'two-dimensional still lifes'.[35] But his awareness of the still life became more precise and enriched with the introduction of scale models, and more so when he began to construct his own models during the 1990s.

An exchange was thus initiated between these three-dimensional models and their flat, painted copies on canvas. After having constructed his maquettes in paper painted with watercolour and encaustic, Morley attached them to a sheet or canvas or used them as models from which he painted on canvas. We see this in his 1995 painting *Flying Cloud*, a small canvas depicting a three-master based on a cut-out photo of the model; this in turn became the model for *Montgolfière with Flying Cloud*, in which Morley added a watercolour-paper model of the *Montgolfière* that casts a (real) shadow on the painted sky. Two years later, he returned not to the original *Flying Cloud* but to *Montgolfière with Flying Cloud*, this time painting it entirely in oil. Although now integrated into the painting, the illusionistic balloon again casts a discrete yet noticeable (painted) shadow over the painted sky, as if it were a foreign object – and in a sense it is, Morley having painted an image of his last painting, this time considered as a still life: a little heterotopic pun in the Baroque-Surrealist tradition, but also in the manner of *Los Angeles Yellow Pages*.

For his painting *Margate*, entirely painted in oil, he composed a still life of two flat watercolours, a vertical one for the sky and a horizontal one for the sea, and three models in painted watercolour paper (page 184). These included a sailing vessel called the *Belem*, a red-and-white lighthouse with a drawing of bricks in black (blue-and-white painted waves

173 *White Cloud*, 1997.

174 *Flying Cloud*, 1995.

175 *Montgolfière with Flying Cloud*, 1995.

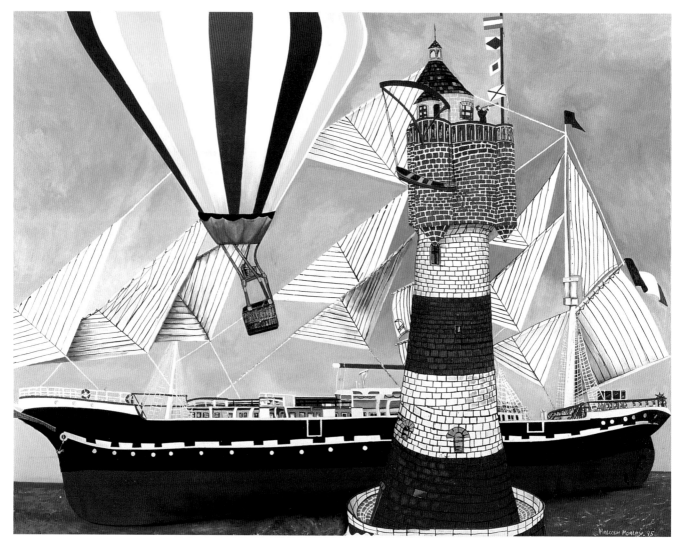

176 *Margate*, 1995–96.

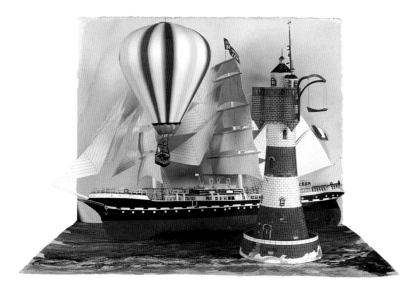

177 *Margate*, 1995.

break over the bottom), and a balloon in white, blue, yellow and red stripes. The picture was painted through a grid with a cover isolating the area to be painted.

Flight of Icarus, Morley's most openly three-dimensional composition, gave impetus in 1997 to an oil painting entitled *Icarus's Flight* (page 186), and in 1998 to another one, *Approaching Valhalla*, where the motif is combined with a triple flat representation of a Hollywood-style Roman galley (based on a Czech kit) with three paragliders (page 187). Lovers of modern art may have a hard time coming to terms with this amazingly sublimated and aggrandized Disneyland exercise. The Greenbergian opposition between avant-garde and kitsch (which a simple examination of Kandinsky's paintings would have sufficed to undermine) is decimated on all fronts.

Greenberg (and the American Modernist tradition he represents) seems to be the target that Icarus' red airplane wants to destroy. 'I have carried out a one-man ideological war with New York for years,' Morley told an Irish journalist who didn't quite want to take this statement seriously.[36] A little earlier he had said:

178 Morley painting *Margate* (176).

> This is my fight. I think New York has betrayed Cézanne. I would love to write a piece called 'Betrayal of Cézanne.' The arch enemy of Cézanne is Clement Greenberg: 'Let's get rid of illusion and keep the plane.' Cézanne would have been horrified by this interpretation, because he believed the problem of painting was to realize three dimensions on a two-dimensional plane, and that the temperament of the painter was to be expressed or the character developed through this engagement. But the third dimension would not be eliminated. Cézanne would be horrified of this idea, because he believed just the opposite – that it cannot be three-dimensional enough. And the paradox is that you achieve this by restricting it to a flat plane. Paradoxically, the more you flatten it, the more illusion you get. But only a certain kind of sensitivity or intelligence – the painterly intelligence – can understand that. It is very hard to keep both the illusion and the plane simultaneously . . . this was the incredible genius of Cézanne. For me Cézanne is to painting what Einstein may be to physics – the quantum leap in eight hundred years of renaissance space.[37]

Morley, who is not Cézanne, experimented widely during the 1990s with planes and depth or relief. The point was not to produce, in Frank Stella's terms, a fractal, intermediate space between two and three dimensions, a

2.7-dimensional space,[38] but rather to maintain all dimensions intact, producing if necessary an n+1 space. *Pamela with Reflection* associates the three-dimensional model of a small sailing boat with its flat, painted reflection on canvas in a space graded from orange to blue. *Pictures from the Azores* (page 188) reproduces two beach scenes on a background of blue and white stripes; these are obviously flat images seen from two slightly different views, the one on the left casting a light shadow over the one on the right. An airplane appears in both skies, but while the left-hand one is a painted image (an element of the image in the image), the right-hand one is a three-dimensional blue and yellow airplane in wax on watercolour. The figurative status of this airplane is uncertain; it is either a three-dimensional model placed before a flat image or an element of the flat image that has taken on a fantastical relief quality, jumping out of the image like the television screen in Cronenberg's film *Videodrome*.

The painted representation of a volumetric object (a boat, airplane or balloon) on a flat paper surface produces a three-dimensional illusion, yet which gaze and which discourse are appropriate when this surface is turned or twisted? Is it a four-dimensional illusion? (One thinks of an

181 *Approaching Valhalla*, 1998.

179 *Pamela with Reflection*, 1994.

180 *Icarus's Flight*, 1997.

182 *Pictures from the Azores*, 1994.

entire tradition combining real and illusionistic volumes from Tatlin or Puni to Lichtenstein.) And what happens when this surface is in turn represented, flattened out in paint? What can be said when, as in *Biplane in Flight*, a model airplane (in fact a monoplane, the Fokker EV/DVIII) is associated with four different aspects of its flattened, shortened projection in a twirling manoeuvre piloted by no-one but the painter himself? Recent commentaries on the artist's obsession with his childhood and childish toys fall flat here; I fail to share Alexi Worth's theory concerning this painting that Morley is inviting the viewer to participate in the game by taking over the controls. His models make no room for human beings, full stop. Memory and nostalgia present themselves as possible elements of a game, but it is one of knowledge and complexity in the charades tradition of Bach's *Musical Offering* or the tradition of semiotic fun in which Picasso indulged around 1912–14.

Especially when Morley disfigures his models by heating, twisting and smashing them. He drove his van over a freighter before painting it in white encaustic, recreating Stella's 2.7-dimensional space in his own way. Morley, who has painted all sorts of watercolours in relief – boats, whales

183 *Biplane in Flight*, 1998.

and waves – took the French sailing boat *Belem* with him into the shower, heating and trampling it before reaping a crop of paintings from it: a small square version in four unequal panels, *Sailing Vessel Floundering in Stormy Seas* (1996); then, in the same year, a large, elongated version, *Sailing Vessel Floundering in Heavy Seas*; and finally, in 1998, a tall version with the addition of two whales and four Viking ships, *Floundering Vessel with Blue Whales and Viking Ships*. In these paintings, the twisted model of the sailing ship seen from above is also torn apart by the viewer's eye shifting over the grid. The French vessel was then submitted to new assaults of torture and dismemberment before finishing up in the three-dimensional watercolour *Belem with Whale* (1997), thus becoming an extraordinary receptacle of aesthetico-maritime fantasies.

184 *Sailing Vessel Floundering in Stormy Seas*, 1996.

185 *Belem with Whale*, 1997.

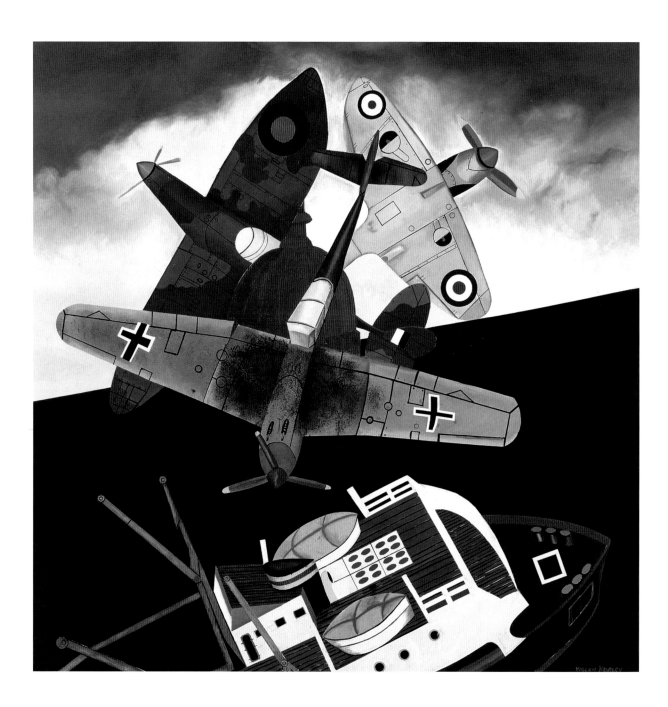

186 *Battle of Britain*, 1999.

The most recent and largest of Morley's models is a scale representation of St Peter's in Rome with Bernini's colonnade, roughly 150 cm long. With the help of his assistant, Morley painted it dark red in April 1999, but he was unsatisfied with the result. He wanted to go over it with pink encaustic; he was also thinking of disfiguring it, maybe running it over with his van. Earlier, he had made a model of the dome alone, painted red, which he used for *Spitfire with Dome* (1998) and *Battle of Britain* (1999) (a boat and three airplanes, two based on the Spitfire model, camouflaged above, light blue below), with a smaller, intermediary painting in oil. Morley pointed out their primary difference to me: in the small version painted directly from the still life composed by the artist from different models (he had intended to make a bronze or maybe, at my suggestion, a ceramic sculpture with them, but abandoned the idea), the spatial relationships are faithfully reproduced. However, in the large one based on the small version, the top of the dome passes behind the airplane wing – one of the artist's customary tricks of spatial impossibility.

187 *Study for Battle of Britain*, 1999.

The same logic led him in 1996 to paint decorative frames – either on a separate stretcher as in *Navy Day*, or on the same support as in *Battle of the Yellow Sea*) – or *trompe-l'œil* frames (in *Santa Maria with Sopwith Camel Wing* and *Medieval with Lemon Sky*). The painted frame became a model like the others, a still-life object to be reproduced in paint. As Brooks Adams observed, the medieval boat appears to lie directly on the painted frame (but one can also imagine its hull hidden by the frame).[39] The illusionism of the rendering accentuates the ambiguity of the painted object's status. Morley says he wants to create a stereoscopic or holographic space, a kind of magic exercise for the eyes. In 1996, he actually constructed a model for a hologram (with a lifeboat) for a holographic studio in Florida (which had also solicited such artists as Lichtenstein, Artschwager and Ryman), but the project was abandoned due to lack of funds.

CONTOURS

With the models emerged a new way of painting, characterized by dense colours and hard contours. These effects were achieved by using non-diluted paint, fine sable brushes and masks made out of plastic or cut out of the *Yellow Pages*. Pencilled contours were often added to the grid. The visual effect of these new paintings lies at the opposite extreme from the broad splashes of the 1980s. In part, this has to do with the change in models; instead of scenes from nature improvised with watercolour, the new models were painstakingly cut out, coloured, assembled and coloured again. As a result, the watercolours are well drawn and precise (*Muizenberg* [1997]), sometimes to a hallucinatory degree (*St. Lucia Canoe* [1993] [page 196]). This work feels like a declaration of independence, a way of letting go of Neo-Expressionism without having to cut off one's hands. Morley has not abandoned the splashes he obtained by projecting paint onto canvas with a supple palette knife, but he's tightened them up, using them for specific wave and foam effects.

This more concentrated technique became apparent in the water-colours of Jamaica (1990) and especially the Canary Islands canvases, in particular *Gypsy* (1992) (page 198), which shows a boat turned over, its hull full of holes, in a marvelous harmony of blue-violet and yellow mixed with warm browns and an acid green. The painting is based on a watercolour done on location which intensified the actual colours of the motif. 'This is very free and anal-retentive at the same time,' the artist commented in a

188 *Santa Maria with Sopwith Camel Wing*, 1996.

189 *Medieval with Lemon Sky*, 1996.

video filmed by his wife Lida as he painted the watercolour at Las Palmas (and where he is seen cleaning his brushes with toilet paper). This tight style was already visible in parts of certain previous works, such as *Arizonac*, but towards 1992 it became generalized, taking on a more regular aspect. The trip to the Canaries seems to have triggered a change in the artist's vision, arousing childhood memories which would in part invoke a rebirth of interest in models, already present in *André Malraux* and *Geronimo*. It was at the beginning of the Second World War while Morley was living in a boarding house at Salcombe in Devon:

> We were sleeping when suddenly we [were] all awakened and told that a Greek cargo ship had been torpedoed in Tankerton Bay. We were all taken down to the cove where a lifeboat had landed with a crew that had been just rescued. The boat was perched between two huge rocks. It looked enormous to me. After a while, we were allowed to go into the boat. There was a great deal of water inside. I remember round loaves of bread mixed with orange cork life preservers floating on the surface of the water.[40]

He rediscovered this childhood memory in the Canaries:

> This bay at Tenerife reminded me exactly of the bay where I had seen this lifeboat. And when I got back to the hotel, I made a watercolour of this bay. There's a painting which is double and it has a lifeboat in it. And even at the hotel I had this memory of the lifeboat, and I wanted to try to make a model, then in the hotel, with just what I had. And I made a primitive model to put in the watercolour.

This lifeboat is the same one he later wanted to make into a hologram: in other words, a three-dimensional hallucination.

Morley associated this recollected bay with the combining process he then began to use. In 1993, he painted a canvas, *Perilous Voyage*, installing the yacht *Pamela* in the bay along with a biplane, a freighter which appears to be sinking and two lifeboats, the whole painted on the canvas except for some rocks, the two lifeboats and a flag in watercolour paper. In 1994, he returned to the watercolour of the bay, adding three watercolour models: the *Pamela*, a lifeboat and a red-and-white biplane. Based on this water-colour – *Lifeboat 1* (page 199) – he made a second, *Lifeboat 2* (page 199), with the lifeboat and the *Pamela* painted on the paper, and two sinking freighters; a yellow plane in relief and a lighthouse in bas-relief were

190 *St. Lucia Canoe*, 1993.

191 *Gypsy*, 1992.

added to the surface, their relief effect accentuated by a large, deep frame. The artist then executed two replicas with models, *Shipwreck I* (page 200) and *Shipwreck II* (page 200), by inverting *Lifeboat 1* using a slide reversed on a light table. Bringing them together, he then painted *Shipwreck* (page 201) on canvas, presenting the two scenes side by side in the symmetrical manner, he says, of a Rorschach test.

With the approach of old age, Morley's painting is more than ever invested with childhood memories: the series of *Shipwreck*s with the rescue at Tankerton Bay, *Margate* with the seaside resorts he frequented as a child, the models with the phase during which he was obsessed with them, *Salvonia* (page 200) with his adolescent voyage to Newfoundland on the tugboat of the same name, and so on. (Though he never went to Margate, he fancied the name for the way it evoked the atmosphere he was trying to

192 *Lifeboat 1*, 1994.

193 *Lifeboat 2*, 1994.

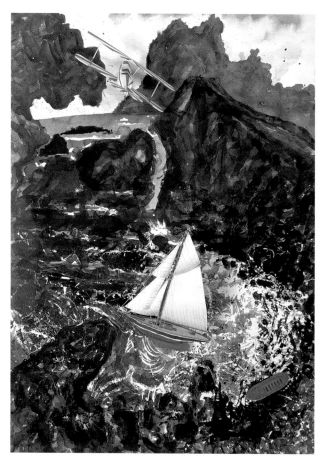

194 *Shipwreck I*, 1994.

195 *Shipwreck II*, 1994.

196 *Salvonia*, 1994.

197 *Shipwreck*, 1993–4.

198 *Racing to the New World*, 1995.

recover.) At the same time, his painting has set sail; the seascapes have
abandoned the shore for open water. Morley progressively replaced the
tropical scenes of places he'd visited – the Canaries, the Azores – with
invented seas and skies. The skies are blue, cloudy, with fine gradations
and soft edges, different from the postcard skies of the Superrealist period.
The seas are stunningly fluid and animated, with Morley exploiting to the
full the technique he developed of projecting paint with a palette knife,
farther from or closer to the canvas depending on the effect he is looking
for. The scenes of the open sea give the intoxicating impression of sailing
into the unknown on a voyage of adventure. *Racing to the New World*,
combining the *Santa Maria*, a balloon and a partly submerged airplane
wing, is the perfect realization of the adventure painter Morley was incited
to become by the voice in the shower.

The new technique culminated in 1994 with canvases like *Titan*,
painted in Morley's bedroom. One sees the white bed, a pink chair, the
blue walls with a pink arched opening, and the old English painting
Richmond Hill (page 15) that Morley bought back from the actor John Mills.
At the foot of the bed in the foreground lies a sailor's outfit, and behind,
the sleeping silhouette of his dog Max. The flattened treatment of this area
makes it difficult to read the distances. Enlarging their scale, the painter
included some of his favourite models of the time: the lighthouse lying
on its side on its rocky base, the tugboat and the blue and yellow airplane
from *Keepers of the Lighthouse*, which we also find in *Salvonia*. The tugboat

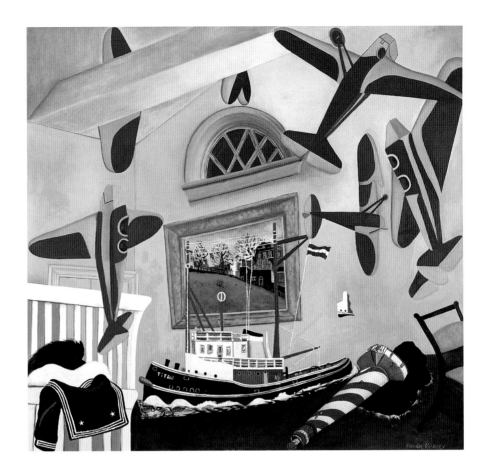

199 *Titan*, 1994.

200 *Bay of Angels*, 1995.

recovers its 'true' name, *Titan*, which in *Salvonia* had been replaced with the name of the boat on which Morley had made his first transatlantic crossing. It lies together with its multicoloured reflection on the dark green surface. Though Morley had begun by painting it further to the right, he repainted the blue wall above, transgressing his own law ('I'm not an oil painter on oil paint, I'm an oil painter on canvas') but leaving as witness a bit of the first boat's white, red and black like a fragment of wallpaper. The airplane is painted five times in different positions, as if a squadron had invaded the room; one of the planes is partially eaten by the space. The texture is softer and more nuanced than reproductions suggest, yet the precise treatment of the whole and the difficult spatial relationships of the models evoke Magritte's *Personal Values*, but Magritte investing intimate space more fully with paint.

This technique sometimes produces a hallucinatory feeling, a true *super*-realism. Rather than a photographed reality, one seems to be seeing a materialized fantasy. A real motif like the orange crane in *Bay of Angels* (page 203), based on a watercolour of the Azores, evokes a giant spaceship; the port scene, in the painter's eyes and hands, takes on a sci-fi reality, transfigured yet remaining perfectly identical with itself – as if, in the words of Homer narrating the return of Ulysses to his island home, everything appeared different to him.[41] (One of the aquatints of Morley's *The Fallacies of Enoch* series [1984] is titled *Return of Ulysses*.) The gradations of the sky from dark blue to white clouds – which literally rise above the horizon – are largely responsible for this effect. The late Malevich never seemed so close at hand.

COMBINATORY

Besides the tighter drawing style, Morley's technique of painting from models developed into a combinatory process. Thus, in 1992, he painted *Flight from Atlantis*, based on a Canary Islands watercolour of two fishing boats on the shore and two boats on the sea, to which he added a three-dimensional airplane (the balsawood Sopwith Camel covered with watercolour paper) propped against the canvas and the sky. At the right, part of the sky reappears perpendicular to the horizon: the painter began this picture vertically, and after painting one strip and the beginning of another one, rotated the canvas 90 degrees and painted everything else, provoking a fortuitous meeting between the snowy summit, the brown

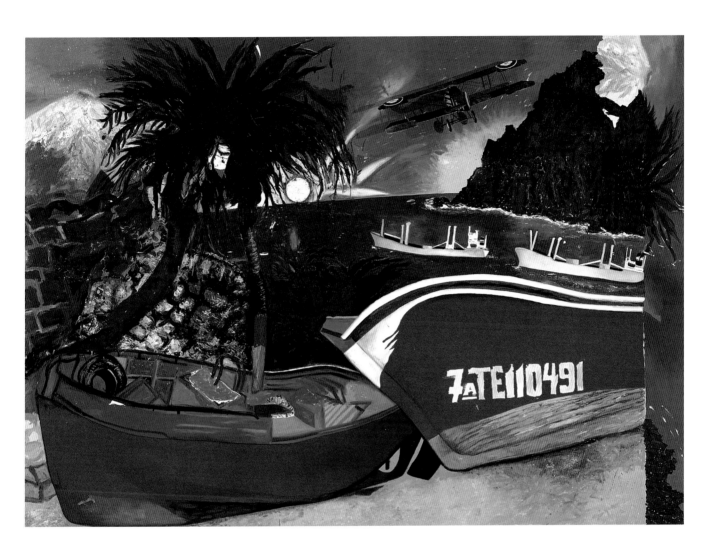

201 *Flight from Atlantis*, 1992.

rock and the top of the palm tree. In 1993–4, he painted a variation of this picture called *Guardian of the Deep*, replacing the 3-D airplane with another in paper painted with wax – still the Sopwith Camel but an instruction model with a decorative motif in white, red and orange – rising into the purplish sky. The airplane's shining sun echoes the 'real' sun on the horizon; the right-hand band was erased and a Navy rifleman added, seen from behind.

In 1994, he returned to the shining biplane, painting it from above (as in *Guardian of the Deep*) and below, and combining it with a trawler and the small yacht *Pamela*. The seascape with its tropical beach is imaginary, and the sky is cut in two by the views of the biplane. Morley painted three variations of this composition beginning with *Regatta*, a small canvas commissioned by a Swiss lingerie manufacturer whose name, Fogal, is written on the trawler. All of the elements are painted in oil on the canvas except for four little flags in painted watercolour paper (the tip of the yacht's mast carrying the [Swiss] flag is a small piece of wood sticking out of the canvas). The painter's signature is furnished with a copyright mark, also found in *Shipwreck* and *Convoy* (1994). On the basis of *Regatta*, traced

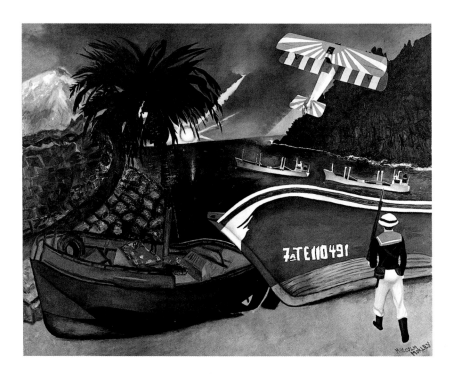

202 *Guardian of the Deep*, 1993–4.

203 *Regatta*, 1994.

204 *Now Voyager*, 1994.

205 *The Rescue*, 1994.

on mylar and enlarged to obtain clearer lines, Morley painted *Now Voyager* (page 207), which comprises few figurative variations but refines and sharpens the elements of *Regatta*; now there are six flags in watercolour paper, and the name Fogal is missing. Finally, he painted *Man Overboard*, the largest of the three compositions, with three flags chosen for their formal qualities, one done in watercolour paper (on the *Pamela*, now American); behind the trawler, which has become *YM 60*, he added the hull of a black ocean liner, another ocean liner in the background and a sailor holding two flags (signifying 'man overboard'). He underlined the upper division by tracing a line in gold leaf which one can read as an abstract division or as a lightning flash criss-crossing the sky.

In the manner of Ingres, Morley does scores of combinatory variations on his own paintings. This was how he painted *The Rescue* in 1994, on the basis of four models – a lifeboat, an upside-down lighthouse, a tugboat and an airplane; then a larger picture to which he added a boat and a

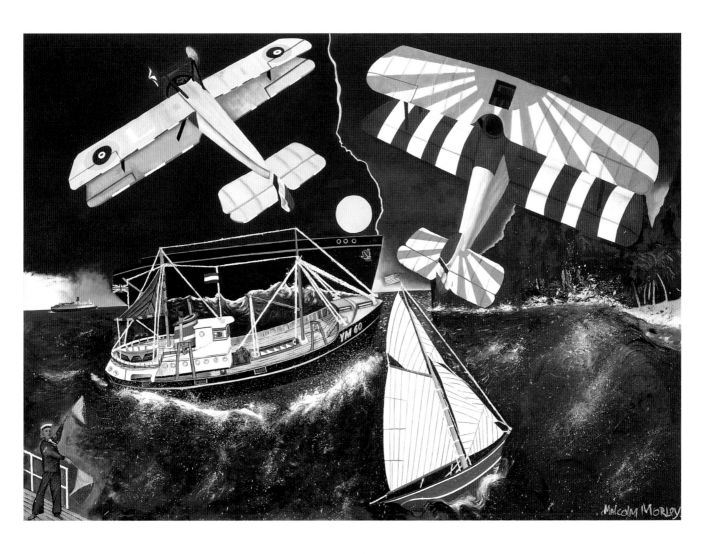

206 *Man Overboard*, 1994.

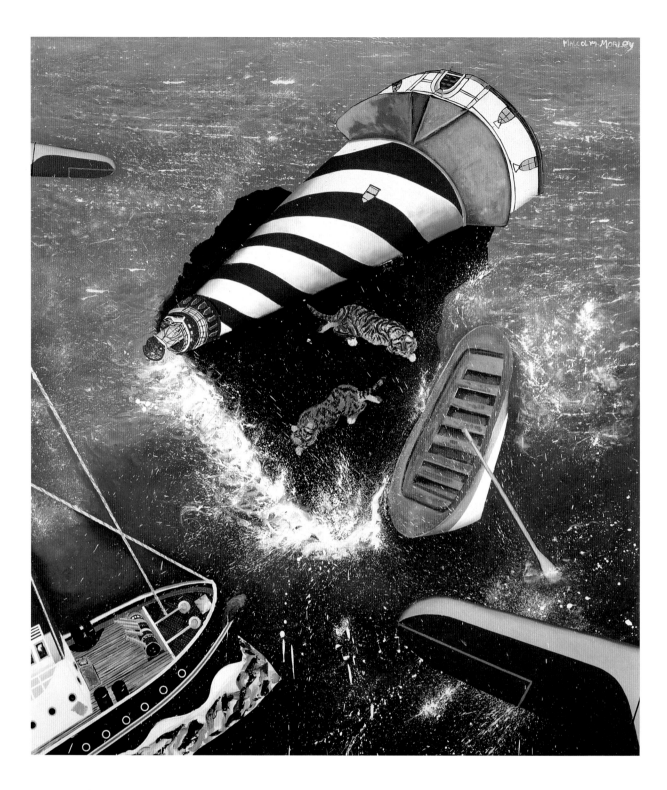

207 *Keepers of the Lighthouse*, 1994.

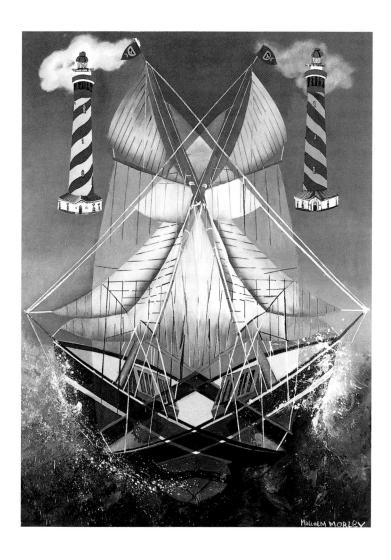

208 *Double Pamela*, 1993.

second wing of the same blue and yellow airplane. Finally, he painted a third composition, *Keepers of the Lighthouse*, in which he cut the top off and added two tigers, one with eyes of different colours, onto the rocky ledge where the lighthouse stands – an unusual composition whose surrealism is accentuated by the very Miró-like reflection of the tugboat and the impossible *trompe-l'œil* effect (*à la* Dalí) of the aquatic surface that appears in relief above the airplane wing in the foreground. In 1996, he reused *Racing to the New World* – itself a version of *Columbus Day* – in *Santa Maria with Sopwith Camel Wing*, replacing the added flags with ones painted on the canvas and adding a frame in *trompe-l'œil*, the composition remaining meanwhile unchanged. *Ship of Shields* (1995), enlarged, became *Medieval Ship*; then, furnished with a yellow sky and a painted frame, *Medieval with Lemon Sky*. As for the yacht *Pamela*, we see it a dozen or more times in 1993 and '94 from *Icarus* to *Man Overboard*; *Double Pamela* was composed on a light-table by superimposing a slide of *Pamela Running the Wind with*

Lighthouse over another slide of the same image reversed. It is obvious that this small yacht aroused Morley's pictorial interest, just as the model Laurette aroused Matisse's in 1916–17.

This proliferation of models increased the artist's production – he had never painted as much as he did during 1994–7 – but it also threatened to produce a sense of *déjà vu*, of refinement more than inventive force. Despite this, it followed the logic of his combinatory approach, associating different types of models, epochs, techniques and textures. The clarity of surfaces highlighted the discontinuity and unusualness of combinatory associations; Morley likes to refer to Lautréamont's dissection table. (One could also speak of a perpetual rat-trap.)

In 1998, Morley focused his efforts on the large recapitulatory canvas, *Mariner*. Measuring 295 × 380 cm, it is the biggest pictorial surface he has ever covered (*New York Postcard Foldout* and *The Oracle* are technically polyptychs). Consequently, *Mariner* sums up the '90s just as *Lonely Ranger* and *Black Rainbow* summed up the two previous decades. A combination of combinations, *Mariner* associates four of the canvases made from models or from other combined canvases based on models: *Man Over-board*, *Racing to the New World*, *Longitude* (itself done from *Salvonia*) and *Keepers of the Lighthouse*. Morley himself said in 1993: 'In a way, the pictures are a lot of little paintings put together,'[42] yet here, the included compositions are enclosed as in some of Kandinsky's later compositions (*A Conglomerate* [1943]). To obtain a relatively satisfying scale, Morley the traditionalist painter, who refuses to touch a computer, had to call on a graphics specialist for help with Photoshop. He painted a large canvas from a synthesized image of the four earlier pictures, observing the divisions between the original works (as well as the subdivision in *Man Overboard*), which sometimes cut a figurative element (the blue and yellow wing on the bottom), but more often invite spillovers from the lighthouse or the boat:

> In realizing specific passages, Morley also relied on cut-up transparencies of prior paintings affixed to a miniature light-box hanging from an adjustable, T-square device positioned above the canvas. The result is a sort of teeming or exploded cruciform, full of drastic inconsistencies in perspectival 'logic'.[43]

Most exploded is the part found at the bottom right, the quadrant taken from *Longitude*. Besides the tugboat with its odd reflection, truncated in

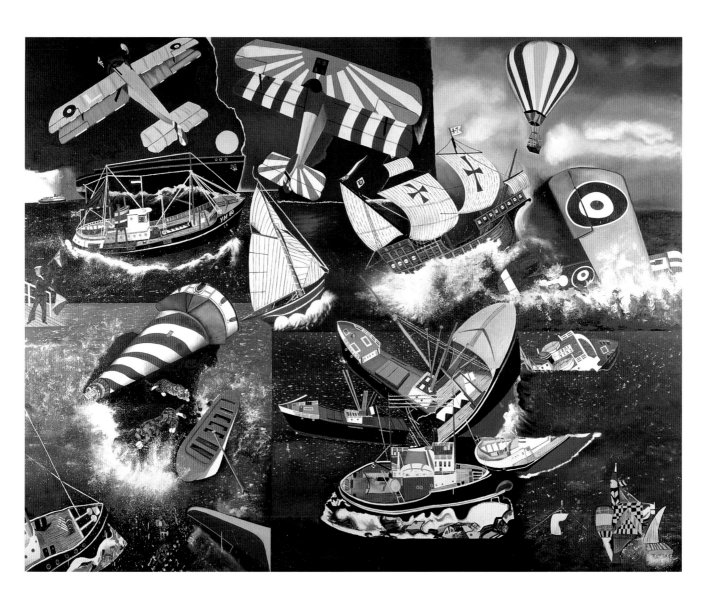

209 *Mariner*, 1998.

the bottom left, all of the boats are cut off and appear to be sinking into or bursting out of the sea; the galley has become a submarine; under the central division, only the stern of the cargo ship is visible (the one whose model was run over and painted in white); off to the left, its bow reappears twice (seen from two different angles, as was already the case in *Salvonia* and *Longitude*). Under the stern of the cargo ship, separated by a stretch of sea, appears the trawler *YM 60* (the same seen intact at the upper left, in the section based on *Man Overboard*), whose bow reappears to the right of the double freighter. All these displacements were simultaneously prepared and improvised with knowing skill; one thinks of W. C. Fields tilting his head as he puts his hat on. Towards the centre of the painting, surging ahead on white-capped waves, the *Pamela* appears to direct this bizarre merry-go-round.

As Patrick Fischer pointed out to me when the painting was shown at the Sperone Westwater Gallery in New York, it enumerates the many ways of painting foam. Morley had mastered the technique of projecting paint with a spatula. The pictorial texture, generally sharp, sometimes loses its edge, as in the image of one of the tigers whose stripes seem to dissolve or unravel like a worn-out plush toy.

YELLOW PAINTINGS

In May 1997, after a trip to South Africa, Morley presented a show of oil paintings and watercolours at the Galerie Templon in Paris which centred on boats of all kinds – caravels, galleys, dreadnoughts and freighters – most of them on lemon-yellow backgrounds. The majority of critics gave well-meaning if uncommitted lectures about little boats being pretexts for painting. Two of them, writing in the events section (under the aegis of Guy Debord) of a trendy magazine, took it upon themselves to declare categorically, though in hesitant French, that Morley had plumbed the depths of painterly inanity:

> One could always claim: if it's that bad, it's best not to say anything about it, it's irrelevant. To the contrary, it strikes us as imperative to say just how bad Malcolm Morley's painting is, and that you really have to see it to realize it. So bad that it tries to flaunt colours and cliches in order to pass for kitsch . . . One boat, two boats; one 'naval', a load of amateurish rot . . . And don't accuse us of a hatred for painting: we just don't reduce it to this level of crap.[44]

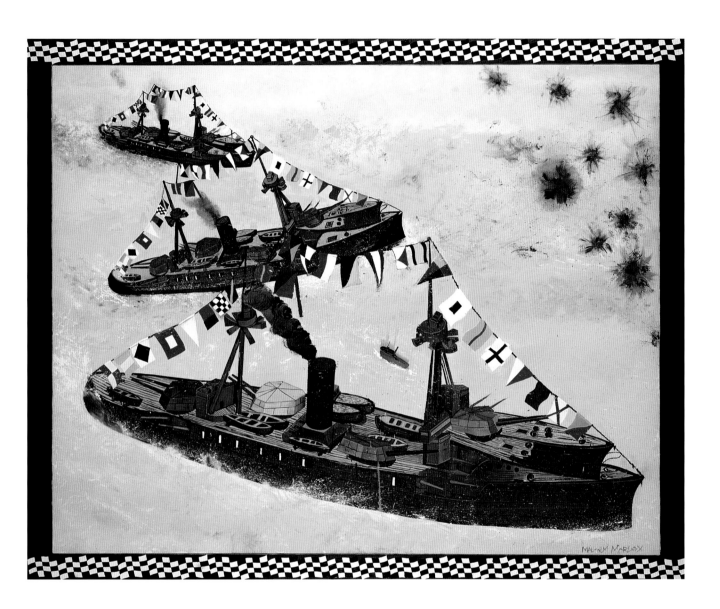

210 *Battle of the Yellow Sea*, 1996.

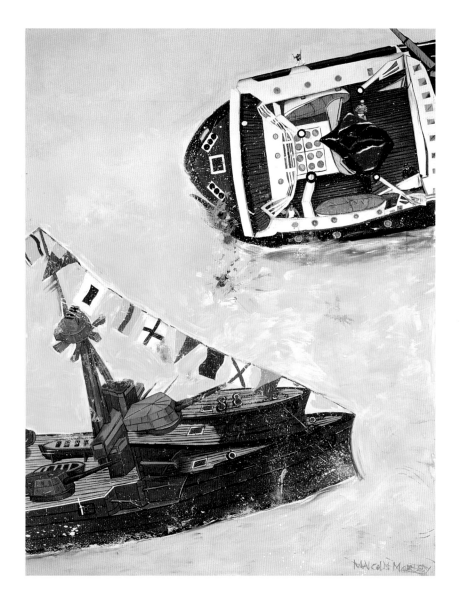

211 *The Raider*, 1997.

More than ever, one thinks of Gauguin's comment to Cézanne, reported by Emile Bernard: 'Nothing resembles crude painting more than a masterpiece.'[45]

Such a reaction is entirely understandable: these yellow paintings are among the most aggressive Morley has ever painted. The presence in the Templon show of appreciably different canvases, *The Landing* or *Daedalus* (page 220), or blue variants of the yellow paintings, only accentuated the works' hard-core quality. Asked why he chose to paint these skies and seas in acid yellow, the painter claimed in his typical *faux naïf* way that his assistant Peter had pointed out an abundance of yellow paint on his shelves (Morley has hundreds of different colours arranged by groups in nine sections: browns, purples, dark reds, light reds and oranges, yellows, greens, blues, whites and blacks, with a shelf for extras.) So he treated

these seascapes as he had previously done, caressing the cloudy skies with his fan-shaped brush, creating foamy seas with splatterings of white, but replacing the skies' and seas' blue with that peculiar yellow, sometimes alternating the yellow canvases with blue versions. The association of illusionist texture and unrealistic colour recalls Magritte with Morley's characteristic sensuousness of paint thrown in. The yellow surfaces are multifunctional, denoting sky, sea, one and the other indistinctly, or an abstract background. The battleships (for example, the three boats of *Battle of the Yellow Sea* [page 215]) come from the same drawing, enlarged or reduced in a photocopier and transferred onto canvas with carbon paper, in the manner employed by fifteenth-century fresco painters. The unreal, illusionistic effects are reinforced by decorative frames, contradictory perspectives (*The Raider*) and impossible transfers: here, part of a bridge is transferred onto a hull (*Navy Day, Battle of the Yellow Sea*); there, another one is cut off (*Below the Water Line, Spanish Dreadnought*). In the 1998 painting *Battleship with Honors*, where military decorations are shown in perfectly illusionist, three-dimensional watercolours (though larger than their model), the arbitrary breaks of the grid produce unexpected divisions, for example the sudden enlargement of part of a bridge or an array of flags where the surface is suddenly multiplied by four. As for *Mariner*, Morley explains that, when blocked, he is sometimes obliged to modify certain aspects arbitrarily:

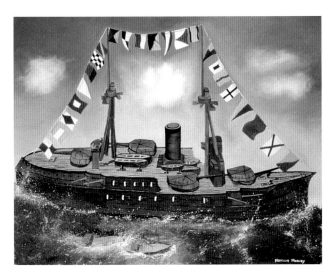

212 *Spanish Dreadnought*, 1996.

213 *Battleship with Honors*, 1998.

I came to a stop and I thought that the size of the squares in relation to the imagery was too small; I couldn't continue. So I changed the scale, but in order to change the scale, it always has to go up by four to stay square, so I have to go up by four, or sixteen, or sixty-four steps. What was being painted in this small one, fitting in all of that [a single square], now could fit in all of this [a square divided in four]. But most of that is made in order to be able to proceed. Once I got going, I could go back to small scale.

The small painting *M.V. Perception with Cargo of Primary and Secondary Colors and Black and White* is a concentrate of problematical perceptions. The fragments of the freighter, seen from above, seem to move forward in a narrow stretch of water, but this area is suddenly framed by a totally abstract field of yellow, even though part of the rigging and splashes representing the foam cross the separation line between it and the water. The freighter transports nothing but pure colours (the yellow is denser, warmer, redder than that on the margin), contained in parallelepiped forms, but the orientation of these volumes is contradictory: the primary colours,

214 *M.V. Perception with Cargo of Primary and Secondary Colors and Black and White*, 1997.

the white and the black appear as if seen from below, the secondary ones from above. The whole produces an intense visual effect due to the mixture of carelessness and harsh constraint, illusionism and spatial impossibility. The viewer's gaze is solicited and disorientated everywhere, at once.

Because of their labyrinthine vision and aggressive colour, the yellow paintings leave an impression both cheerful and poisonous, extremely vicious, confounding the habits of perception. Materially and semantically, these paintings are opaque, but they open the door to all kinds of delirium. (At the time, I proposed a thalassal-urinary reading for them – a dream of pure fantasy – in a Swiss magazine.) Perceived by critics as nostalgic or radically bad, these works are in fact radically up-to-date; few people realize this, for few people are contemporary.

SPRINGBOKS AND PARAGLIDERS

Morley's recent paintings flirt with effects of absolute bad taste. *Daedalus* is like the reverse of *Flight of Icarus*: where the invisible son with his red three-dimensional Fokker flew right into the sun, the invisible father in Christopher Columbus's flat caravel leaves a sun of incredible form and colour, an orange monstrosity whose bizarre shape is underscored by a dark contour which sets in a reddish purple sea under a blue-violet sky. The harmony is intense and original, like a hardcore revival of the blood-red-orange cathedral painted ten years earlier. Morley's jubilation in attacking the sea with the point of his palette knife in order to render the stream split by the caravel is palpable.

Another painting liable to cause shivers is *Springbok* (page 221), a work modelled on a South African postcard. Unlike *Daedalus*, this scene of a herd of antelopes travelling through the bush is treated in fluid contours and soft light blue, grey-blue and beige tones. The strange, skilful rendering of movement and shadow that dissolves the animals' bodies contrasts with the quasi-Disney imagery. Here, the heterogeneity at the heart of Morley's aesthetic vision provokes such a bittersweet sensation that one can almost taste it.

Morley, who has an eye for kitsch (I was able to confirm this once when we went to a yard sale in Brookhaven), told me one day that kitsch was an invention of Clement Greenberg. This seems accurate on reflection. The concept rests on an hierarchical opposition between tastes, which

215 *Daedalus*, 1996.

216 *Springbok*, 1997.

Morley's art, since the beginning and with increasing frequency, has largely sapped of its strength. Jackson Pollock summed up his own painting in nine words: 'Energy and motion made visible – Memories arrested in space.'[46] As soon as Morley's direction became clear, he barely needed more than nine words to define it: 'I am painting the world bit by bit by recycling garbage into art.' The only thing he asks of his material is that it be interesting to paint. Kitsch is not a problem; at best, it's a spice to wake up one's taste buds. Morley uses it when he needs to, uninhibitedly, with a carelessness recalling the regal immodesty of Manet's *Olympia*.

In 1997, on a visit to Aspen, Colorado, Morley was impressed by the sight of paragliders manoeuvring through the mountain air; a champion of this new sport was killed during the artist's stay when he fell onto a rocky slope on the Fourth of July. Morley added gliders to his stock of aero-naval imagery. On location, he painted a watercolour of Maroon Bells; from photos (cut from speciality magazines like *Discovering Paragliding* and combined in various ways and at various scales), he made a work in oil on paper showing four paragliders – one pink, one green and two yellow –

217 *Parasailors with Maroon Bells*, 1998.

218 *Synthetic History*, 1996.

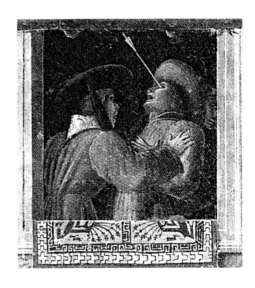

219 Detail of fresco by Andrea Mantegna showing the martyrdom of St Christopher, Ovetari Chapel, Church of the Eremitani, Padua, *c.* 1449–51.

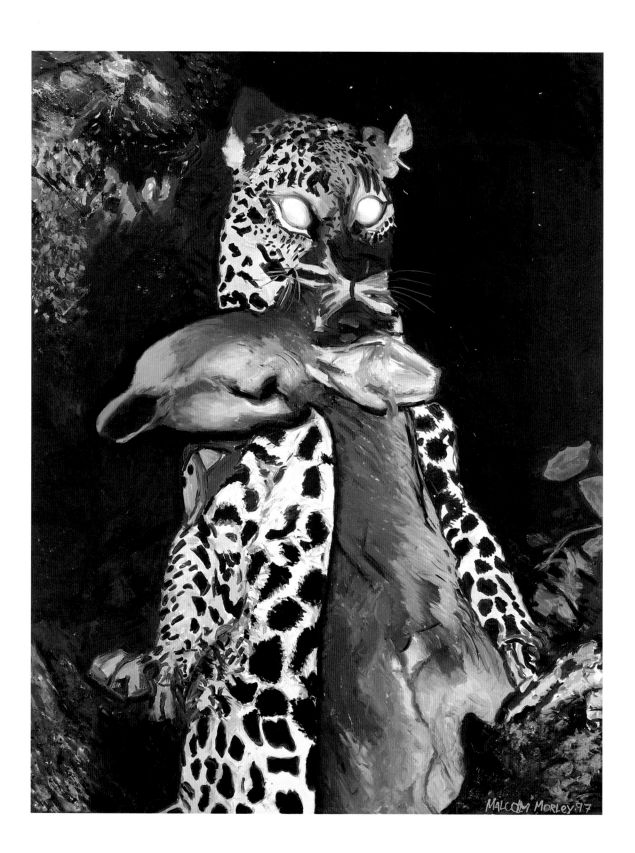

Malcolm Morley '97

soaring in a blue sky. In 1998, he transformed this watercolour into a canvas, adding to the wild landscape a small model of a paraglider minus ropes but with his glider, each of them affixed to the canvas by a movable magnet. In *Approaching Valhalla*, he combined the four paragliders with three views of a Roman galley and the Fokker from *Flight of Icarus*, associating these new athletes with the overly audacious Icarus. This canvas is a pictorial equivalent of the audacious youth, though less so than *Parasailors with Maroon Bells* (page 222), in which three large paragliders in disco colours float in a landscape of violet and white. Despite their synthetic appearance, the paragliders are painted in oil; only the ropes attaching the gliders to their invisible pilots are traced in fluorescent acrylic. The visual effect is one of monstrous, psychedelic larvae. Morley was probably seduced by the high-tech colour of these gliders, the gratuitous risk taken by the pilots, the sensation of full flight in open country and the sense of modern savagery. It is interesting that these paintings appeared after other images of danger and death: a medieval knight in armour whose eye is pierced with a three-dimensional arrow (the diptych *Synthetic History* [page 223] – Morley is not familiar with Mantegna's bombed fresco in the church of the Eremitani at Padua) or a white-eyed leopard holding a dead antelope in its jaws (*Leopard Panthera*). This last work is part of a larger series of South African animals which Morley holds in reserve, both postcards and watercolours; one of the latter is modelled on a painting done from the back of a bus, while the others were painted on a freighter off the South African coast from postcards of snakes, giraffes, zebras, storks and elephants. Several of these watercolours were shown in Aspen in 1997. A visual element linking the paragliders he saw there to the medieval knights is their violent chromatic saturation, which gives the sensation of jubilant death.

220 *Leopard Panthera*, 1997.

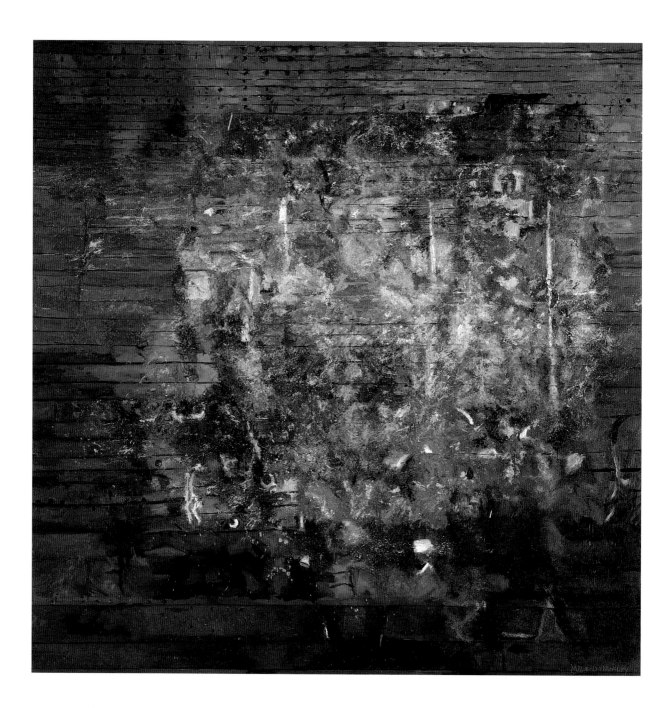

221 *Painter's Floor*, 1999.

7 *Painter's Floor*

In March 1999, soon after his show at the Sperone Westwater Gallery
whose main focus was paintings made from models, Morley painted a
2.5 × 2.5-m picture from a photo of Pollock's studio floor, cut out of the
catalogue of Pollock's recent retrospective at the Museum of Modern Art,
New York. (When the painting was finished, we went to visit Pollock's
studio, now open to the public, which turned out to look quite different
from the photo.) The ceiling view is nearly adirectional like the canvas,
which Morley rotated after completing half of it. He thought of affixing
objects to it, but gave up this idea, perhaps judging that the painting in
oil sufficed. He then flirted with the notion of sprinkling it with diamond
dust (he'd just finished reading Victor Bockris's biography of Warhol).
Resembling nothing he had done previously, the painting appears multi-
dimensional and somewhat Dalí-like in its hallucinatory atmosphere
(though not in its technique). The idea was to project the image of what
Morley saw onto the canvas in small cut-outs roughly 12 mm in size.
There are sixteen-by-sixteen pieces of the cut-up photo, each glued above
its corresponding 15 × 15 cm square. The information supplied by these
units is reduced to a minimum in order to leave more room for pictorial
invention. The harmony is a rather unsaturated but rich and varied in
warm browns, light greys and some bursts of vivid colour here and there
– orange, violet and silver. In the middle, a Rothko-like configuration
represents the remains of paint left on Pollock's studio floor: from a
distance, this becomes three ghostlike figures, a fantastical version of
Picasso's *Three Musicians*. The brown wooden boards were drawn with a
brush, but the paint spots on the floor were mostly painted with plastic
wrap. (Morley uses plastic wrap like a glove, putting paint on his fingers
and moving it around with his wrist to create a pockmarked effect similar
to a lunar landscape.) The surface is astounding, filled with fantastic
effects which vary according to lighting and distance. From far away, it
looks like a strange architecture of brick whose base has been eaten away,
forming a hollow in the wall. When the lighting is soft, some elements
seem to float off the painted surface. In this painting, Morley combined
in all possible ways three styles of applying paint to canvas: with brushes,
by projecting it from close up with a palette knife, and with a sheet of
plastic. He has said that this is a new direction for him; he wonders if
he should try an abstract painting with no model but the grid. Abstraction
is impossible for him, but so is representation; he lives with it like a
curse. (A linguistic curse, since for him '. . . all painting is abstract.

222 *Fallen Hero*, 1997.

223 *Out of Africa*, 1999.

The idea of whether there was a figure or not is a figure of speech.'[1])

With this painting, Morley drew away from the neat style he had adopted during the 1990s. He had just abandoned a canvas of a medieval knight based on *Fallen Hero*, a three-dimensional watercolour over a floral background from 1997; this large, precisely drawn painting did not satisfy him. But this does not signify an unequivocal return to a more pictorial technique. The paintings he began just after *Painter's Floor* recovered a freer texture with little outlining and no clear-cut contours; the main idea was to associate or combine different pictorial textures. In *Out of Africa*, from a watercolour of a lion modelled on a cut-out postcard, the lion is painted, like Morley's other animals, in a dense but fluid style, its paws

sinking into the ground. But the added elements offer a different surface to the eye: a small two-coloured biplane is done in the same clean technique as his previous paintings; a herd of elephants gives an unprecedented visual sensation whose precision lies more in texture than in line.

Morley has recently purchased a copy of *Velázquez: The Technique of Genius* by Jonathan Brown and Carmen Garrido,[2] a book in which several details of the Spaniard's paintings are reproduced. He's very interested in the process that Diderot, considering Chardin, called the magic of painting: the transformation produced by the distance of the gaze, which transforms formless spots into air, light, objects and natural textures. He also started painting *July*, since retitled *Fire Boat* (page 230), from a page of a Dutch calendar depicting several seagoing vessels; he's planning to use such calendars for seven paintings. This one shows the *Città della Spezia*, a tugboat testing its fire-fighting equipment: a double spray of water rising over the sea creates an iridescent vapour. This seems like a return to 30 years ago; as in the Superrealist period, he's back to boat pictures, each one painted from a single photographic reproduction. No more three-dimensional models, no more complex compositions. Now, Morley copies the image by itself without margins or text, intensifying the colour of the source. What defines the tension between surface and depth is the image's pictorial texture and the shift of vision from front to back. In order to accomplish this, the painter tries to reduce the information supplied by the source to a minimum; he cut the photo into sixteen-by-sixteen pieces, and when there's too much information (in the boat area), he subdivides each square in four. The idea is to translate each of these elements by means of a painting which renders itself visible.

Concerning *The Landing*, Philippe Dagen has remarked that each of the areas of the image – sky, sea, coast – has its own coloured texture.[3] In *Fire Boat*, almost every square of the grid has its own texture, resulting from a pictorial interpretation of each of the 12×16-mm pieces. The painter goes over two border squares with a large brush to obtain soft transitions. Once the image that offers the largest variety of textures is chosen, he can continue indefinitely.

Finishing the painting *Fire Boat*, Morley says: 'There's something wacky about it.' (One of the water sprays, rectilinear on the photographic source, is somewhat twisted in the canvas.) True, but one can say that about all of his paintings.

224 *The Landing*, 1996.

225 *Fire Boat*, 1999.

Epilogue

In 1999, Morley announced that he was going to repaint all of his paintings.

References

I MEMORY

1 Patricia Scanlan, 'The Sailor Who Went to Sea to See', *Lovely Jobly* (December 1990).
2 Sarah Mc Fadden, Interview with MM, in 'Expressionism Today: An Artist's Symposium', *Art in America* (December 1982), p. 68.
3 Nena Dimitrijevic, 'MM', *Flash Art* (October 1988), p. 76.
4 Richard Milazzo, 'MM and the Art of the Incommensurable', in *MM: Dipinti/Acquerelli/Disegni/Sculture* (Modena, 1998), p. 90.
5 Robert Pincus-Witten, 'Entries: I: Baselitzmus; II: Borstal Boy Goes Mystic', *Arts Magazine* (June 1984), p. 98.
6 Dimitrijevic, 'MM', p. 77.
7 Brian Fallon, 'MM: A Major Artist on Both Sides of the Atlantic', *Irish Times*, 9 September 1990.
8 Gordon Burns, 'An Artist with No Artifice', *Times*, 15 November 1984, p. 15.

2 YOUTH

1 R. Milazzo, ed., 'Showing the View to a Blind Man', unpub. ms., 1998–9, p. 4.
2 *Ibid.*, p. 12.
3 *Ibid.*, p. 8.
4 Richard Francis, 'MM', *Bomb*, 55 (Spring 1996), p. 28.
5 Anthony Haden-Guest, 'Daddy-O: The Wild Life and Art of MM', *New York Magazine*, 20 February 1984, p. 42.
6 Milazzo, '*Showing the View*', p. 22.
7 Haden-Guest, 'Daddy-O', p. 42.
8 John Yau, 'MM', *Flash Art*, 122 (April–May 1985), p. 31.
9 See Kim Levin, 'Malcom Morley [*sic*]: Post Style Illusionism', *Arts Magazine* (February 1973), p. 61; Nena Dimitrijevic, 'MM', *Flash Art* (October 1988), p. 79; Francis, 'MM', p. 29.
10 Lawrence Alloway, 'The Paintings of MM', *Art and Artists* (February 1967), p. 17.
11 Dore Ashton, 'Unconventional Techniques in Sculpture: New York Commentary', *Studio International* (January 1965), p. 25.
12 Michael Compton, *MM: Paintings 1965–82* (London, 1983), p. 8.

3 FIDELITY PAINTINGS

1 Robert Bechtle, 'The Photo-Realists: 12 Interviews', *Art in America* (November–December 1972), pp. 72–3.
2 Kim Levin, 'Malcom Morley [*sic*]: Post Style Illusionism', *Arts Magazine* (February 1973), p. 60.
3 Richard Francis, 'MM', *Bomb*, 55 (Spring 1996), p. 29.
4 Lawrence Alloway, 'The Paintings of MM', *Art and Artists* (February 1967), pp. 17–18.
5 Francis, 'MM', p. 29.
6 Levin, 'Illusionism', p. 61.
7 Francis, 'MM', p. 30.
8 Alloway, 'Paintings', p. 18.
9 William C. Seitz, 'The Real and the Artificial: Painting of the New Environment', *Art in America* (November–December 1972), p. 65.
10 Brooks Adams, '1990s Morley: The Return of the Prodigal Son', in *MM, 1965–1995*, exh. cat., Fundación La Caixa, Madrid (1995), p. 58.
11 William Kloss, '30 Years of a Sometimes Puzzling Artist', *Washington Times*, 13 September 1983.
12 See Alloway, 'Paintings', p. 19; *idem*, 'Art as Likeness', *Arts Magazine* (May 1967), p. 37.
13 Robert Pincus-Witten, 'Sound, Light and Silence in Kansas City', *Artforum* (January 1967), pp. 51–2 (a review of a group show at the Nelson-Atkins Museum in Kansas City entitled *Light, Sound and Silence*).
14 Janet Daley, 'Pop Vulgarism', *Arts and Artists* (July 1969), p. 44.

15 Frederic Tuten, 'MM', *Arts Magazine* (March 1967).
16 Lawrence Alloway, 'Morley Paints a Picture', *Arts News* (Summer 1968), p. 43.
17 *Ibid.*, pp. 42–4, 69–71.
18 See Andy Warhol, *POPism* (New York, 1980), pp. 185–8.
19 Robert Storr, 'Let's Get Lost: Interview with MM', *Art Press* (May 1993), p. E7.
20 Alan G. Artner, 'MM: Still Bucking Trends and Surprising His Peers', *Chicago Tribune*, 27 November 1983.
21 Storr, 'Let's Get Lost', p. E4.
22 Matthew Collings, 'The Happy Return', *Artscribe* (January–February 1985), p. 18.
23 Ted Castle, 'The Paint Drain', *Art Monthly* (July–August 1981), p. 12.
24 Alloway, 'Morley Paints', p. 69.
25 Jean-Claude Lebensztejn, 'Photorealism, Kitsch and Venturi', *Sub-Stance*, 31 (1981), pp. 86–7.
26 Bruce Kurtz, 'Documenta 5: A Critical Preview', *Arts Magazine* (June 1972), p. 37.
27 MM, Statement, in *Environment USA, 1957–1967*, Ninth Biennal of São Paulo, p. 89.
28 Barnett Newman in 1962; Barnett Newman, *Selected Writings and Interviews*, ed. John P. O'Neill and Mollie McNickle (New York, 1990), p. 251.
29 Nena Dimitrijevic, 'MM', *Flash Art* (October 1988), p. 79.
30 Francis, 'MM', p. 30.
31 Levin, 'Illusionism', p. 61.
32 Barnett Newman in 1962; see Newman, *Selected Writings*, p. 250.
33 Dimitrijevic, 'MM', p. 78.
34 Artner, 'Still Bucking Trends'.
35 Sarah Kent, 'Art Attack', *Time Out* (26 September–3 October 1990), p. 16.
36 Dimitrijevic, 'MM', pp. 78–9.
37 Storr, 'Let's Get Lost', p. E6.
38 Alfred Frankenstein, 'The High Pitch of New Realism', *San Francisco Examiner & Chronicle*, 17 August 1969, p. 30.
39 H. D. Raymond, 'Beyond Freedom, Dignity and Ridicule', *Arts Magazine* (February 1974), p. 25.
40 Sarah McFadden, Interview with MM, in 'Expressionism Today: An Artists' Symposium', *Art in America* (December 1982), p. 68.
41 'MM, The Outsider', *Omnibus*, BBC TV broadcast produced by Mike Mortimer, 1985.
42 Kurtz, 'Documenta 5', p. 37.
43 Brice Marden to Mark Rosenthal, in *Mark Rothko*, exh. cat., National Gallery of Art, Washington, DC (1998), pp. 359–60.
44 Phyllis Tuchman, 'An Interview with Carl Andre', *Artforum* (June 1970), p. 57.
45 Robert Venturi, Denise Scott Brown and Steven Izenour, *Learning from Las Vegas* (Cambridge, MA, and London, 1972), p. 112.
46 Gene Swenson, 'What is Pop Art?', *Art News* (November 1963), pp. 60–61.
47 See Rainer Crone, *Andy Warhol* (New York and Washington, 1970), p. 270; *Andy Warhol*, exh. cat., Museum of Modern Art, New York (1989), p. 305.
48 Lawrence Alloway, Introduction, *The Photographic Image*, exh. cat., Guggenheim Museum, New York (1966), p. 4.
49 See Carter Ratcliff, Review of the *22 Realists* exhibition at the Whitney Museum of American Art, New York, *Art International* (April 1970), p. 68.
50 William C. Seitz, 'The Real and the Artificial: Painting of the New Environment', *Art in America* (November–December 1972), p. 65.
51 Rosalind Constable, 'Style of the Year: The Inhumanists', *New York Magazine* (16 December 1968), p. 44.
52 Lawrence Alloway, 'The Paintings of MM', *Art and Artists* (February 1967), p. 18.

4 CATASTROPHES

1 Richard Francis, 'MM', *Bomb*, 55 (Spring 1996), p.30.
2 Nena Dimitrijevic, 'MM', *Flash Art* (October 1988), p. 78.

3 *Ibid.*
4 Alan G. Artner, 'MM: Still Bucking Trends and Surprising His Peers', *Chicago Tribune*, 27 November 1983.
5 *Ibid.*
6 Patricia Scanlan, 'The Sailor Who Went to Sea to See', *Lovely Jobly* (December 1990).
7 Klaus Kertess, 'MM: Talking about Seeing', *Artforum* (Summer 1980), p. 49.
8 Francis, 'MM', p. 30.
9 Robert Storr, 'Let's Get Lost: Interview with MM', *Art Press* (May 1993), p. E3.
10 Dimitrijevic, 'MM', p. 77.
11 See Kim Levin, 'Malcom Morley [sic]: Post Style Illusionism', *Arts Magazine* (February 1973), p. 60.
12 See Michael Compton, *MM: Paintings 1965–82*, exh. cat., Whitechapel Art Gallery, London (1983), p. 11.
13 Levin, 'Illusionism', p. 63.
14 Dimitrijevic, 'MM', p. 77.
15 *Ibid.*, p. 76.
16 Kertess, 'Talking about Seeing', p. 49.
17 Lawrence Alloway, 'Morley Paints a Picture', *Art News* (Summer 1968), pp. 42–3, 70–71.
18 Levin, 'Illusionism', p. 62.
19 *Ibid.*, p. 63.
20 *Ibid.*, p. 60.
21 William Slattery, 'A Free-Wheeling Artist Talks Back', *New York Post*, 28 January 1974, p. 36.
22 Thierry Delaroyère, 'Mords-les Morley', *Joie de Paris*, no. 0 (December 1974) (this magazine was never published; the article is reproduced in *MM*, exh. cat., Centre Georges Pompidou, Paris [1993], p. 174).
23 See 'Dialogue: Malcom Morley [sic] with Les Levine', *Cover*, I/3 (Spring–Summer 1980), p. 30.
24 Ted Castle, 'The Paint Drain', *Art Monthly* (July–August 1981), p. 13.
25 Sarah McFadden, Interview with MM, in 'Expressionism Today: An Artists' Symposium', *Art in America* (December 1982), p. 68.
26 Barnett Newman in 1968; see Barnett Newman, *Selected Writings and Interviews*, ed. John P. O'Neill and Mollie McNickle (New York, 1990), p. 301.
27 Lawrence Alloway, 'MM, The Clocktower, 7–30 October 1976'; reprint in *Unmuzzled Ox*, IV/2 (1976), p. 53.
28 Levin, 'Illusionism', p. 11.
29 Kertess, 'Talking about Seeing', p. 49.
30 Alloway, 'Morley', pp. 51–3.
31 Compton, 'MM', in *MM: Paintings 1965–82*, p. 13.
32 Francis, 'MM', p. 30.
33 Compton, 'MM', p. 14.
34 Cézanne, *Correspondance* (Paris, 1978), p. 324.
35 Compton, 'MM', p. 14.
36 Leo Rubenfien, Review of the MM exhibition at the Clocktower, *Artforum* (December 1976), p. 64.
37 Philippe Dagen, 'Un Peintre d'histoires: MM au Centre Georges Pompidou', *Le Monde*, 6–7 June 1983, p. 11.
38 Barnett Newman in 1944–5; see Newman, *Selected Writings*, p. 81.
39 Michael R. Klein, 'Traveling in Styles', *Art News* (March 1983), pp. 93, 97.
40 See 'Showing the View to a Blind Man: MM Talking to David Sylvester', in *MM*, exh. cat., Anthony d'Offay Gallery, London (1990), p. 16.
41 Barnett Newman in 1962; see Newman, *Selected Writings*, p. 248.
42 See 'A Conversation: MM and Arnold Glimcher. Bellport, Long Island, October 3, 1988', in *MM*, exh. cat., Pace Gallery, New York (1988), p. [7].
43 John Loring, 'The Plastic Logic of Realism', *Arts Magazine* (October 1974), p. 48.

44 Félix Vallotton, 'Salon d'Automne', *La Grande Revue*, 25 October 1907, quoted in *Cézanne*, exh. cat., Philadelphia Museum of Art, Philadelphia (1996), p. 43.

45 C. R. Leslie, *Memoirs of the Life of John Constable, Esq., R. A.* (1843) (London, 1845), pp. 309, 355.

46 See 'A Conversation', pp. [7], [11].

5 TROPICS

1 'MM, The Outsider', *Omnibus*, BBC TV broadcast produced by Mike Mortimer, 1985.

2 See Kurt Badt, *Die Kunst Cézannes* (1956); English trans. *The Art of Cézanne* (London, 1965), p. 38.

3 Klaus Kertess, 'Seeing is Imagining', in *MM: Watercolours*, exh. cat., Tate Gallery Liverpool (1991), p. 7.

4 Richard Francis, 'MM', *Bomb*, 55 (Spring 1996), p. 31.

5 Picasso in 1932; see Dore Ashton, ed., *Picasso on Art: A Selection of Views* (1972) (Harmondsworth, 1977), p. 79.

6 See Kim Levin, 'Get the Big Picture?', *Village Voice*, 22–28 April 1981, p. 80.

7 Vicki Goldberg, 'MM, Keeping Painting Alive', *New York Times*, 14 March 1993, p. H31.

8 Klaus Kertess, 'MM: Talking about Seeing', *Artforum* (Summer 1980), p. 51.

9 Michael R. Klein, 'Traveling in Styles', *Art News* (March 1983), p. 97.

10 Kertess, 'Talking about Seeing', p. 51.

11 *Ibid.*

12 'Dialogue: Malcom Morley [*sic*] with Les Levine', *Cover*, 1/3 (Spring–Summer 1980), p. 31.

13 See Lawrence Alloway, *MM: Matrix 54*, exh. leaflet, Wadsworth Atheneum, Hartford (1980).

14 Picasso in 1938; see Dore Ahston, ed., *Picasso on Art: A Selection of Views* (1972) (Harmondsworth, 1977), p. 28.

15 See 'Sensation without Memory: A Conversation Between Archie Rand and MM', *Tema Celeste*, 32–33 (Autumn 1991), p. 113.

16 Valentine Tatransky, 'Morley's New Paintings', *Art International* (October 1979), p. 57.

17 Charles Baudelaire, *The Painter of Modern Life and Other Essays* (London, 1964), p. 199.

18 MM, in Kertess, 'Talking about Seeing', p. 50.

19 MM, in Patricia Scanlan, 'The Sailor Who Went to Sea to See', *Lovely Jobly* (December 1990).

20 Nena Dimitrijevic, 'MM', *Flash Art* (October 1988), p. 79.

21 *Ibid.*

22 Nicolas and Elena Calas, 'Artificial Realism', *Icons and Images of the Sixties* (New York, 1971), p. 157.

23 See 'Sensation without Memory', p. 113.

24 Ted Castle, 'The Paint Drain', *Art Monthly* (July–August 1981), p. 12.

25 Kertess, 'Talking about Seeing', p. 49.

26 Dimitrijevic, 'MM', p. 80.

27 Daniel Pinchbeck, 'NY Artist Q&A: MM', *Art Newspaper*, 89 (February 1999), p. 71.

28 Picasso in 1944; see Ashton, 'Picasso on Art', p. 87.

29 R. Milazzo, ed., 'Showing the View to a Blind Man', unpub., 1998–9, p. 26.

30 'Dialogue: Malcolm Morley [*sic*]', p. 30.

31 Kertess, 'Talking about Seeing', p. 51.

32 Scanlan, 'The Sailor Who Went to Sea to See'.

33 Klein, 'Traveling in Styles', p. 97.

34 John Rewald, ed., *Paul Cézanne, Correspondance* (Paris, 1978), p. 318.

35 Scanlan, 'The Sailor Who Went to Sea to See'.

36 *Ibid.*

37 See 'MM: The Outsider'.

38 Dimitrijevic, 'MM', p. 80.

39 Scanlan, 'The Sailor Who Went to Sea to See'.
40 Francis, 'MM', p. 30.
41 Gary Indiana, 'Disasters in the Sandbox', *Art in America* (May 1984), p. 123.
42 Patrick Boyd-Carpenter, 'Turner Prizewinner' (letter to the editor), *Times*, 15 November 1984, p. 17.
43 Peter Fuller, 'The Visual Arts', in Boris Ford, ed., *The Cambridge Guide to the Arts in Britain*, vol. 9, *Since the Second World War* (Cambridge, 1988), p. 117.
44 Kay Larson, review of MM's exhibition at the Pace Gallery, New York, *New York Magazine* (16 January 1989), p. 57.
45 Ken Johnson, 'MM at Pace', *Art in America* (February 1989), p. 160.
46 Richard Kalina, 'MM', *Arts Magazine* (March 1989), p. 83.
47 See 'Showing the View to a Blind Man: MM Talking to David Sylvester', in *MM*, exh. cat., Anthony d'Offay Gallery, London (1990), p. 10.
48 See 'A Conversation: MM and Arnold Glimcher. Bellport, Long Island, October 3, 1988', in *MM*, exh. cat., Pace Gallery, New York (1988), p. [5].
49 Sarah McFadden, Interview with MM, in 'Expressionism Today: An Artists' Symposium', *Art in America* (December 1982), p. 70.
50 See 'Showing the View', p. 14.
51 Matthew Collings, 'MM', *Artscribe* (August 1983), p. 55.
52 Picasso in 1965; see Ashton, 'Picasso on Art', p. 40.

6 OPEN SEA

1 Gordon Burns, 'An Artist with No Artifice', *Times*, 15 November 1984, p. 15.
2 'MM, The Outsider', *Omnibus*, BBC TV broadcast produced by Mike Mortimer, 1985.
3 Anthony Haden-Guest, 'MM', *New York Magazine* (4 April 1983) (special issue entitled 'The British Are Here'), p. 37.
4 Howard Risatti, 'MM – Baumgartner Galleries', *Artforum* (February 1998), p. 96.
5 Alexi Worth, 'MM. Sperone Westwater', *Art News* (February 1999), p. 100.
6 Baudelaire in 1859; see Charles Baudelaire, *The Painter of Modern Life and Other Essays* (London, 1964), p. 8.
7 Dodie Kazanjian and Calvin Tomkins, 'Sanctuary for Art', *House & Garden* (May 1989), p. 152.
8 Kay Larson, 'Master of the Manic', *New York Magazine* (5 March 1984), p. 97.
9 See Joshua Decter's review of the MM exhibition at the Pace Gallery, New York, *Arts Magazine* (April 1991), p. 101.
10 Lois E. Nesbitt, 'MM – Pace Gallery', *Artforum* (May 1991), p. 139.
11 Eleanor Heartney, 'MM – Pace', *Art News* (April 1991), p. 146.
12 Michael Kimmelman, 'A Painter's Painter Whose Art Is About Art', *New York Times*, 25 July 1993, p. H30.
13 Sarah Kent, 'Art Attack', *Time Out* (26 September–3 October 1990), p. 17.
14 Alan G. Artner, 'MM: Still Bucking Trends and Surprising His Peers', *Chicago Tribune*, 27 November 1983.
15 See 'Sensation without Memory: A Conversation between Archie Rand and MM', *Tema Celeste*, 32–3 (Autumn 1991), p. 110.
16 Michael R. Klein, 'Traveling in Styles', *Art News* (March 1983), p. 93.
17 John Yau, 'MM', *Flash Art*, 122 (April–May 1985), p. 32.
18 See 'MM, The Outsider'.
19 See Wassily Kandinsky, Note on *Composition VI* (1913), in Kenneth C. Lindsay and Peter Vergo, eds, *Complete Writings on Art*, vol. I (Boston, 1983), p. 386.
20 Francis Ponge, 'L'Atelier' (1948), in *Le Grand Recueil: Pièces* (Paris, 1961), p. 126.
21 'Dialogue: Malcom Morley [sic] with Les Levine', *Cover*, 1/3 (Spring–Summer 1980), p. 30.
22 Robert Storr, 'Let's Get Lost: Interview with MM', *Art Press* (May 1993), p. E6.
23 Richard Francis, 'A Long Sort of Exile', in *MM: Watercolours*, exh. cat., Tate Gallery Liverpool (1991), p. 12.

24 'A Conversation: MM and Arnold Glimcher. Bellport, Long Island, October 3, 1988', in *MM*, exh. cat., Pace Gallery, New York (1988), p. [10].
25 Patricia Scanlan, 'The Sailor Who Went to Sea to See', *Lovely Jobly* (December 1990).
26 Vicki Goldberg, 'MM, Keeping Painting Alive', *New York Times*, 14 March 1993, p. H31.
27 Scanlan, 'The Sailor Who Went to Sea to See'.
28 Klaus Kertess, 'MM: Talking about Seeing', *Artforum* (Summer 1980), p. 48.
29 'Showing the View to a Blind Man: MM Talking to David Sylvester', in *MM*, exh. cat., Anthony d'Offay Gallery, London (1990), p. 15.
30 Risatti, 'MM', p. 97.
31 Decter, Review, p. 102.
32 David Ebony, 'MM at Pace', *Art in America* (June 1991), p. 140–41.
33 'Sensation without Memory', p. 113.
34 MM, Statement, in *MM*, exh. cat., Sidney Janis Gallery, New York (1996).
35 Nena Dimitrijevic, 'MM', *Flash Art* (October 1988), p. 76.
36 Brian Fallon, 'MM: A Major Artist on Both Sides of the Atlantic', *Irish Times*, 9 September 1990.
37 Dimitrijevic, 'MM', p. 76.
38 William S. Rubin, *Frank Stella, 1970–1987*, exh. cat., Museum of Modern Art, New York (1987), p. 77.
39 See Brooks Adams, 'Malcolm's Marinara', in *MM*, exh. cat., Sperone Westwater Gallery , New York (1999), p. 6.
40 'Showing the View to a Blind Man', unpub. ms., ed. R. Milazzo, 1998–9, pp. 12–13.
41 Homer, *Odyssey*, XIII (trans. Fitzgerald [1990] p. 236).
42 Storr, 'Let's Get Lost', p. E7.
43 Adams, 'Malcolm's Marinara', p. 7.
44 Jean-Max Colard and Jade Lindgaard, 'Guide de bord (de la société du spectacle) – Arts', *Les Inrockuptibles*, 7–13 May 1997, p. x.
45 Emile Bernard, 'Paul Cézanne' (1891), in Anne Rivière, ed., *Propos sur l'art*, vol. I (Paris, 1994), p. 22.
46 F. O'Connor and E. Thaw, *Jackson Pollock: Catalogue Raisonné* (New Haven and London, 1978), vol. IV, doc. 90.

7 *PAINTER'S FLOOR*

1 'MM, The Outsider', *Omnibus*, BBC TV broadcast produced by Mike Mortimer, 1985.
2 Jonathan Brown and Carmen Garrido, *Velázquez: The Technique of Genius* (New Haven and London, 1998).
3 Philippe Dagen, 'Une Histoire d'œil et de bateaux', *Connaissance des arts* (May 1997), p. 84.

Bibliography

CATALOGUES

Compton, Michael, *MM: Paintings 1965–82*, exh. cat., Whitechapel Art Gallery, London (1983)

Juncosa, Enrique, Francisco Calvo Serraler and Brooks Adams, *MM: 1965–1995*, Fundación La Caixa, Madrid (1995)

Kertess, Klaus, and Richard Francis, *MM: Watercolours*, exh. cat., Tate Gallery Liverpool (1991)

Kertess, Klaus, Les Levine and David Sylvester, *MM*, exh. cat., Centre Georges Pompidou, Paris (1993)

ESSAYS

Adams, Brooks, '1990s Morley: The Return of the Prodigal Son', in Enrique Juncosa, Francisco Calvo Serraler and Brooks Adams, *MM: 1965–1995*, Fundación La Caixa, Madrid (1995), pp. 52–71 (in English and Spanish)

——, 'Malcolm's Marinara', in *MM*, exh. cat., Sperone Westwater Gallery, New York (1999), pp. 5–8

Alloway, Lawrence, Introduction, in *The Photographic Image*, exh. cat., Solomon R. Guggenheim Museum, New York (January 1966), pp. 3–5

——, 'The Paintings of MM', *Art and Artists* (February 1967), pp. 16–19

——, 'Morley Paints a Picture', *Art News*, Summer 1968, pp. 42–4, 69–71

——, 'MM, Clocktower, 7–30 October 1976'; reprint in *Unmuzzled Ox*, IV/2 (1976), pp. 48–55

——, Exh. leaflet, *MM: Matrix 54*, Wadsworth Atheneum, Hartford, January–March 1980

Artner, Alan G., 'MM: Still Bucking Trends and Surprising His Peers', *Chicago Tribune*, 27 November 1983

Ashton, Dore, 'Unconventional Techniques in Sculpture: New York Commentary', *Studio International* (January 1965), pp. 22–5

Bechtle, Robert, in 'The Photo-Realists: 12 Interviews', *Art in America* (November–December 1972), pp. 73–4

Boyd-Carpenter, Patrick, 'Turner Prizewinner' (letter to the editor], *Times*, 15 November 1984, p. 17

Burns, Gordon, 'An Artist with No Artifice', *Times*, 15 November 1984, p. 15

Calas, Nicolas and Elena, 'Artificial Realism', in *Icons and Images of the Sixties* (New York, 1971)

Colard, Jean-Max, and Jade Lindgaard, 'Guide de bord (de la société du spectacle) – Arts', *Les Inrockuptibles*, 7–13 May 1997, p. x

Collings, Matthew, 'MM', *Artscribe* (August 1983), pp. 49–55

Compton, Michael, 'MM', in Compton, Michael, *MM: Paintings 1965–82*, exh. cat., Whitechapel Art Gallery, London (1983), pp. 8–16

Constable, Rosalind, 'Style of the Year: The Inhumanists', *New York Magazine*, 16 December 1968, pp. 44–50

Dagen, Philippe, 'Un peintre d'histoires: MM au Centre Georges Pompidou', *Le Monde*, 6–7 June 1993, p. 11

——, 'Une Histoire d'œil et de bateaux', *Connaissance des arts* (May 1997), pp. 84–9

Decter, Joshua, Review of *MM* at Pace Gallery, *Arts Magazine* (April 1991), pp. 101–2

Delaroyère, Thierry, 'Mords-les Morley', *Joie de Paris*, no. o (December 1974) (this magazine was never published; the article is reproduced in *MM*, exh. cat. Centre Georges Pompidou, Paris [1993], p. 174)

Ebony, David, 'MM at Pace', *Art in America* (June 1991), pp. 140–41

Fallon, Brian, 'MM: A Major Artist on Both Sides of the Atlantic', *Irish Times*, 19 September 1990

Francis, Richard, 'A Long Sort of Exile', in Klaus Kertess and Richard Francis, *MM: Watercolours*, exh. cat., Tate Gallery Liverpool (1991), pp. 11–17

Frankenstein, Alfred, 'The High Pitch of New Realism', *San Francisco Examiner & Chronicle*, 17 August 1969, pp. 29–30

Fuller, Peter, 'The Visual Arts', in Boris Ford, ed., *The Cambridge Guide to the Arts in Britain*, vol. 9, *Since the Second World War* (Cambridge, 1988), pp. 99–145

Goldberg, Vicki, 'MM, Keeping Painting Alive', *New York Times*, 14 March 1993, p. H31

Haden-Guest, Anthony, 'MM', *New York Magazine*, 4 April 1983 (special issue entitled 'The British Are Here'), p. 37

——, 'Daddy-O: The Wild Life and Art of MM', *New York Magazine*, 20 February 1984, pp. 40–44

Heartney, Eleanor, 'MM –- Pace', *Art News* (April 1991), p. 146

Indiana, Gary, 'Disasters in the Sandbox', *Art in America* (May 1984), pp. 112–23

Johnson, Ken, 'MM at Pace', *Art in America* (February 1989), pp. 159–60

Kalina, Richard, 'MM', *Arts Magazine* (March 1989), p. 83

Kent, Sarah, 'Art Attack', *Time Out*, 26 September–3 October 1990, pp. 16–17

Kimmelman, Michael, 'A Painter's Painter Whose Art Is About Art', *New York Times*, 25 July 1993, p. H30

Klein, Michael R., 'Traveling in Styles', *Art News* (March 1983), pp. 90–97

Kloss, William, '30 Years of a Sometimes Puzzling Artist', *Washington Times*, 13 September 1983

Kurtz, Bruce, 'Documenta 5: A Critical Preview', *Arts Magazine* (June 1972), p. 37

Larson, Kay, 'Master of the Manic', *New York Magazine*, 5 March 1984, pp. 96–7

——, Review of MM's exhibition at Pace Gallery, *New York Magazine*, 16 January 1989, p. 57

Lebensztejn, Jean-Claude, 'Photorealism, Kitsch and Venturi', *Sub-Stance*, 31 (1981), p. 75–104

——, 'Une Source oubliée de Morley' (1991), in *Ecrits sur l'art récent: Marden, Morley, Sharits* (Paris 1995), pp. 108–20

Levin, Kim, 'Malcom Morley [*sic*]: Post Style Illusionism', *Arts Magazine* (February 1973), pp. 60–63; reprint in Gregory Battcock, ed., *Super Realism: A Critical Anthology* (New York, 1975)

——, 'MM', *Arts Magazine*, June 1976, p. 11

——, 'Get the Big Picture?', *Village Voice*, 22–28 April 1981, p. 80

Loring, John, 'The Plastic Logic of Realism', *Arts Magazine* (October 1974), pp. 48–9

Milazzo, Richard, 'MM and the Art of the Incommensurable', in *MM: Dipinti/Acquerelli/Disegni/Sculture*, exh. cat., Emilio Mazzoli Galleria d'Arte Contemporanea, Modena (1998), pp. 88–99

Nesbitt, Lois E., 'MM – Pace Gallery', *Artforum* (May 1991), p. 139

Pincus-Witten, Robert, 'Entries: I: Baselitzmus; II: Borstal Boy Goes Mystic', *Arts Magazine* (June 1984), pp. 96–8

Ratcliff, Carter, Review of *22 Realists* at Whitney Museum of American Art, *Art International* (April 1970), pp. 67–9

Raymond, H. D., 'Beyond Freedom, Dignity and Ridicule', *Arts Magazine* (February 1974), pp. 25–6; reprint in Gregory Battcock, ed., *Super Realism: A Critical Anthology* (New York, 1975)

Risatti, Howard, 'MM –- Baumgartner Galleries', *Artforum* (February 1998), pp. 95–6

Rubenfien, Leo, Review of *MM* at Clocktower, *Artforum* (December 1976), pp. 63–4

Seitz, William C., 'The Real and the Artificial: Painting of the New Environment', *Art in America* (November–December 1972), pp. 58–72

Slattery, William, 'A Free-Wheeling Artist Talks Back', *New York Post*, 28 January 1974, p. 36

Sylvester, David, 'A Dance of Paint, a Dance of Death', in *MM*, exh. cat., Anthony d'Offay Gallery, London (1990) pp. 5–10

Tatransky, Valentine, 'Morley's New Paintings', *Art International* (October 1979), pp. 55–9

Worth, Alexi, 'MM. Sperone Westwater', *Art News* (February 1999), p. 110

STATEMENTS AND INTERVIEWS

Castle, Ted, 'The Paint Drain', *Art Monthly* (July–August 1981), pp. 11–13

Collings, Matthew, 'The Happy Return: MM Interviewed by Matthew Collings', *Artscribe*, 50 (January–February 1985), pp. 17–21

'A Conversation: MM and Arnold Glimcher. Bellport, Long Island, 3 October 1988', in *MM*, exh. cat., Pace Gallery, New York (1988–9), pp. [5–11]

'Dialogue: Malcom Morley *[sic]* with Les Levine', *Cover*, 1/3 (Spring-Summer 1980), pp. 28–31

Dimitrijevic, Nena, 'MM', *Flash Art* (October 1988), pp. 6–80

Francis, Richard, 'MM', *Bomb*, 55 (Spring 1996), pp. 26–31

Kazanjian, Dodie, and Calvin Tomkins, 'Sanctuary for Art', *House & Garden* (May 1989), pp. 151–6, 210, 212

Kertess, Klaus, 'MM: Talking about Seeing', *Artforum* (Summer 1980), pp. 48–51

MM, 'Showing the View to a Blind Man', ed. R. Milazzo, unpub. ms., 1998–9

——, Statement, in *Environment USA, 1957–1967*, Ninth Biennial of São Paulo, p. 89

——, Statement, in *MM*, exh. cat., Sidney Janis Gallery, New York (1996)

'MM, The Outsider', *Omnibus*, BBC TV broadcast produced by Mike Mortimer, 1985

McFadden, Sarah, Interview with MM, in 'Expressionism Today: An Artists' Symposium', *Art in America* (December 1982), pp. 58–75, 139–41

Pinchbeck, Daniel, 'NY Artist Q&A: MM', *Art Newspaper*, 89 (February 1999), p. 71

Scanlan, Patricia, 'The Sailor Who Went to Sea to See', *Lovely Jobly* (December 1990)

'Sensation Without Memory: A Conversation between Archie Rand and MM', *Tema Celeste*, 32–3 (Autumn 1991), pp. 108–13

'Showing the View to a Blind Man: MM Talking to David Sylvester', in *MM*, exh. cat., Anthony d'Offay Gallery, London (1990), pp. 13–18

Storr, Robert, 'Let's Get Lost: Interview with MM', *Art Press* (May 1993), pp. E3–E7

Yau, John, 'MM: Découvrir son masque', *Art Press*, 86 (November 1984), pp. 30–33

——, 'MM', *Flash Art*, 122 (April–May 1985), pp. 30–32

226 Morley in New York, 1988.

Artist's Chronology

227 Morley (third from left), Richard Smith (seated on radiator), Robyn Denny (far left) and others at the Royal College of Art, London, c. 1956–7.

All exhibitions are solo unless annotated (G) to signify group shows.

1931	MM is born in London on 7 June
1953–4	Attends Camberwell School of Arts and Crafts, London
1954–7	Attends Royal College of Art, London
1955	*Young Contemporaries* (London) (G)
1956	*Young Contemporaries* (London) (G)
1957	*Young Contemporaries* (London) (G); first visits New York
1958	Moves to New York; visits Toronto
1964	Kornblee Gallery, New York
1965–6	Associate Professor, Ohio State University, Columbus
1966	*The Photographic Image*, Solomon R. Guggenheim Museum, New York (G); *Sound, Light and Silence*, Nelson-Atkins Museum of Art, Kansas City, MO (G)
1967–9	Instructor, School of Visual Art, New York
1967	Kornblee Gallery, New York; *Environment USA, 1957–1967*, Biennale de São Paulo 9 (G)
1969	Kornblee Gallery, New York
1969–70	*Aspects of New Realism*, Akron Art Institute, OH; Contemporary Art Museum, Houston, TX; Milwaukee Art Center, WI (now Milwaukee Art Museum); O. K. Harris Gallery, New York (G); *Pop Art*, Hayward Gallery, London (G)
1970	*American Art Since 1960*, Art Museum, Princeton University, NJ (G); *22 Realists*, Whitney Museum of American Art, New York (G)
1971	*Kunst des 20. Jahrhunderts (Freie Berufe Sammeln)*, Stadtische Kunsthalle, Düsseldorf (G); *Radical Realism*, Museum of Contemporary Art, Chicago, IL (G)
1972	Galerie de Gestlo, Hamburg; Gallerie Ostergren, Malmö; Galerie Art in Progress, Zurich; *Contemporary American Painting*, Whitney Museum of American Art, New York (G); *Documenta V*, Kassel (G)
1972–3	Time Magazine Building, New York; *Amerikanischer Fotorealismus*, Frankfurter Kunstverein; Württembergischer Kunstverein Stuttgart; Kunst- und Museumverein Wuppertal (G); *Image, Reality and Superreality*, Arts Council, London (G)
1972–4	Associate Professor, State University of New York, Stonybrook
1973	Steffanoty Gallery, New York; *Ein grosses Jahrzehnt Amerikanischer Kunst: Sammlung Ludwig Köln/Aachen*, Kunstmuseum Luzern (G)
1973–4	*Art Conceptuel et Hyperréaliste: Collection Ludwig Aix-la-Chapelle*, ARC, Musée d'Art Moderne de la Ville de Paris (G); *Photo-Realism: Paintings, Sculptures and Prints from the Ludwig Collection and Others*, Serpentine Gallery, London (G)
1974	Galerie M. E. Thelen, Cologne; Steffanoty Gallery, New York; Galerie Gérald Piltzer, Paris; *Kunst bleibt Kunst: Projekt '74. Aspekte*

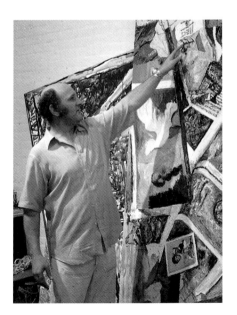

228 Morley in his New York studio in 1973 talking about his canvas *Untitled Souvenirs, Europe* (68).

229 Morley teaching at the State University of New York at Stonybrook, 1972. *School of Athens* (61), still in progress, is visible in the background.

230 Morley signing autographs at the auction at the Palais Galliera, Paris, 1974.

	internationaler Kunst am Anfang der 70er Jahre, Wallraf-Richartz Museum, Cologne; Kölnischer Kunstverein, Cologne; Kunsthalle Köln (G)
1976	Clocktower Institute for Art and Urban Resources, New York; *New York in Europa: Amerikanische Kunst aus Europäischen Sammlungen*, Nationalgalerie Berlin; *Soho*, Louisiana Museum, Humlebaek (G); *Peripatetic Cross* event, New York
1977	Galerie Jurka, Amsterdam; Galerie Jöllenbeck, Cologne; *British Painting 1952–1977*, Royal Academy of Arts, London (G); *Documenta VI*, Kassel (G); *Illusion and Reality*, Art Gallery of South Australia, Adelaide; Queensland Art Gallery, Brisbane; Australian National Gallery, Canberra; Tasmanian Museum and Art Gallery, Hobart; National Gallery of Victoria, Melbourne; Western Australian Art Gallery, Perth; Art Gallery of New South Wales, Sydney (G); spends time in Germany on academic exchange programme
1978–9	*Art about Art*, Whitney Museum of American Art, New York; Frederick S. Wight Art Gallery, University of California, Los Angeles; Portland Art Museum, OR; North Carolina Museum of Art, Raleigh (G); lives in Florida
1979	Susanne Hilberry Gallery, Birmingham, MI; Nancy Hoffman Gallery, New York; spends six months in south of France
1979–80	*A Penthouse Aviary*, Museum of Modern Art, New York (G)
1980	*Matrix 54*, Wadsworth Atheneum, Hartford, CT; revisits England for first time in 20 years
1981	Xavier Fourcade, Inc., New York; *A New Spirit in Painting*, Royal Academy of Arts, London (G); travels to Arizona
1982	Akron Art Institute, OH; Xavier Fourcade, Inc., New York; *Zeitgeist*, Martin-Gropius-Bau, Berlin (G); travels to Greece

1983 *The First Show: Painting and Sculpture from Eight Collections, 1940 to 1980*, Museum of Contemporary Art, Los Angeles, CA (G); *New Art*, Tate Gallery, London (G)

1983–84 *Malcolm Morley: Paintings, 1965–82*: Kunsthalle Basel; Brooklyn Museum, NY; Museum of Contemporary Art, Chicago, IL; Whitechapel Art Gallery, London; Museum Boymans-van Beuningen, Rotterdam; Corcoran Gallery of Art, Washington, DC; travels to Africa, India and the Caribbean

1984 Fabian Carlsson Gallery, London; Xavier Fourcade, Gallery, New York; Poneva Gallery, Toronto; Galerie Nicoline Pon, Zurich; *An International Survey of Paintings and Sculpture*, Museum of Modern Art, New York (G); is first recipient of Turner Prize awarded by Tate Gallery, London

1985 Fabian Carlsson Gallery, London; Galerie Georges Lavrov, Paris; *1985 Carnegie International*, Carnegie Museum of Art, Pittsburgh, PA (G); *Pop Art, 1955–70*, Queensland Art Gallery, Brisbane; National Gallery of Victoria, Melbourne; Museum of Modern Art, New York; Art Gallery of New South Wales, Sydney (G); travels to Egypt, Kenya, Greece and the West Indies

1986 Xavier Fourcade Inc., New York; Pace Prints, New York; *Focus on the Image: Selections from the Rivendell Collection*, Phoenix Art Museum, AZ; University of Oklahoma Museum of Art, Norman; Munson-Williams-Proctor Institute, Utica, NY; University of South Florida Art

231 An installation view of the 1983–4 Morley retrospective at the Whitechapel Art Gallery, London. Visible from left to right are *Cradle of Civilization with American Woman* (114), *Arizonac* (108) and *Macaws, Bengals, with Mullet* (84).

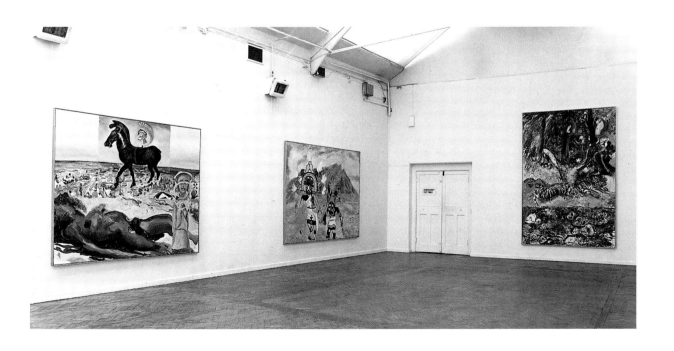

	Galleries, Tampa (now University of South Florida Art Museum); Lakeview Museum of Art and Sciences, IL; California State University Art Museum, Long Beach; Laguna Gloria Art Museum, Austin, TX (G); travels to the Bahamas, Spain and India
1987	*Art of Our Time: The Saatchi Collection*, Scottish Royal Academy, Edinburgh (G)
1987–8	*Berlinart, 1961–1987*, Museum of Modern Art, New York; San Francisco Museum of Modern Art, CA (G)
1988	Temperance Hall Gallery, Bellport, NY; travels to Costa Rica
1988–9	Pace Gallery, New York
1990	Anthony D'Offay Gallery, London; travels to Jamaica
1991	Pace Gallery, New York
1991–2	*Malcolm Morley: Watercolours*, Kunsthalle Basel; Tate Gallery, Liverpool; Musée Cantini, Marseille; Bonnefantenmuseum, Maastricht; Parrish Art Museum, Southampton, NY
1992	Galerie Montenay, Paris; receives Painting Award from Skowhegan School of Painting and Sculpture; travels to the Canary Islands
1993	Mary Boone Gallery, New York
1993–4	Centre Régional d'Art Contemporain Midi-Pyrénées, Labège-Toulouse; Musée National d'Art Moderne, Paris; *Opening Exhibit*, Astrup Fearnley Museum for Moderne Kunst, Oslo (G)
1994	Daniel Weinberg Gallery, San Francisco, CA; Baumgartner Galleries, Washington, DC; travels to the Azores
1995	Mary Boone Gallery, New York
1995–6	Fundacion 'La Caixa', Barcelona; Astrup Fearnley Museet for Moderne Kunst, Oslo; Michael Klein Gallery, New York
1996	Arts Club of Chicago, IL; Sidney Janis Gallery, New York; Visiting Lecturer, Columbia University, New York, and Harvard University, Cambridge, MA
1997	Baldwin Gallery, Aspen, CO; Galerie Daniel Templon, Paris; Baumgartner Galleries, Washington, DC; *Birth of the Cool*, Deichtorhallen, Hamburg; Kunsthaus Zürich (G); travels to South Africa
1998	Galleria d'Arte Contemporanea Emilio Mazzoli, Modena; *Wounds: Between Democracy and Redemption in Contemporary Art*, Moderna Museet, Stockholm (G); travels to the Canary Islands
1999	Sperone Westwater, New York; *Reality and Desire*, Fundació Joan Miró, Barcelona (G); *The Virginia and Bagley Wright Collection*, Seattle Art Museum, WA (G); travels to Cuba
2000	Sperone Westwater, New York; *Arte Americana: Ultimo Decennio*, Museo d'Arte della Citta di Ravenna (G); gives Duncan Phillips Lecture Series
2001	Hayward Gallery, London

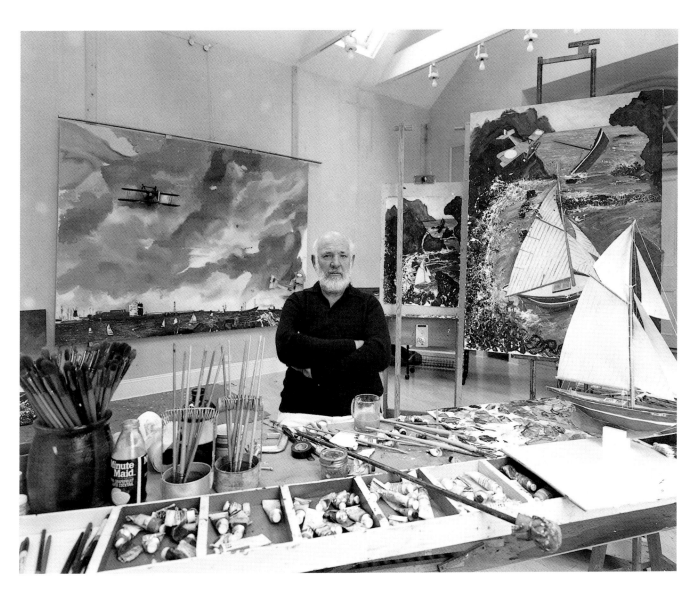

232 Morley in his studio with the model of the *Pamela*, the 1993 oil *Icarus* (166) and the watercolours *Shipwreck I* and *II* (194, 195). The model of the *Pamela* was used in many of his paintings, including *Shipwreck* (197), *Now Voyager* (204), *Man Overboard* (206), *Double Pamela* (208) and *Mariner* (209).

List of Illustrations

37 *Marine Sergeant at Valley Forge*, 1968, Liquitex on canvas, 152.5 × 127 cm (60 × 50 in.). Private collection.

38 *Portrait of Esses in Central Park*, 1969–70, Liquitex on canvas, 182.9 × 182.9 cm (72 × 72 in.). Museum Moderne Kunst/Ludwig Foundation, Vienna (on loan from the Ludwig-Stiftung, Aachen).

39 *The Ruskin Family*, 1967, Liquitex on canvas, 137.2 × 213.4 cm (54 × 84 in.). Personal Collection of the Ruskin Family.

40 *Horses*, 1967, oil on canvas, 76.2 × 101.6 cm (30 × 40 in.). Private collection.

41 *Coronation and Beach Scene*, 1968, Liquitex on canvas, 227.6 × 228.9 cm (89 ⁵/₈ × 90 ¹/₈ in.). Hirshhorn Museum and Sculpture Garden, Smithsonian Institution, Washington, DC (The Joseph H. Hirshhorn Bequest, 1981).

42 *Vermeer, Portrait of the Artist in his Studio*, 1968, Liquitex on canvas, 266.5 × 221 cm (105 × 87 in.). The Eli Broad Family Foundation, Santa Monica, CA.

43 *Vermeer, Portrait of the Artist in his Studio* (42) in progress.

44 *A Mistress and Her Maid After Vermeer, a Ram and View of Amagansett by MM*, 1976, oil on canvas, 50.8 × 40.6 cm (20 × 16 in.). Les and Catherine Levine Collection, New York.

45 *Beach Scene*, 1968, Liquitex on canvas, 279.4 × 228.3 cm (110 × 89 ⁷/₈ in.). Hirshhorn Museum and Sculpture Garden, Smithsonian Institution, Washington, DC (gift of Joseph H. Hirshhorn, 1972).

46 *Birthday Party*, 1969, Liquitex on canvas, 101.6 × 101.6 cm (40 × 40 in.). Private collection.

47 *Safety is your Business*, 1971, oil, wax and Liquitex on canvas, 223.5 × 279.4 cm (88 × 110 in.). Robert Lehrman Collection, Washington, DC.

48 *Race Track*, 1970, Liquitex on canvas, 170.2 × 220.3 cm (67 × 86 ³/₄ in.). Ludwig Museum, Budapest.

49 Kazimir Malevich, *Composition with Mona Lisa*, c. 1915, oil, collage and graphite on canvas, 62.2 × 49.5 cm (24 ¹/₂ × 19 ¹/₂ in.). State Russian Museum, St Petersburg.

50 *Buckingham Palace with First Prize*, 1970, Liquitex with encaustic and ribbon on canvas (water pistol added in 1974), 182.9 × 248.9 cm (72 × 98 in.). Bo Alveryd Collection, Vaumarcus, Switzerland.

51 Detail of *Buckingham Palace with First Prize* (50).

52 *Knitting Machine*, 1971, oil on canvas, 61 × 61 cm (24 × 24 in.). Private collection.

53 *A Death in the Family*, 1971, oil, encaustic, watercolour collage on canvas, 200.7 × 160 cm (79 × 63 in.). Museum of Contemporary Art, Chicago (gift of Gael Neeson and Stefan Edlis).

54 *At a First-Aid Center in Vietnam*, 1971, oil on canvas, 160 × 240 cm (63 × 94 ¹/₂ in.). The Eli Broad Family Foundation, Santa Monica, CA.

55 *Regatta (Check #185)*, 1972, Liquitex on canvas, 123.2 × 245.7 cm (48 ¹/₂ × 96 ³/₄ in.). Armand Ornstein Collection, Paris.

56 *Kodak Castle*, 1971, oil on masonite, 91.4 × 121.9 cm (36 × 48 in.). Munson-Williams-Proctor Art Institute, Museum of Art, Utica, NY.

57 *Rhine Chateau*, 1969, Liquitex on canvas, 72.4 × 94 cm (28 ¹/₂ × 37 in.). Private collection.

58 *Madison Telephone Book Cover*, 1970, Liquitex on canvas, 83.8 × 68.6 cm (33 × 27 in.). The Stefan T. Edlis Collection.

59 *View of Paris (Eiffel Tower)*, 1971, oil and wax on canvas, 167.6 × 137.2 cm (66 × 54 in.). Private collection.

60 *Los Angeles Yellow Pages*, 1971, Liquitex and encaustic on canvas, 233 × 203 cm (91 ³/₄ × 79 ¹⁵/₁₆ in.). Louisiana Museum of Modern Art, Humlebaek.

61 *School of Athens*, 1972, Liquitex on canvas, 170.2 × 247.7 cm (67 × 97 ¹/₂ in.). The Stefan T. Edlis Collection.

62 Detail of *School of Athens* (61).

63 *New York City Postcard*, 1971, Liquitex on canvas, 157.5 × 595 cm (62 × 234 ¹/₄ in.). Astrup Fearnley Museet for Moderne Kunst, Oslo.

64 *New York City Postcard Foldout* (face A), 1972–3, encaustic on canvas, 180 × 870 cm (70 ⁷/₈ × 342 ¹/₂ in.). Bo Alveryd Collection, Vaumarcus, Switzerland.

65 *New York City Postcard Foldout* (face B).

66 *The General*, 1974, mixed media, oil on canvas with objects, 152.4 × 101.6 cm (60 × 40 in.). The Museum of Contemporary Art, Los Angeles (Lowen Collection).

67 *Piccadilly Circus*, 1973, oil on canvas, 182.9 × 274.3 cm (72 × 108 in.). Bo Alveryd Collection, Vaumarcus, Switzerland.

68 *Untitled Souvenirs, Europe*, 1973, oil and mixed media on canvas, 244.5 × 173.4 cm (96 ¹/₄ × 68 ¹/₄ in.). Virginia and Bagley Wright Collection.

69 *Miami Postcard Foldout (A Painting with Separate Parts which are Self-Generating)*, 1974, mixed media, 320 × 569 × 26.7 cm (126 × 224 × 10 ¹/₂ in.). Museum of Contemporary Art, Los Angeles (Lannan Foundation Collection).

70 *Belly*, 1973, oil on canvas, 95.3 × 92 cm (37 ¹/₂ × 36 ¹/₄ in.). Courtesy Magnus Bromander Gallery, Sweden.

110 *Arizonac*, 1981, watercolour on paper, 88.3 × 76.2 cm (34 3/4 × 30 in.). Private collection.

111 *Still-Life with Mangoes*, 1979, watercolour on paper, 45.7 × 66 cm (18 × 26 in.). Ellen Phelan and Joel Shapiro Collection.

112 *Alexander Greeting A.B. Seaman Ulysses M.A. Evans, Jr., at the Foot of the Colossus of Peanigh*, 1982, oil on canvas, 91.4 × 106.7 cm (36 × 42 in.). Anne and William J. Hokin Collection.

113 *The Palms of Vai*, 1982, oil on canvas, 123.2 × 96.5 cm (48 1/2 × 38 in.). Marieluise Hessel Collection (on permanent loan to the Center for Curatorial Studies, Bard College, Annandale-on-Hudson, NY).

114 *Cradle of Civilization with American Woman*, 1982, oil on canvas, 203.2 × 254 cm (80 × 100 in.). Centre Beaubourg-MNAM-CCI, Paris.

115 *Farewell to Crete*, 1984, oil on canvas, 203.2 × 416.6 cm (80 × 164 in.). Saatchi & Saatchi Collection.

116 *Untitled (Statue)*, 1982, watercolour on paper, 91.4 × 37.5 cm (36 × 14 3/4 in.). Private collection.

117 *Untitled (American Woman)*, 1982, watercolour on paper, 57.2 × 76.8 cm (22 1/2 × 30 1/4 in.). Private collection.

118 *Untitled (Horse)*, 1982, watercolour on paper, 37.5 × 45.2 cm (14 3/4 × 17 3/4 in.). Ann and Gilbert Kinney Collection, New York.

119 *Beach #3*, 1982, watercolour on paper, 61 × 71.1 cm (24 × 28 in.). Private collection.

120 *Day Fishing at Heraklion*, 1982, watercolour on paper, 71.1 × 105.4 cm (28 × 41 1/2 in.). Private collection.

121 *Day Fishing at Heraklion*, 1983, oil on canvas, 203.2 × 238.8 cm (80 × 94 in.). Private collection.

122 *Géricault II*, 1978, charcoal and pencil on paper, 61 × 47 cm (24 × 18 1/2 in.). Private collection.

123 *Géricault III*, 1978, pencil, charcoal, pastel and crayon on paper, 45 × 30.5 cm (17 3/4 × 12 in.). Private collection.

124 Théodore Géricault, *Officer of the Chasseurs of the Imperial Guard Charging*, 1812, oil on canvas, 292.1 × 193.4 cm (115 × 76 1/8 in.). Musée du Louvre, Paris.

125 *The Injuns are Cuming, The Officer of the Imperial Guard is Fleeing*, 1983, oil on canvas, 203.2 × 279.4 cm (80 × 110 in.). Astrup Fearnley Collection, Oslo.

126 *Day of the Locust III*, 1979, oil on canvas, 121.9 × 121.9 cm (48 × 48 in.). Private collection.

127 *Night on Bald Mountain*, 1987, oil and wax on canvas, 198.1 × 330.2 cm (78 × 130 in.). Onnasch Collection, Berlin.

128 *Kachinas*, 1982, watercolour on paper, 73 × 100.3 cm (28 3/4 × 39 1/2 in.). Private collection.

129 *Night on Bald Mountain (Kachina and Drummers)*, 1983, watercolour on paper, 57.2 × 76.8 cm (22 1/2 × 30 1/4 in.). Margulies Family Collection, Miami.

130 *Seastroke*, 1986, oil on canvas, 152.4 × 248.9 cm (60 × 98 in.). Marieluise Hessel Collection (on permanent loan to the Center for Curatorial Studies, Bard College, Annandale-on-Hudson, NY).

131 *Michael's Cathedral*, 1988, oil and wax on canvas, 177.8 × 198.1 cm (70 × 78 in.). Astrup Fearnley Collection, Oslo.

132 *Barcelona Cathedral as a Blood Red Orange*, 1986–7, oil and wax on canvas, 203.2 × 228.6 cm (80 × 90 in.). Michael and Judy Ovitz Collection, Los Angeles.

133 *The Sky Above, The Mud Below*, 1984, oil on canvas, 215.9 × 152.4 cm (85 × 60 in.). Ann and Gilbert Kinney Collection, New York.

134 *The Sky Above, The Mud Below*, 1988, oil and wax on canvas, 330.2 × 198.1 cm (130 × 78 in.). The Museum of Contemporary Art, Los Angeles.

135 *Aegean Crime*, 1987, oil and wax on canvas, 198.1 × 404.5 cm (78 × 159 1/4 in.). Courtesy PaceWildenstein, New York.

136 *Aegean Crime*, 1986, etching and aquatint, five colours on Velin Arches paper, 74.9 × 105.1 cm (29 1/2 × 41 1/2 in.). Private collection.

137 *Trojan Cavalcade*, 1986, etching and aquatint, eleven colours on Velin Arches paper, 105.4 × 74.9 cm (41 1/4 × 29 1/2 in.). Private collection.

138 *Oedipus at Thebes*, 1982, charcoal on paper, 36.8 × 44.5 cm (14 1/2 × 17 1/2 in.). Private collection.

139 *Rainbow Over Mount Kenya*, 1986, watercolour on paper, 69.9 × 85.1 cm (27 1/2 × 33 1/2 in.). Robert and Gayle Greenhill Collection.

140 *Black Rainbow Over Oedipus at Thebes*, 1988, oil and wax on canvas, 289.6 × 323.2 cm (114 × 127 1/4 in.). Hirshhorn Museum and Sculpture Garden, Smithsonian Institution, Washington, DC (The Joseph H. Hirshhorn Bequest Fund, 1991).

141 *Rite of Passage*, 1988, watercolour on paper, 68.6 × 78.7 cm (27 × 31 in.). Private collection.

142 Detail of *Black Rainbow Over Oedipus at Thebes* (140) in progress.

143 *Black Rainbow Over Oedipus at Thebes I*, 1988, eleven-colour lithograph and screenprint on Arches Cover White paper, 119.4 × 145.9 cm (47 × 57 7/16 in.).

National Gallery of Art, Washington, DC (gift of Gemini G.E.L. and the artist, 1991).

144 Detail of *Black Rainbow Over Oedipus at Thebes* (140) in progress.

145 Morley in his studio at Bellport, New York, at work on *Black Rainbow Over Oedipus at Thebes*, 1988.

146 *The Oracle*, 1992, oil and gold leaf on linen; paper, metal and aluminium, 436.9 × 609.6 cm (172 × 240 in.). The Nelson-Atkins Museum of Art, Kansas City, MO (on loan from the Nerman Collection).

147 *The Boat, The Knight, The Tank*, 1990, oil on canvas, 327.7 × 198.1 cm (129 × 78 in.). Courtesy Emilio Mazzoli Galleria d'Arte Contemporanea, Modena.

148 *El Palenque*, 1988–9, watercolour on paper, 57.2 × 78.1 cm (22 1/2 × 30 3/4 in.). Courtesy Emilio Mazzoli Galleria d'Arte, Modena.

149 *Erotic Blando Fruto: La Mariposa*, 1988–9, watercolour on paper, 57.2 × 78.1 cm (22 × 30 in.). Private collection.

150 *Erotic Blando Fruto*, 1989, oil on canvas, 339.7 × 273.7 cm (133 3/4 × 107 3/4 in.). National Gallery of Art, Washington, DC (gift of the Collectors Committee).

151 *Watermelon on Monkey Beach*, 1989, oil on canvas, diam. 194.3 cm (76 1/2 in.). Private collection.

152 *Kristen and Erin*, 1991, oil on canvas, 147.3 × 203.2 cm (58 × 80 in.). Private collection.

153 *Gloria*, 1990, oil on canvas, 236.2 × 315 cm (93 × 124 in.). Nerman Family Collection.

154 *Gloria I*, 1988–9, watercolour on paper, 57.8 × 78.1 cm (22 3/4 × 30 3/4 in.). Private collection.

155 *Cimi the Turk*, 1977, watercolour on paper, 66 × 50.2 cm (26 × 19 3/4 in.). Private collection.

156 *Air Show with the Red Baron Plane*, 1989, watercolour on paper, 55.9 × 76.2 cm (22 × 30 in.). Les and Catherine Levine Collection, New York.

157 *Gustavia St. Barts*, 1988, watercolour on paper, 53.3 × 83.8 cm (21 × 33 in.). Private collection.

158 *André Malraux Flying the Spad-Herbemont S20 Bis over Gustavia*, 1991, oil on canvas with watercolour on paper and magnet, 162.6 × 254 cm (64 × 100 in.). Private collection.

159 *Maasai*, 1985, oil on canvas, 203.2 × 228.6 cm (80 × 90 in.). Stefan T. Edlis Collection.

160 *Geronimo*, 1991, oil on canvas, watercolour on paper airplane, 101.6 × 142.2 cm (40 × 56 in.). Ninah and Michael Lynne Collection, New York.

161 *Sentinel*, 1989, patinated bronze, edition of six, 175.3 × 27.9 × 27.9 cm (69 × 11 × 11 in.). Private collection.

162 *The Chariot of Darius II*, 1990, patinated bronze, edition of six, 130.8 × 50.8 × 29.2 cm (51 1/2 × 20 × 11 1/2 in.). Private collection.

163 *Navy*, 1990, patinated bronze, edition of six, 142.2 × 53.3 × 21 cm (56 × 21 × 8 1/4 in.). Private collection.

164 *Port Clyde*, 1990, painted bronze, edition of six, 25.4 × 61 × 6.4 cm (10 × 24 × 2 1/2 in.). Private collection.

165 *The Flying Dutchman*, 1989, mixed media on board, 141.6 × 105.4 × 10.2 cm (55 3/4 × 41 1/2 × 4 in.). Ann and Anthony D'Offay Collection.

166 *Icarus*, 1993, oil on linen with airplanes and boat, 203.2 × 279.4 cm (80 × 110 in.). Audrey and Sydney Irmas Collection.

167 *Nocturnal Canarias*, 1992, watercolour on paper, 109.2 × 149.9 cm (43 × 59 in.). Private collection.

168 Oblique studio view of *The Oracle* (146).

169 Model knight used by Morley in *The Oracle* (146).

170 *Flight of Icarus*, 1995, oil and wax on canvas; oil and wax on paper with wood and steel structure, 114.3 × 287 × 231.1 cm (45 × 113 × 91 in.) overall. Timothy Eggert Collection, Washington, DC.

171 Studio view of *Flight of Icarus* (170).

172 *Reverie*, 1994, oil and wax on canvas, 50.8 × 61 cm (20 × 24 in.). Private collection.

173 *White Cloud*, 1997, oil on canvas, 200.7 × 257.2 cm (79 × 101 1/4 in.). Courtesy Emilio Mazzoli Galleria d'Arte Contemporanea, Modena.

174 *Flying Cloud*, 1995, oil on linen, 71.1 × 91.4 cm (28 × 36 in.). Ann and Gilbert Kinney Collection, New York.

175 *Montgolfière with Flying Cloud*, 1995, oil on linen with canvas balloon, 142.2 × 182.9 cm (56 × 72 in.). Private collection.

176 *Margate*, 1995–96, oil on canvas, 147.3 × 182.9 cm (58 × 72 in.). Gallerie Xavier Hufkens, Brussels.

177 *Margate*, 1995, assemblage of watercolour on paper models, 62.2 × 86.4 × 60.3 cm (24 1/2 × 34 × 23 3/4 in.). Private collection.

178 Morley painting *Margate* (176).

179 *Pamela with Reflection*, 1994, oil on linen with watercolour on paper boat, 35.6 × 45.7 cm (14 × 18 in.). Mary Boone Collection, New York.

180 *Icarus's Flight*, 1997, oil on canvas, 97.8 × 132.1 cm (38 1/2 × 52 in.). Walter Stiemel Collection, Washington, DC.

181 *Approaching Valhalla*, 1998, oil on linen, 259 × 201.9 cm (102 × 79 1/2 in.). Courtesy Sperone Westwater, New York.

182 *Pictures from the Azores*, 1994, oil on canvas, wax encaustic airplane, 58.4 × 91.4 cm (23 × 36 in.). Courtesy Baumgartner Gallery, New York.

183 *Biplane in Flight*, 1998, oil on linen; watercolour on paper (three-dimensional), 202.2 × 260 cm (79⁵/₈ × 102³/₈ in.). Private collection.

184 *Sailing Vessel Floundering in Stormy Seas*, 1996, oil on linen (four panels), 90.8 × 91.4 cm (35³/₄ × 36 in.). Private collection.

185 *Belem with Whale*, 1997, three-dimensional watercolour with watercolour attachments, 86.4 × 127 × 33 cm (34 × 50 × 13 in.). Gallery Xavier Hufkens, Brussels.

186 *Battle of Britain*, 1999, oil on linen, 182.9 × 182.9 cm (72 × 72 in.). Courtesy Sperone Westwater, New York.

187 *Study for Battle of Britain*, 1999, oil on linen, 76.2 × 76.2 cm (30 × 30 in.). Private collection.

188 *Santa Maria with Sopwith Camel Wing*, 1996, oil on linen, 142.2 × 182.9 cm (56 × 72 in.). Cottrell-Lovett Collection.

189 *Medieval with Lemon Sky*, 1996, oil on linen, 142.2 × 182.9 cm (56 × 72 in.). Roger R. Hazewinkel Collection.

190 *St. Lucia Canoe*, 1993, watercolour on paper, 75.6 × 54.6 cm (29³/₄ × 21¹/₂ in.). Telfair Museum of Art, Savannah, GA (gift of Mr and Mrs Dwight H. Emanuelson).

191 *Gypsy*, 1992, oil on canvas, 198.1 × 276.9 cm (78 × 109 in.). Mr and Mrs Howard Ganek Collection, New York.

192 *Lifeboat 1*, 1994, watercolour on paper with three paper additions, 76.2 × 55.9 cm (30 × 22 in.). Dr and Mrs Stephen McMurrary Collection.

193 *Lifeboat 2*, 1994, watercolour with paper and encaustic and one paper collage element, 76.2 × 55.9 cm (30 × 22 in.). John Toole Collection, Washington, DC.

194 *Shipwreck I*, 1994, watercolour on paper with three paper additions, 76.2 × 55.9 cm (30 × 22 in.). Courtesy Galerie Daniel Templon, Paris.

195 *Shipwreck II*, 1994, watercolour on paper with three paper additions, 76.2 × 55.9 cm (30 × 22 in.). Private collection, Salzburg.

196 *Salvonia*, 1994, oil on canvas with two paper additions, 124.5 × 172.7 cm (49 × 68 in.). Mr and Mrs Donald M. Cox Collection.

197 *Shipwreck*, 1993–4, oil on canvas, 142.2 × 198.1 cm (56 × 78 in.). Stefan T. Edlis Collection.

198 *Racing to the New World*, 1995, oil on linen with paper attachments, 142.2 × 182.9 cm (56 × 72 in.). Courtesy Emilio Mazzoli Galleria d'Arte, Modena.

199 *Titan*, 1994, oil on canvas, 142.2 × 152.4 cm (56 × 60 in.). Private collection.

200 *Bay of Angels*, 1995, oil on linen, 142.2 × 182.9 cm (56 × 72 in.). Private collection (courtesy Baldwin Gallery, Aspen, CO).

201 *Flight from Atlantis*, 1992, oil on canvas with watercolour paper airplane, 226 × 314.3 cm (89 × 123³/₄ in.). Phil Schrager Collection, Omaha, NE.

202 *Guardian of the Deep*, 1993–4, oil on canvas, paper and wax encaustic airplane, 198.1 × 254 cm (78 × 100 in.). Courtesy Emilio Mazzoli Galleria d'Arte Contemporanea, Modena.

203 *Regatta*, 1994, oil on canvas with watercolour attachments, 96.5 × 132.1 cm (38 × 52 in.). Private collection.

204 *Now Voyager*, 1994, oil on canvas with paper attachments, 124.5 × 172.7 cm (49 × 68 in.). Private collection.

205 *The Rescue*, 1994, oil on canvas, 175.3 × 121.9 cm (69 × 48 in.). Private collection.

206 *Man Overboard*, 1994, oil on canvas, three paper flags, 142.2 × 198.1 cm (56 × 78 in.). Baumgartner Gallery, New York.

207 *Keepers of the Lighthouse*, 1994, oil on canvas, 142.2 × 124.5 cm (56 × 49 in.). Ninah and Michael Lynne Collection, New York.

208 *Double Pamela*, 1993, oil on linen, 172.7 × 124.5 cm (68 × 49 in.). Private collection, France (on extended loan to Lieu d'Art Contemporain, Sigean).

209 *Mariner*, 1998, oil on canvas, 294.6 × 375.9 cm (116 × 148 in.). Tate Modern, London.

210 *Battle of the Yellow Sea*, 1996, oil on linen, painted frame attached (two parts), 158.1 × 198.8 cm (62¹/₄ × 78¹/₄ in.). Private collection, Paris.

211 *The Raider*, 1997, oil and encaustic on linen, 137.2 × 106.7 cm (54 × 42 in.). Gian Enzo Sperone Collection, New York.

212 *Spanish Dreadnought*, 1996, oil on linen, 71 × 91.5 cm (28 × 36 in.). Private collection, New York.

213 *Battleship with Honors*, 1998, oil on linen with watercolour on paper attachments, 142.2 × 182.9 cm (56 × 72 in.). Private collection, Turin.

214 *M.V. Perception with Cargo of Primary and Secondary Colors and Black and White*, 1997, oil on linen, 71.1 × 91.4 cm (28 × 36 in.). Private collection. courtesy Baldwin Gallery, Aspen, CO.

215 *Daedalus*, 1996, oil on linen, 152.4 × 142.2 cm (60 × 56 in.). Courtesy Galerie Daniel Templon, Paris.

216 *Springbok*, 1997, oil on linen, 113 × 167.6 cm (44^1/$_2$ × 66 in.). Herb and Grace Boyer Collection.

217 *Parasailors with Maroon Bells*, 1998, oil on linen, 142.2 × 182.9 cm (56 × 72 in.). Courtesy Sperone Westwater, New York.

218 *Synthetic History*, 1996, oil on linen with arrow (approx. length 13 cm), 88.9 × 142.2 cm (35 × 56 in.). Lola and Allen Goldring Collection.

219 Detail of fresco by Andrea Mantegna showing the martyrdom of St Christopher, Ovetari Chapel, Church of the Eremitani, Padua, *c.* 1449–51.

220 *Leopard Panthera*, 1997, oil on linen, 142.2 × 109.2 cm (72 × 56 in.). National Academy of Design, New York.

221 *Painter's Floor*, 1999, oil on linen with diamond chips, 241.3 × 241.3 cm (95 × 95 in.). Albright-Knox Art Gallery, Buffalo, NY (Sarah Norton Goodyear Fund, 1999).

222 *Fallen Hero*, 1997, watercolour, gouache and encaustic on paper, 78.1 × 55.9 × 30.5 cm (30^3/$_4$ × 22 × 12 in.). Lola and Allen Goldring Collection.

223 *Out of Africa*, 1999, oil on linen, 182.9 × 142.2 cm (72 × 56 in.). Courtesy Sperone Westwater, New York.

224 *The Landing*, 1996, oil on linen, 203 × 138.5 cm (80 × 54^1/$_2$ in.). Private collection, Paris.

225 *Fire Boat*, 1999, oil on linen, 142.2 × 182.9 cm (56 × 72 in.). Angela Westwater Collection, New York.

226 Morley in New York, 1988.

227 Morley (third from left), Richard Smith (seated on radiator), Robyn Denny (far left) and others at the Royal College of Art, London, *c.* 1956–7.

228 Morley in his New York studio in 1973 talking about his canvas *Untitled Souvenirs, Europe* (68).

229 Morley teaching at the State University of New York at Stony Brook, 1972. *School of Athens* (61), still in progress, is visible in the background

230 Morley signing autographs at the auction at the Palais Galliera, Paris, 1974.

231 An installation view of the 1983–4 Morley retrospective at the Whitechapel Art Gallery, London. Visible from left to right are *Cradle of Civilization with American Woman* (114), *Arizonac* (108) and *Macaws, Bengals, with Mullet* (84).

232 Morley in his studio with the model of the *Pamela* used in many of his paintings, including *Shipwreck* (197), *Now Voyager* (204), *Man Overboard* (206), *Double Pamela* (208) and *Mariner* (209). Also visible are the 1993 oil *Perilous Voyage, Icarus* (166) and the watercolours *Shipwreck I* and *II* (194, 195).

Photographic Acknowledgements

The author and publisher wish to express their thanks to the following sources of illustrative material and/or permission to reproduce it:

Unless otherwise credited, all photographs are courtesy of Sperone Westwater, New York (or from loaning bodies named in the captions or preferring to remain anonymous). We would like to acknowledge the following photographers for their contributions: Richard Brintzenhofe, Ivan Dalla Tana, Jonathan Dent, Jason Dewey, Jacques Faujour, Beatrice Itatala, Bill Jacobson, Richard Loesch, Tom Powel, Adam Rzepka, Kenn Schles, Lee Stalsworth, Joseph Szasfai, Szepsy Szücs, Tim Thayer, Dorothy Zeidman and Zindman/Fremont. These photographers and institutions should be credited individually: Marilyn Aitken: 76; Fred R. Conrad: 232; © 1990 The Detroit Institute of Arts: 23; Xavier Fourcade Inc: 115; © 1980 The Metropolitan Museum of Art, New York: 31; Daniel Moss: 171, 178; Jozsef Rosta: 48; Bent Ryberg: 60; Tore H. Røyneland: 63, 125, 131; the author, 169; courtesy of the artist: 71, 227–31.